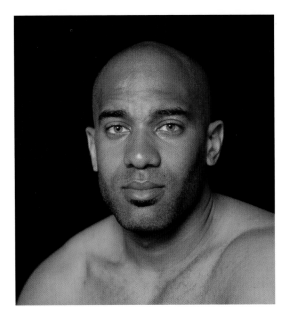

Blended Nation

Portraits and Interviews of Mixed-Race America

Photographs and Interviews by Mike Tauber
Co-produced by Pamela Singh

Introduction by Rebecca Walker Foreword by Ann Curry Essay by Alan H. Goodman, Ph.D.

For Wyatt and Rohwan

Foreword *by Ann Curry*

America's children of mixed race are evidence that love is overcoming even racism, which once seemed insurmountable.

"We come from open minded lovers," I like to tell people about my siblings, to maybe get a laugh and ease the feeling that we are different from everyone else.

It can be lonely sometimes to see people stare and struggle to figure out your ancestry. Since I was a child I have been asked, "What are you anyway?" The question used to hurt, but as you can see in Mike Tauber's photos, we are the new face of America and its noble ideals of equality and freedom.

For me it is impossible to say I am Asian or Caucasion, as choosing one would mean denying the other. No, the only way to honor the courage of my Japanese mother and white father to love in the face of adversity is to embrace both equally. As dad would say, "You are the best of both worlds," and so are the people you see on these pages, who cannot but strengthen America's dream, as they are living proof it comes true.

Introduction by Rebecca Walker

This has been one of the hardest introductions I have ever had to write. Not because *Blended Nation* isn't wonderful, because it is, but because the stories and faces in it are so familiar. Multiracial people have had to be shape-shifters. We have been ostracized. We have had to figure out how to move and be and live and love in the midst of racial categorization that has left us, the Mulatto Nation, betwixt and between.

But a new generation, a multiracial President, and a shifting global environment demand we rethink the old tropes of multiracial identity. It's hip to be multi now. The half Iranian, half African American woman has social currency, and the part Polynesian, Irish-American man does too. Multiracial people have at least two plots to follow in one story line, and three or four worlds to traverse on one trip. People still want to know "what we are," but our answers are met with admiration more often than not, and even envy. After years of pity, now we're "lucky" to have been exposed to so much.

The tragic mulatto is in transition. We've yet to reach the promised land of total acceptance, but we're closer than ever. And it feels good. Not as much explaining to do, and wondering how we should wear our hair. Multiracial people sell everything from Vodka to cell phones on billboards around the world, and rock runways from Sao Paulo to New York. Mutts, as Obama called himself in one of his first press conferences as President, are hot. The multiracial body is the new melting pot. Like the washing machine forty years ago, the multiracial body is the latest symbol of change, a better tomorrow. We are the future.

Blended Nation proves we are ripping the tragic out of mulatto, but it's a precarious moment. If we fetishize the multiracial story, and create our own version of the cool and exotic Other, we run the risk of putting the tragic right back into the equation. Our power as multiracial people is not in the idea of enlightened racialism – we don't have all the answers just because we're mixed – but in our refusal to be co-opted into any racial category or political narrative based on race, even the one marked "multiracial."

But it's hard. The conflicts between cultures and races and peoples have captured us. Our identities, the stories we tell ourselves about ourselves, are of being neither here nor there, blending it all together, feeling like an outcast, or making the most of it. Whichever we choose, race still leads. We feel the need to discuss it, to lament its particular trials and tribulations. Of course it is relevant. But what will save us from this new, blended identity? At what point does our new story become just another variation on a theme?

What now? I ask myself, reading the stories in this book. I know these stories, each and every one of them, too well. Which means our language has evolved, but not enough. We run the risk of being cliché. Again.

But I feel the future in Clive Tucker's statement, smack in the middle of *Blended Nation*. When he says he tries not to recognize "any part of his so-called heritage if the inquiry is solely based on pigmentation," he's pointing at a larger truth: our heritage is vast. We contain multitudes. Human history belongs to all of us. Each of us is entitled to claim its riches. And each of us is responsible for what we do with its wealth.

Of course I am encouraged by the election of Barack Obama, but I am equally inspired by the way thousands, if not millions, of people are self-identifying as Other. As the Dutch have abandoned their churches, and use them as museums and runway locations, so too are many of us dropping out of the race game. It has taken our self-determination and given us, in return, conflict, confusion, and turmoil.

Why bother? *Blended Nation* captures the contemporary moment perfectly. It's a bridge piece; it's how we get from there to here and here to there. The story is in the photographs – how people look and shine separate from their stories, from their ideas about themselves. Their bodies speak louder, much louder, than their words.

I'm happy to lend my words – but most of all that part of "me" that shines through the page. It's the part of me that's a part of you: inseparable and irrefutable.

Human. Blended. One.

Half Indian (Bombay, Goa), Half White (Jewish Russian-Romanian)

Ananda, Ari & Rehana Ellis

Photographed in New York City

Ananda (left): Being a person of mixed race has made me more open to other cultures and people who are different because I understand what it feels like to be different. I've never really dealt with society's "pigeon holing" of what am I and I've never struggled with it inside either. I'm not sure why that is. Maybe because I'm an identical twin, I never felt alone in that. Or maybe because it never affected me negatively. People always seemed interested in the fact that we

> I identify more with the Indian side. But growing up in America, I feel like an American who has an Indian heritage.
> – Ananda

> I feel more White than Indian. I have always been proud of my Indian heritage and feel that it has brought color and spice to my life.
> – Rehana

were half Indian, half Russian-Romanian. They thought it was a "cool" mix.

I identify more with the Indian side. But growing up in America, I feel like an American who has an Indian heritage. As I get older, I want to learn more about my Indian side. My father was American (Russian-Romanian parents) but he loved the Indian culture and didn't talk so much about his own culture because he was born in America. My mom was born in India and she would share stories about growing up there and we loved hearing them. I think the reason that we don't have identity issues is because of the way my parents raised us. We never questioned who or what we were because they helped us to feel secure with ourselves.

Rehana (right): I grew up in a WASPy area of Long Island, New York. I went to a private school that was predominantly white and very preppy. My sister and I were the only "brown" kids in our class. We got favorable attention because we were twins and because we were half Indian. I didn't have a bad experience in school being in the minority. I feel more white than Indian. When I fill out forms that ask

about my racial identity I check the box that says white. There is no box that says "mixed." This has not been a struggle for me. I think if I were an only child maybe this would be an issue for me. I think of myself as lucky to have such a unique background and be able to fit in almost anywhere. When people meet me they don't know what my ethnic background is and it almost becomes like a game. I have fun with it. People think I am Spanish, Greek, Italian, Middle Eastern or Brazilian. Very few say Indian.

I have always been proud of my Indian heritage and feel that it has brought color and spice to my life. From my father's side we have celebrated many of the Jewish holidays and I love the tradition behind them all. I feel fortunate to have been exposed to both sides growing up and when people ask me what my background is and I say, "I am a Russian, Romanian, Indian, Catholic Jew," I get quite a response!

Ari: On the one hand we felt we were the only three people in the universe who understood what it was to have a Catholic-Indian mother and a Russian-Romanian Jewish father. So we

are outsiders to every group but our own. On the other hand it is a gift that gives insight into each of the cultures/races that are a part of us as well as understanding as to what it is like to be a minority/person of color in general. Because we are diluted we are less threatening to white society and therefore more easily accepted. Because we are brown we are immediately connected to all people of color. While we identify with the heritage that is in the forefront at that moment, I think we identify with the Indian side more often because the Indian elements (like skin color, food etc.) seem to remain separate from generalized American culture so we are more aware of them.

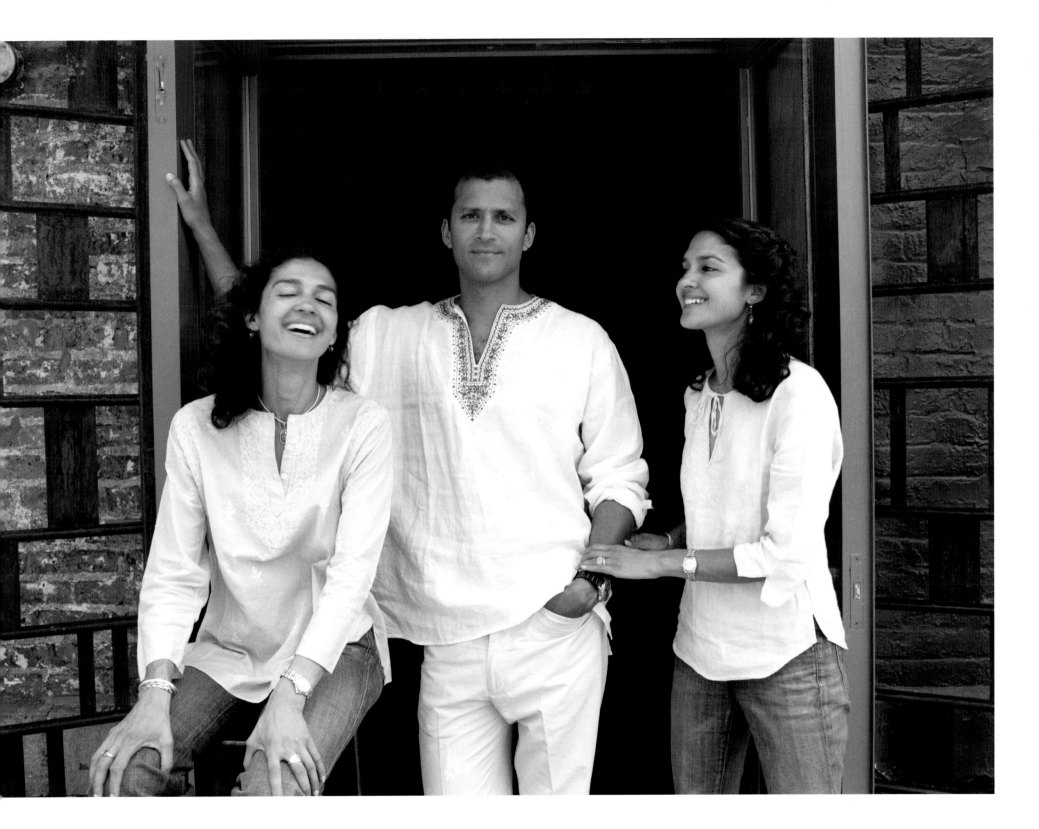

Photographed in New York City

Phoenix Blackhorse

I'm what is commonly called a "Native American" though that's not what we commonly refer to ourselves. We are the indigenous people of this land. I also identify with my African heritage. I was raised a "Native American" with Native values in my formative years. Being from and raised on the Isle of Manhattan in New York City, I grew up outside my household as a teen with others of many different backgrounds.

Until I was five years old, I didn't know other people were different. Not until I was twelve did I know I was different and unique. Each time it was a jolt to my way of being. I'm not a racist person, but I know other people can be, so I stay close to myself. I don't reveal who or what I am. Most people come with their own pre-conceptions, which makes them feel more comfortable. I mostly get people thinking I'm Brazilian, but I also get Latin, Caribbean, Spaniard,

I mostly get people thinking I'm Brazilian, but I also get Latin, Caribbean, Spaniard, Polynesian, South American and Hispañolan.

Polynesian, South American, Cape Verdian and Hispañolan.

My background and experiences have been the main influences on my beliefs. As a Native, religion is a practice that follows a very spiritual and philosophical direction. I'm pragmatic about the origins, beliefs and pursuits of life. Being raised by my grandparents and THEIR elders has been an immense value to my being. That parental influence has played the only significant role in the sense of my racial identity. Society as a whole doesn't know what racial category to try to place me in.

My elders were the most influential in the creation of my comprehension of self. My lessons also included what all other people are, so I have a better sense of being than most. I can refrain from passing judgment on those whom I have no understanding about. It's a shame that others don't do the same.

Like all men in my family's bloodline, we are warriors. It is something that has traveled through the blood. Due to our warrior culture, military service has been a big part of my family's history. My grandfather, a career soldier like his brothers, was a Master ("Top")

Sergeant in the U.S. Army and a veteran of three wars. That's had a very large influence on the generation ahead and me. Most have served and some are career soldiers. True to our warrior beliefs, we believe all races are creations of the Supreme Being's and we fight for what we believe in.

Perhaps now that we have Barack Obama, the first American president of African descent, society as a whole will mature to fully accept those of different AND mixed backgrounds. "Tops" always taught me I was a Thoroughbred from the Blood of Stallions...and not to ever forget it. I never have.

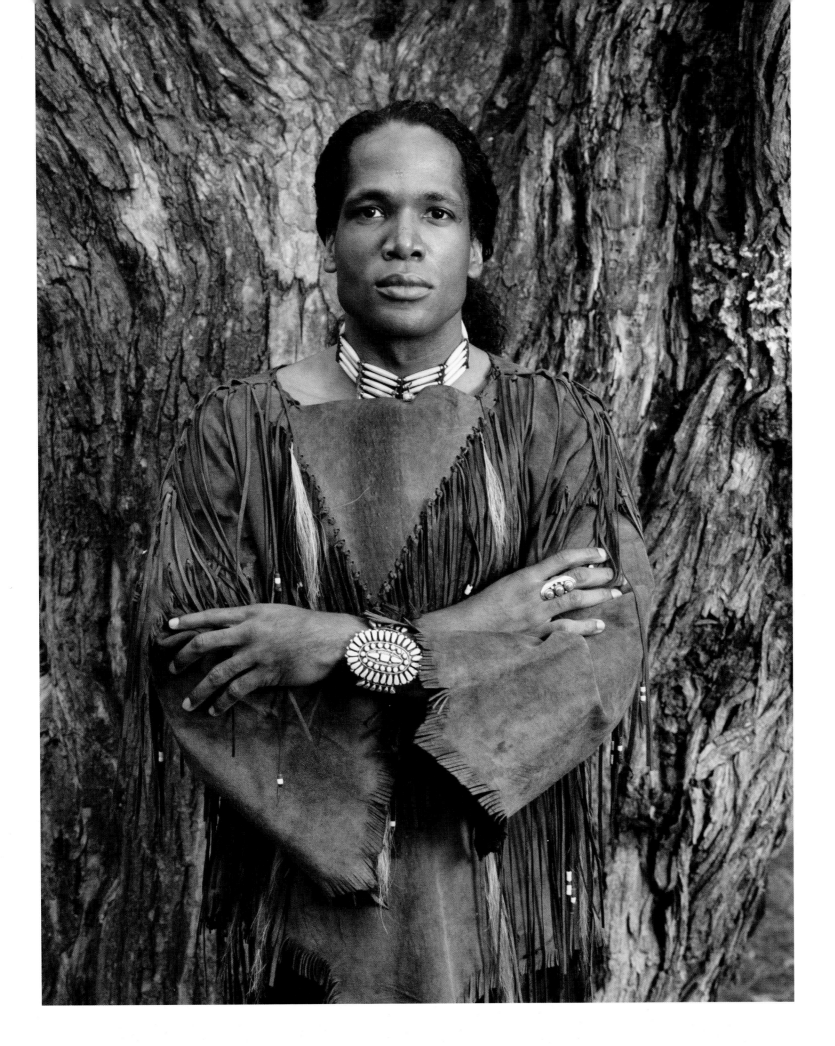

Janine: White, some Native American (Aleutian Indian)
Evan: African American, Native American (Cherokee, Choctaw), White
Children: African American, White, Native American (Cherokee, Choctaw, Aleutian Indian)
Bianca: White (pictured in photo on wall, center)
Geraldine (left): Evan's mother

Janine, Evan & their children Weston, Austin & Isabella

Photographed at home in Benicia, California

Bianca & Austin: Being multicultural has gotten us a few compliments because people seem interested. It has kind of affected our path in life because sometimes we'll be the only (part) black person in our class. It doesn't make too big of a difference, but you can always feel sometimes out of place. Externally we both just say what we are and sometimes people can be surprised. Internally we just think some people are curious. We don't take it too bad because we have been asked this often.

Bianca: I identify with my white side most because we live in a mainly white town and our school is mostly white. I also have all white friends so it's fun to be different. Some people will be surprised that my mom

We feel our position as a multiracial family is beneficial, special, unique, and beautiful… but definitely more difficult. The world is not always kind to us.
— Janine

is white, and that Austin's dad is black, because I look more black and Austin looks more white. Some people wouldn't think we're brother and sister because we don't have any features that are the same. Austin looks like he could be all white, but I could look like I'm mostly black. Austin's leaner and I'm not. Austin's high-strung and loud while I'm quiet and shy.

Austin: I don't really feel one way or the other. Half the time I'll feel black while the other half of the time I'll feel white.

Evan: My family disowned me for a few years, and that's been the biggest impact. I haven't seen an effect [on our children] yet—they are proud of who and what they are. Later it might manifest itself in some way, but as of yet I don't see any effects. The good thing is that we have a much broader view of life. The negative aspect of it was that one member of my family wasn't ready for it. So far it has only been a superficial relationship to our childrens' sense of identity; they haven't had any earth-shattering experiences that have made them have to protect or testify as to their identity.

Janine: By being involved with and married to an African American man, I see the world in a much broader sense than I ever did before. Ever since I met my husband Evan, I have been able to see the world through a multicolored lens, and not just the white one I was born with. His daily experiences have included many struggles as a man of color in a white society, yet he possesses tremendous courage to move forward despite these many obstacles. His experiences have both inspired me and incited me to become an advocate for racial equity.

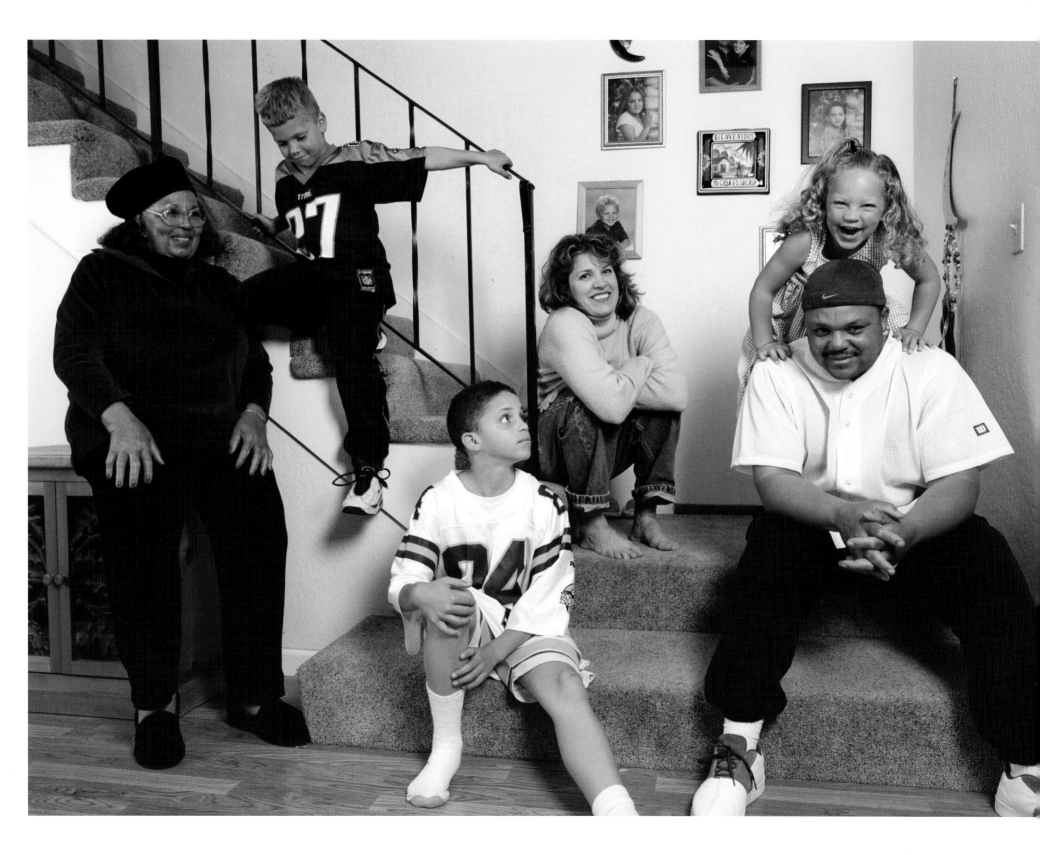

Half Asian (Japanese), One-Eighth Asian (Filipino), Three-Eighths White (German, French, Spanish)

From the time I was very young, I had an exposure to a rich assortment of cultures in my extended family. I have family who are European, Asian, and African American. I think the impact of growing up multiracial has allowed me to maneuver within the diverse fabric of cultures that make our country unique. In that respect, I am fortunate to have been raised with a mixed heritage.

I think most people automatically identify me as Asian because of the way I look. I was raised with a strong Japanese influence, and if I HAD to identify with one side, it would be my Japanese heritage.

I think the general influences of society have shaped my own self-image to an extent. Being constantly identified as something has contributed to my own identification with my Japanese and Filipino heritage. Not being "accepted" as European when I was young was a reality of dark hair and slightly smaller eyes.

I think the general influences of society have shaped my own self-image to an extent.

Kelly Ogilvie *Photographed in Seattle, Washington*

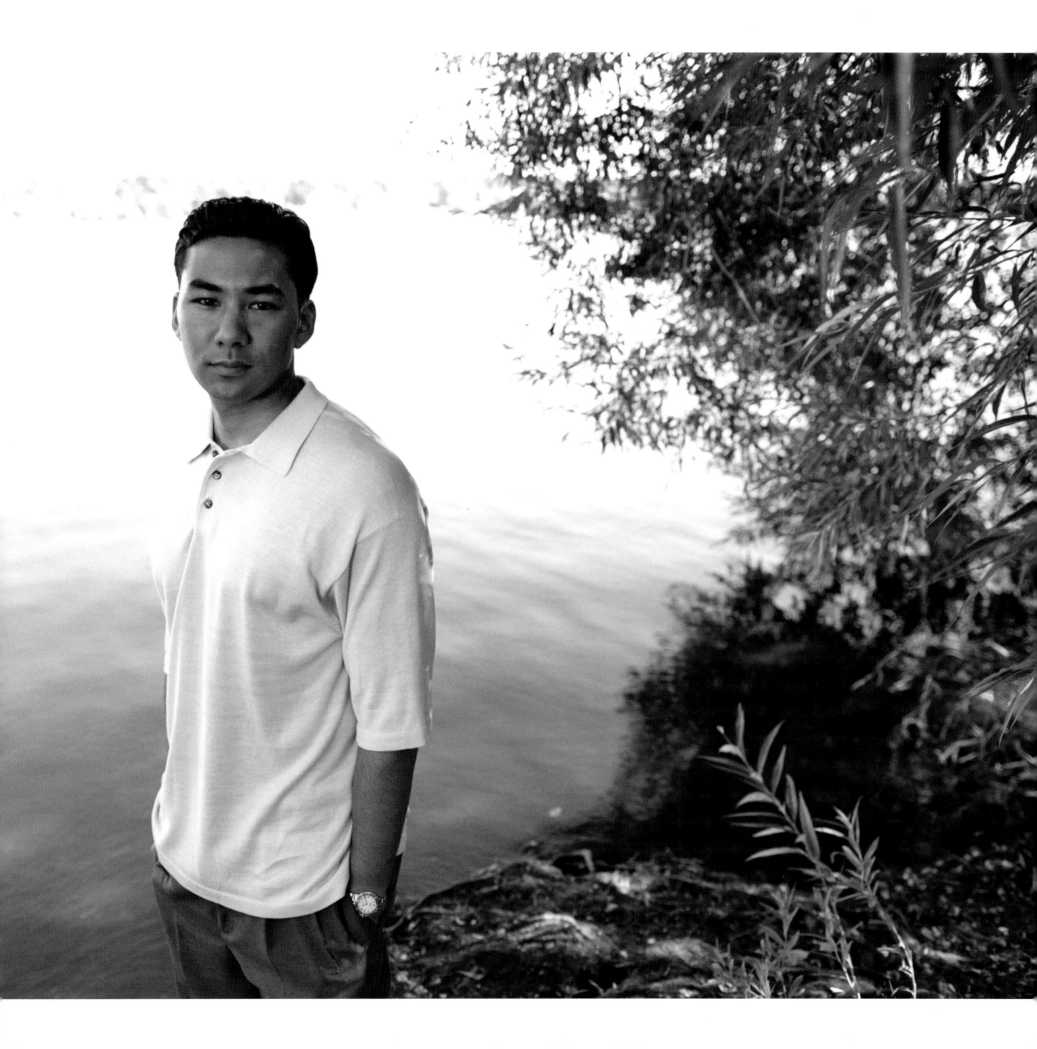

Ryan: Half Black, Half White

Photographed in Queens, New York

Ryan Schlachter & his mother Tracy Schlachter

Ryan: I feel more comfortable with African-American kids than Caucasians because I feel like I fit in a bit more. When we go out and stuff, I don't feel like I am a fifth wheel kind of. Like when I'm with my African-American friends I can be myself rather than adapting to my other group of friends and their interests. When I show people who my mother is they are surprised because we don't really look alike. I've been asked if I was adopted a few times. It's also hard spending a lot of time with my mother's father's family (they live in Ohio) because I'm the only one who really doesn't fit in as opposed to my father's family where I feel more comfortable.

Tracy: Ryan says that the biggest thing he's noticed is that most people assume he is adopted. He also doesn't feel like he fits into one group

> When I show people who my mother is they are surprised because we don't really look alike.
> – Ryan

or the other (black or white) – when I asked him this question, he said the place he feels like he fits into most is "our family." He feels that he fits in better at school with his African-American friends, and for the most part chooses to spend more time with them. Because he grew up in a very diverse neighborhood in Queens, through the years, his friends have truly been a range of all backgrounds.

Through the years of playing sports in the community leagues, he was almost always the only member of the team who wasn't white and/or Jewish; while he was able to fit in because of his love of sports, he often felt "different" – it wasn't really until he attended junior high, and then high school that he found a niche of friends with whom he felt the most comfortable. Today he definitely considers himself to be a "young African-American man." He doesn't have much contact with his father, so he hasn't really had strong African-American role models in his life, but he is very drawn to strong African-American men that he encounters (both his age and older). That's not to say that he isn't drawn to

white men, either. His musical preferences definitely run toward rap and hip-hop, as well as jazz.

As far as my point of view, I have had long-term relationships with three African-American men: Ryan's father and then two afterwards. I do wish that he had someone in his life consistently who could give him a stronger sense of his African-American heritage, as that is an area I can't really help him in.

I do remember when Ryan was a baby. I got a LOT of comments from people who passed us on the street. I spent a lot of time in Manhattan when he was a baby – I worked there, went to church there, and did most of my socializing there... I was always amazed by the audacity people had when they made comments (mostly by African-American men, and a few women). I've also found that in recent years when I have been walking around with an African-American boyfriend, African-American women stare and give very nasty looks. I was at a point where I was very aware of the looks, but I'm now at the point where I

don't even notice anymore. I know there are times when I will go to pick Ryan up somewhere and people have no idea who I am there to pick up! I find things like that funny... it's so much a part of my life, and has been for 16 years, that it's second nature to me.

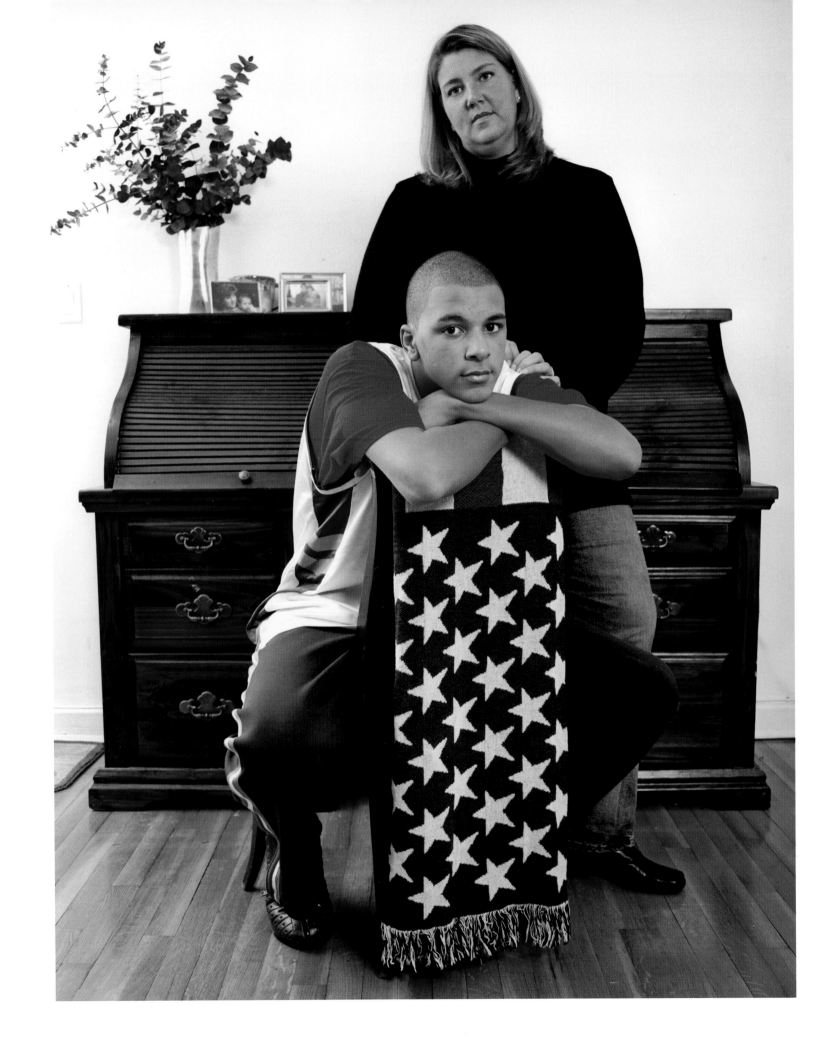

Liz: Mestizo Colombian, White

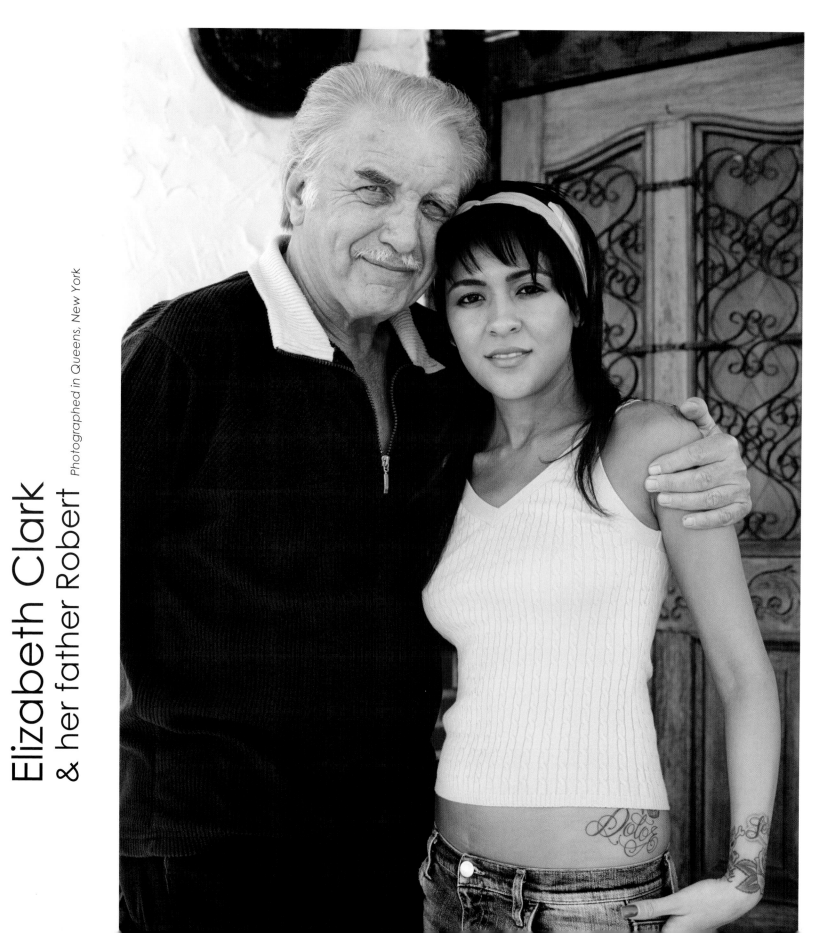

Elizabeth Clark
& her father Robert *Photographed in Queens, New York*

Half Black, Half Asian [Okinawan (Japanese)]

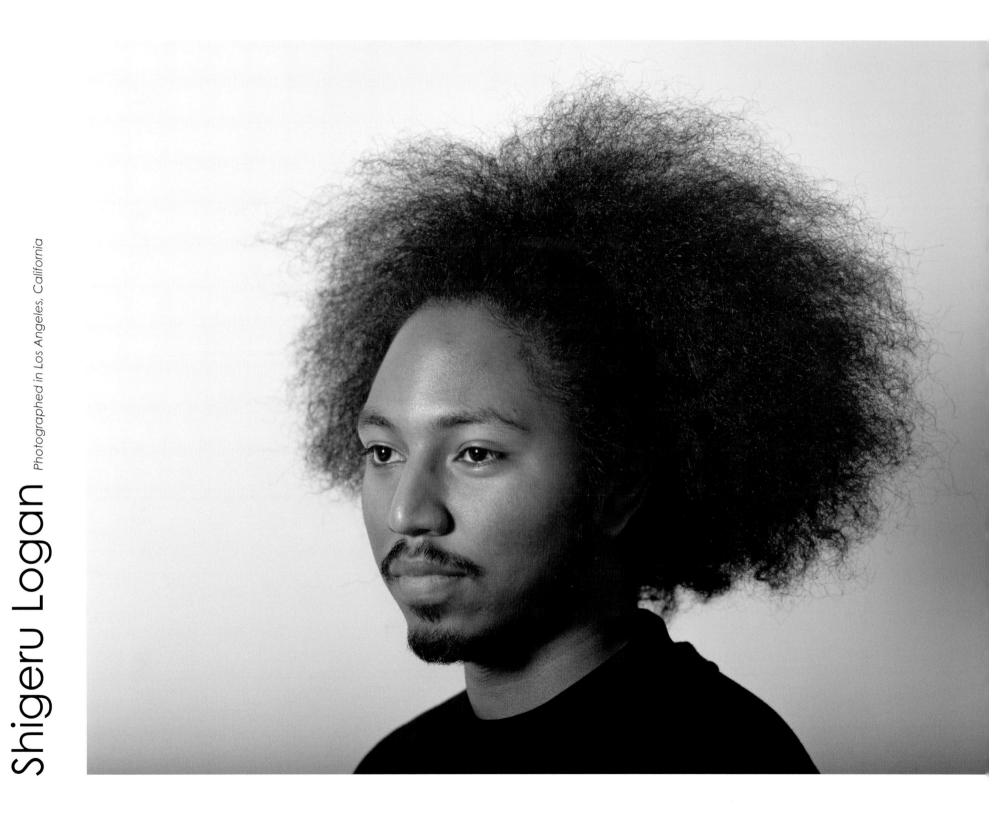

Shigeru Logan

Photographed in Los Angeles, California

Anita (left): Half Mexican, Quarter White (English), One-Eighth African American, One-Eighth Native American
Naomi (right): Quarter African American, Half White, Quarter Native American
Tanya: Half African American, Half White (English)

Anita Orozco, Naomi Gagnier & their mother Tanya Roome

Photographed in Los Angeles, California

Tanya: I grew up during the 1960s and 1970s when there were very few ethnically mixed neighborhoods and (primarily white) public schools were not tolerant of biracial children. My family moved often and my mother never appeared concerned about the racial make-up of the neighborhoods we lived in. Many times we lived in all white neighborhoods and the children in school were brutal. I lost count of how many times I've been called a nigger or excluded from school activities. The fact that my mother was white had no bearing on their opinion of me.

Similarly, I have lived in primarily black neighborhoods where I was called derogatory names like "high yellow" or "Oreo"

The truth was I felt extremely inferior to both black and white people. Regardless of the difference in their skin color, both groups appeared to have a sense of belonging and camaraderie.
– Tanya Roome

because of the way I talked or wore my hair. I even had several black girls threaten me because they claimed that I thought I was better than they were. The truth was I felt extremely inferior to both black and white people. Regardless of the difference in their skin color, both groups appeared to have a sense of belonging and camaraderie. Something I didn't have at school or at home. Growing up, I cannot remember a time when I did not feel like an outsider. I don't identify with any race in particular. I am grateful the world is a different place than it was 40 years ago when I was growing up. Both my daughters grew up with diverse groups of friends and the most astonishing thing has been they seem to like showing off their exotic looking mother.

Anita: When a person asks, "What are you?" I don't get offended. Curiosity is human nature. I can't always tell someone's ethnic background by looking at them, and I know that being a multiracial person has made me curious about the ethnic backgrounds of others.

My mom has done a wonderful job of educating my sister and me on the many cultures of the world, given us

a sense of appreciation for people, no matter what their ethnic background. I love knowing that I can identify with each of my multi races, however having my Mexican father's entire family in the same city, and living in San Diego, a city on the Mexican border, has allowed me to identify more with my Mexican heritage. Growing up, I was always going to family reunions and barbecues with my father's family. The Mexican people have an undying pride in their family and community.

My mom almost looks like she could be Mexican, because her ethnicity. I don't think my dad ever looked at her as anything but beautiful. I know that my father's family had issues with her being half African American. I've held resentments towards my father's family for how they treated her. The funny thing is they love her to death now. But there are people in my family that still have ignorant views on race, even though out of 10 cousins (including myself), only 1 is full Mexican.
Naomi: I identify with my African-American heritage more than my Caucasian but there are times when I feel like I have to act differently around people or places when I identify more with my

Caucasian heritage.

I had to stand up to my stepmother when I lived in New York because she felt that because I had blue eyes and red hair it wouldn't be acceptable for me to say I was anything but Caucasian. When I did that at first I was scared and she looked at me like she was going to stone me to death and then I was proud cause the aunt came over and after hearing about what had happened, my aunt stood up and said that on that side of my family I was not the only one who was African-American and Caucasian and that I am who I am and that I had every right to stand up for myself in that situation. Needless to say my stepmother never brought it up again.

Naomi: I identify with my African-American heritage more than my Caucasian but there are times when I feel like I have to act differently around people or places when I identify more with my Caucasian heritage.

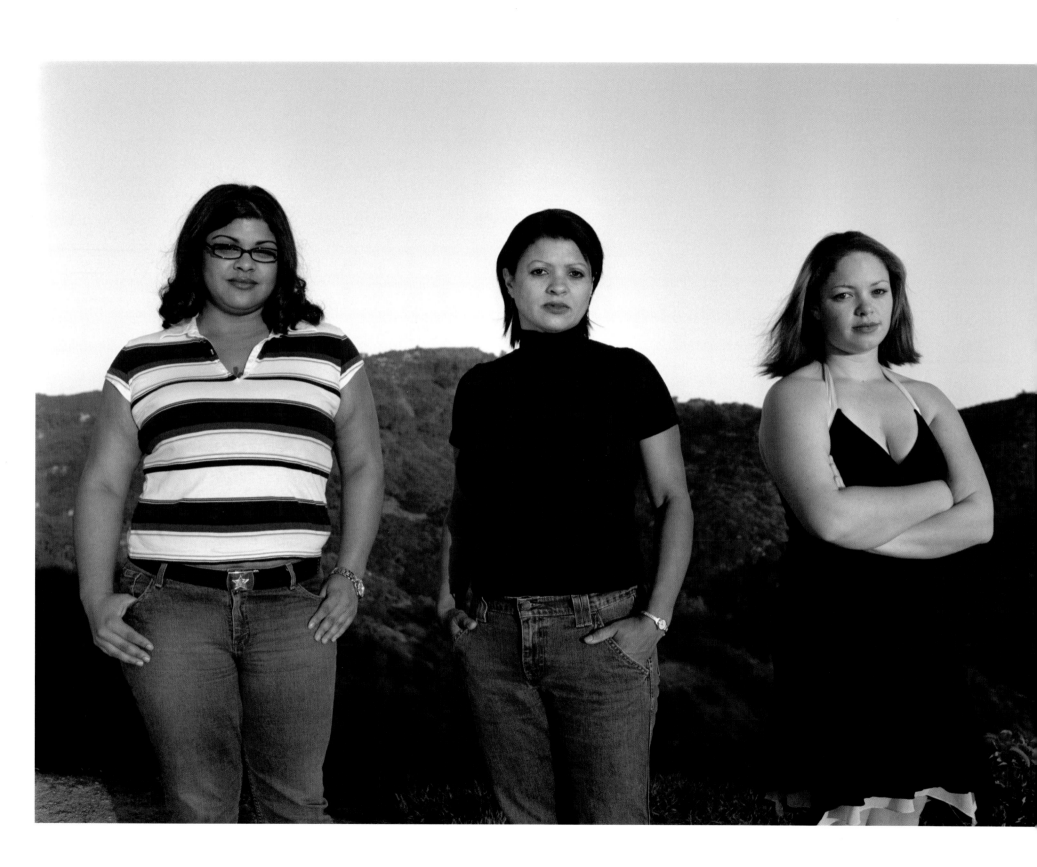

Cheryl Quintana Leader

Photographed in Mar Vista Hills, California

Being a person of mixed race has impacted my life in a few ways: Of the "East/West European (Spanish/Portuguese/Russian/German/Polish/French) descent-ness" of me, my blue eye status, and with regard to my last name – Leader – I have been able to get through life fairly unscathed.

Of the "Latino (Spanish/Portuguese/Aztec Indian) descent-ness" of me, my wide cheekbones/almond shaped eyes, and with regard to my last name – Quintana – I have received mixed reviews. The Caucasian community that are my friends feel that I should "take advantage" of being

"You are what they call 'a bridger.' You will be able to open and enter doors others cannot, and then hand over hand (with a rope pulling motion) be able to bring them through behind you."
– Gloria Bonilla-Santiago to Cheryl

"the flavor of the month" and opt into all the opportunities afforded to my community by the government. Then, there are those in the Caucasian community that are not my friends, who feel that I am just a mere opportunist who is "scavenging off" what they feel to be unfair "hand-outs" by the government. Then, there is the Latino community who feel that I am not "Latino enough" because I don't speak Spanish fluently, I don't come from the "neighborhood," and I don't subscribe to the same religious or cultural beliefs as more traditional Latinos do.

I have chosen to deal with society's "pigeon-holing" by placing my "x" in the "other" category and list myself as "American", with a Mexican: Spanish/Portuguese & Aztec Indian, Russian, German, Polish & French descent. This has been quite empowering for me, as I have always chosen to be a "redefiner" for those around me who continue to live life by rote. As a writer and director, I've experienced how impacting words, concepts and imaging can lead others to "believe" the will of those doing the writing, conceptualizing and

painting/filming/broadcasting impressions.

Due to my external appearance, I tend to lean to the Caucasian aspects since it's more predominantly woven into my physical presence. As well, I identify more with the "American" culture aspects of who I am, as I had been raised with a mother of Mexican origins who was not proud of being "Mexican" nor honored much of anything in her culture nor chose to actively share it with her own children.

Having the piercing blue eyed gene of a German soldier who fled the trials of World War II into the safe arms of Mexico, I was never initially considered anything other than "Caucasian or White." Ironically, also encased in my DNA was the combination of the Jewish people persecuted in Russia, Germany and Poland, where, of my father's thirteen distant relatives, only four made it alive to the Boston shores.

"Mexican" seemed to have a negative connotation where I grew up both in Phoenix, Arizona and Torrance, California. My father's family in Milton, Massachusetts seemed

to have not fully bonded with this "mixed" family of my father's, and felt that marrying a Mexican woman was equivalent to marrying a black woman; and that was not to be fully tolerated in the Jewish community nor in my father's family. There always seemed to be a feeling of superiority and prejudice among my "Caucasian/Jewish" relatives from back East. We rarely saw them or connected with them.

Much like a lighthouse beacon, it was after having met Gloria Bonilla-Santiago of Rutgers University, that I felt fully guided to port. It was she who stated, "You are what they call 'a bridger.' You will be able to open and enter doors others cannot, and then hand over hand (with a rope pulling motion) be able to bring them through behind you."

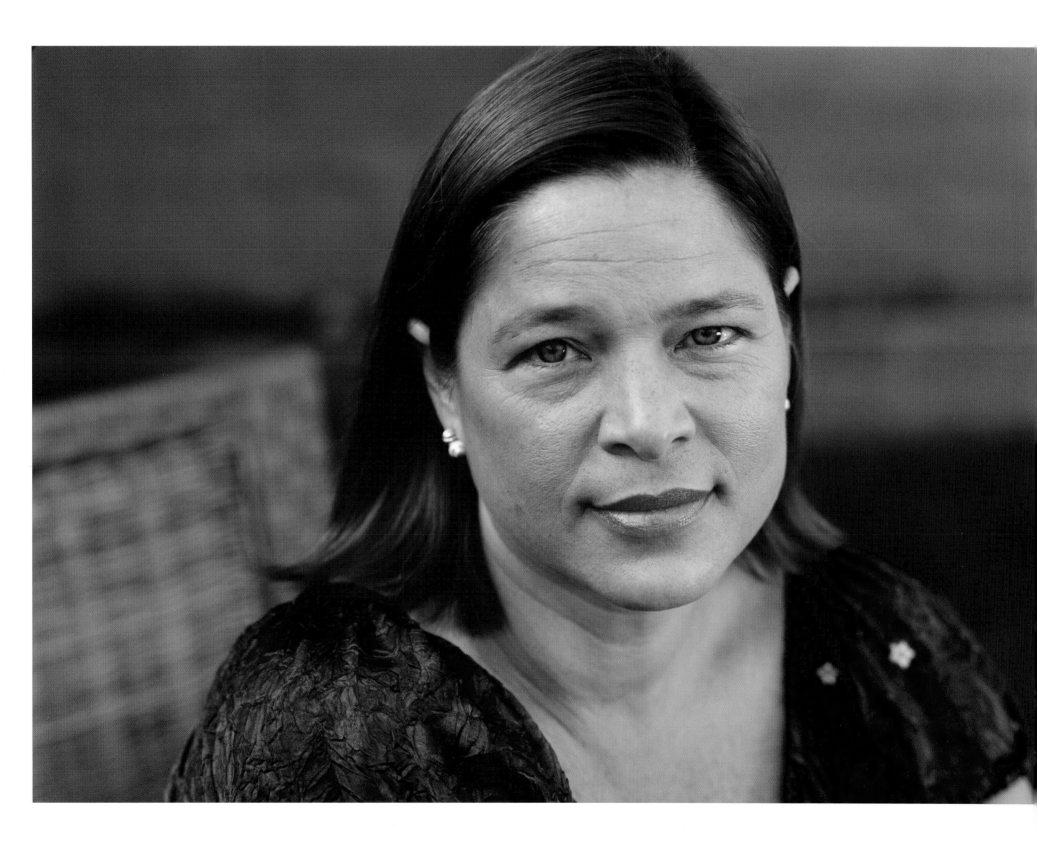

Half Asian (Japanese), Half White (Irish, French-Canadian)

I'd say society has been more influential in terms of identifying me as a person of mixed race. Having racial slurs directed at me really drove home how my non-white status appeared to others. Unfortunately, the racial slurs continue still.

There have been so many situations in which my race has come into question or been a factor. One thing that continues to amaze me is how differently others perceive my mixed-race heritage. One person might not even care while another will be offended that I don't speak Japanese. As an adult, I think I identify most with my Japanese heritage. Unintentionally it seems to come out in my creative work. Of course it helps that I grew up in a house filled with Japanese arts and crafts.

John Ross

Photographed in his boutique in New York City

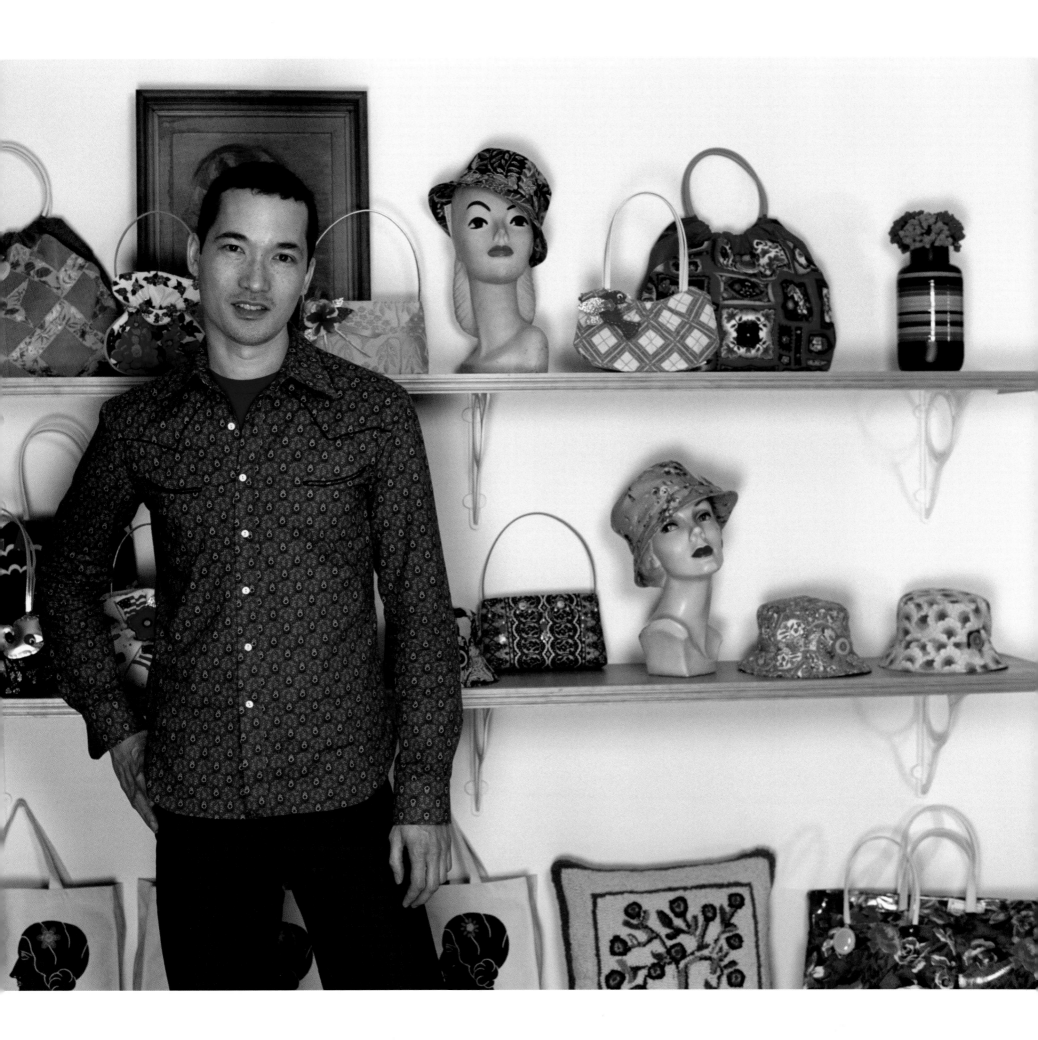

Half White (English), Half African (Mchaga from Tanzania)

Alexis Johara Hoag
Photographed at Yale University, New Haven, Connecticut

I cannot compartmentalize aspects of myself – race, gender, sexuality, poverty – to describe how each has affected my path of life because they are all interdependent. My ethnic make-up is black and white; two seemingly opposite ends of the "race spectrum," but my existence as biracial destroys

When I was four-years-old, a classmate innocently prodded, "Is that your mother?" And I naively replied, "Of course," only to hear in return, "No, your real mother?" As I approached the sidewalk that afternoon to meet the woman in question, I looked down at my brown skin and up at my mother's white complexion and recognized for the first time that I was different.

the paradigm of distinct racial categories and allows me to think about things outside of strict dichotomies. When I came out as queer years later, I discovered that I could explain my sexuality using the same discourse as my race. I recognize my sexuality as part of a continuum, somewhere between homosexual and heterosexual. And to bring it full circle, my sexuality does not exist in a vacuum, but within the context of my ethnicity and gender.

Becoming comfortable in my skin was a long process and didn't really happen until I left home for college. I grew up in a predominately white area and the only other brown person in my home and immediate community was my older sister. When I was four-years-old, a classmate innocently prodded, "Is that your mother?" And I naively replied, "Of course," only to hear in return, "No, your real mother?" As I approached the sidewalk that afternoon to meet the woman in question, I looked down at my brown skin and up at my mother's white complexion and recognized for the first time that I was different. I had to be told I was "black" because it wasn't part of my self-identification. My mother always told us we

were racially mixed and that addressed any curiosity I had up to that point.

Yet when I went to Los Angeles to visit my mother's sister who lived in a black neighborhood with her three African-American children, I encountered tension from the other end of the spectrum. One weekend afternoon, I rode my bike through my aunt's neighborhood and two older black girls stopped me: "Why you always tryin' to act like you white, huh? Talkin' like you was white, you think you better than us, huh?" In tears, I rode back to my older sister who shared my confusion in silence. I was too black for my white classmates and too white for those black girls.

I always identify as mixed and I always check off two boxes. If I called myself anything else, I'd be denying a significant portion of what makes me Alexis. Of course, others generally perceive me as black, especially whites. Other African-Americans can usually tell I'm mixed and Africans often ask me if I'm East African.

My father immigrated to the United States from Tanzania in the late 1960s and started teaching at a Southern California college; meanwhile

my mother was taking classes at the same school to finish her degree – but he wasn't her teacher! There was a 14-year age gap and they had two children together. Unfortunately, my father chose not to be a physical, emotional, or financial support in our lives. It was hard to be a brown-skinned kid in a white community without having a cultural connection to my ethnicity. My father never stayed around long enough to teach my sister and me Swahili or the history of our Mchaga tribe. In an attempt to fill that void, my mother surrounded us with images – toys and books – that reflected what we looked like. Most importantly, she was there for us and sacrificed everything to ensure her daughters grew up self-confident, intelligent, and well-adjusted. I wouldn't be where I am today without my mother's support. When I was younger I used to resent being brown-skinned, it meant I was different and I so desperately wanted to blend in with everyone else. Today, I happily embrace my brown skin and curly hair. I love being different and couldn't imagine myself any other way.

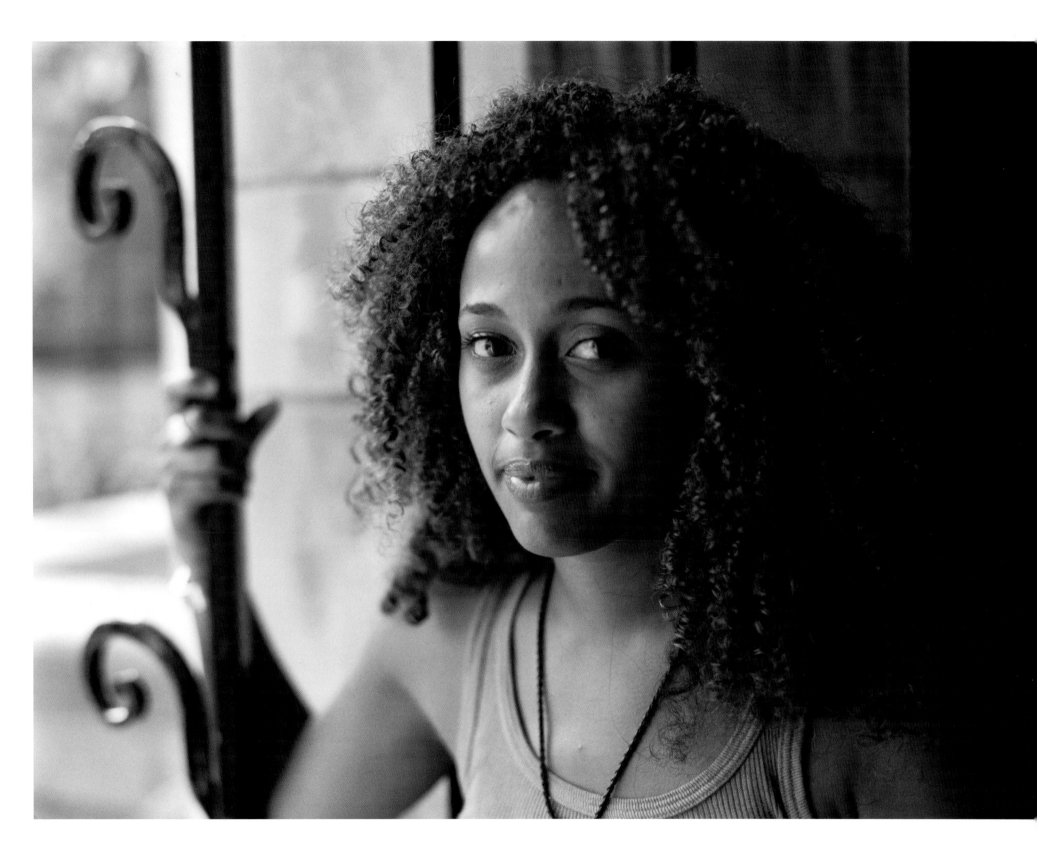

Half Asian (Korean), Half African American (Creole)

Diana Bernard, Lynne Angione, Julia Bernard & Laura Loftsgaarden

Photographed in Alhambra, California

Laura Loftsgaarden (right): As a child, I felt excluded by both races, although African-Americans were the most tolerant of my mixed race status. The Koreans have had a much harder time reconciling their feelings of racism. When filling out race surveys in school, there was always an "other, please state" box that I would check and write "hybrid." Some teachers would notice this, and come to me and ask me about it. I would explain that I didn't most identify with either race, and the teachers would check the "Black/Negro" category and walk away. Older African-Americans would laughingly

I identify with the diversity of my racial heritage. I am the "flavor of the month." If I feel like chocolate, I am chocolate. If I feel like cherry, I am cherry. I indulge myself. I love being multiracial. –Julia Bernard

say, "If you've got one drop, you're black."

My Korean heritage is not obvious at first sight. When Korean people ask, I usually say that my body is black; my blood is Korean. Black people never ask which side I identify with—I think they assume, like most whites, that I identify with the blacks. Basically, all my childhood all I wanted was to fit in and be accepted by either group, but I never felt fully accepted by either. As other mixed-race over-achievers began to gain national attention, it became "cool" to be of mixed race! When people learned about my mixed race, they stopped staring as though I was a freak, but they would stare with envy, and say something like, "You're like Tiger Woods!" After so many years of being the outsider, I never would have thought it would be cool to be me.

Lynne Angione (center): I look more like a full-blooded Mexican than a mix of Creole (black and French) and Korean. When I was younger (childhood to mid-twenties) it made me angry that people would come up to me trying to speak Spanish. I was angry

that neither the African-Americans nor the Koreans would identify with me. The African-Americans were more accepting, once they found out that I was part black. The Koreans treated me very badly. They were openly racist and would turn their noses up at me and act like I was something dirty. As I got older, I realized that I had all these different cultures in my background. The history alone of Africa, France, Korea and American Creoles is intriguing and captivating. I started researching the cultures and found them quite fascinating. I felt special. On surveys and questionnaires asking for my ethnicity, I usually check "African-American" or "Other." I most identify with my African-American heritage.

My parents met in Korea. My dad was a sergeant in the U.S. Army. My mother was a secretary working at the U.S. Army office in Korea. My father grew up in Chicago and my mother grew up in Te-Gu, Korea. It was 1961, I think. My mother was engaged to a Korean general. She became very ill and was hospitalized. My father took care of her and visited her every day. They fell in love and my mother

broke off her engagement to the general. After that, my parents married in Korea. My mother's family did not approve, especially marrying a black man. A year later, my parents moved back to the United States. My father's family was openly hostile to my mother. They treated her like a maid. They told my father that the only reason she married him was to come to the United States. My mother was eventually accepted into the family along with the children. My father passed away in 2001. Relations between my mother and my father's family are still good.

Julia Bernard (standing): Attempts to "pigeon hole" me into a particular racial stereotype have been unsuccessful. On the down side, I am a misfit to all races in my heritage. On the up side, there are no expectations to consider, and I am free to be me and cater to my every whim. People who know me say I don't fit any particular race. There are no boundaries. I identify with the diversity of my racial heritage. I love being multiracial. I cross all color lines. Being multilingual is a plus, and seemed to come naturally to me.

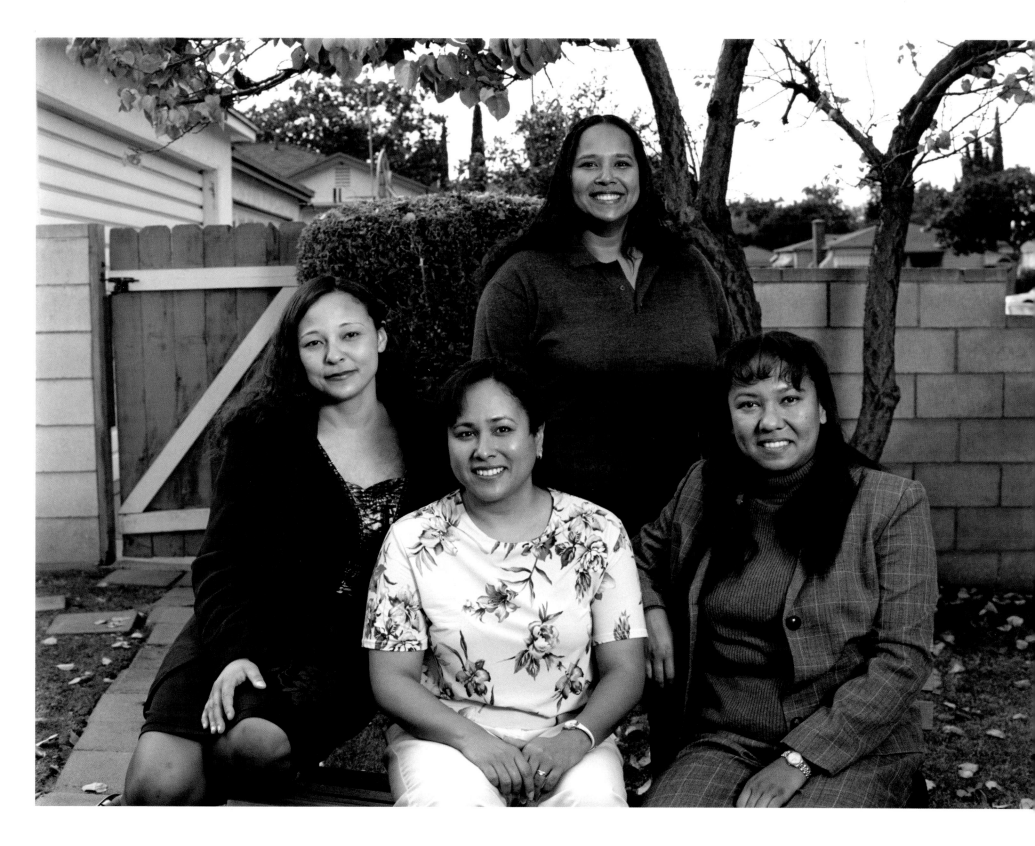

Half White, Quarter Black (Creole), Quarter Asian (Korean)

Alex Davis
Photographed in Alhambra, California

It's hard to identify myself by the terms most people are used to. Many forms for things like tests or applications only allow me to fill a single bubble for my ethnicity. Many times when I have asked questions on whether I should identify myself with a single race or fill in "other/ prefer not to answer," teachers have laughed at me or tell me to figure it out on my own because they have never heard of a situation like mine.

When I was in the first grade, I went to a mostly Korean school. Since I'm only a fourth Korean and have never looked Korean, the other kids would make fun of me when I said I was Korean too. They never believed me. I didn't know the language as well as them so they would like to make fun of me in Korean. I

Why is it that everyone else can have their opinion on whether or not I am enough of a race to be included, but I can never include myself?

could understand bits of what they said and all of what they said when they spoke in English. They would say things like "She doesn't know Korean because she doesn't look Korean," or "She's weird." The most common thing the other kids would do to me was isolate me and ignore me because they could not understand what I was.

Usually I'll think [I identify as] White because I'm half White, but only a fourth Korean and a fourth Black. So since I'm more White than anything else, I should consider myself White. But then I'll think, well, I'm only half White, and that's not really enough to consider myself as being White, but then the other choices don't supply much more reassurance in that sense.

Now that I'm older, most of my peers don't estrange me because of my race. It usually sparks their interests, especially when I tell them of growing up in a household with mixed culture. They find it hard to imagine being four feet tall sitting on the rug and playing with toys while the smell of your grandfather's Creole cooking

filled the house, and at the same time your grandmother sat listening to the Korean radio and snacking on Korean food. They find it fascinating to hear about a house with Han Boks in one closet, and in the next closet a military uniform from the Korean War. Both hold the story of a Korean War bride coming to America with her soldier husband to escape the Japanese.

As I go through high school and discover who I am more and more, I have begun to feel a sense of pride about being multiracial. Few are, and I want to present this to the world. I have never been included with a race, I've only ever been not enough White to count as being White, or not enough Black to count as being Black, or not enough Korean to count as being Korean. Just last week someone called me a "nothing." Why don't I identify with anything? Why is it that everyone else can have their opinion on whether or not I am enough of a race to be included, but I can never include myself? For example, if I tell someone that I like to consider myself Korean, they

look at me like I'm blind, like somehow I haven't realized that I can't possibly consider myself Korean when I have two whole other races to consider.

And lastly, why is it that only people like me who are multiracial ever ask these questions? Many people wonder what it's like to be another race, learn about those cultures, but multiracial people do not. All my interactions with people have been affected and changed because of my race.

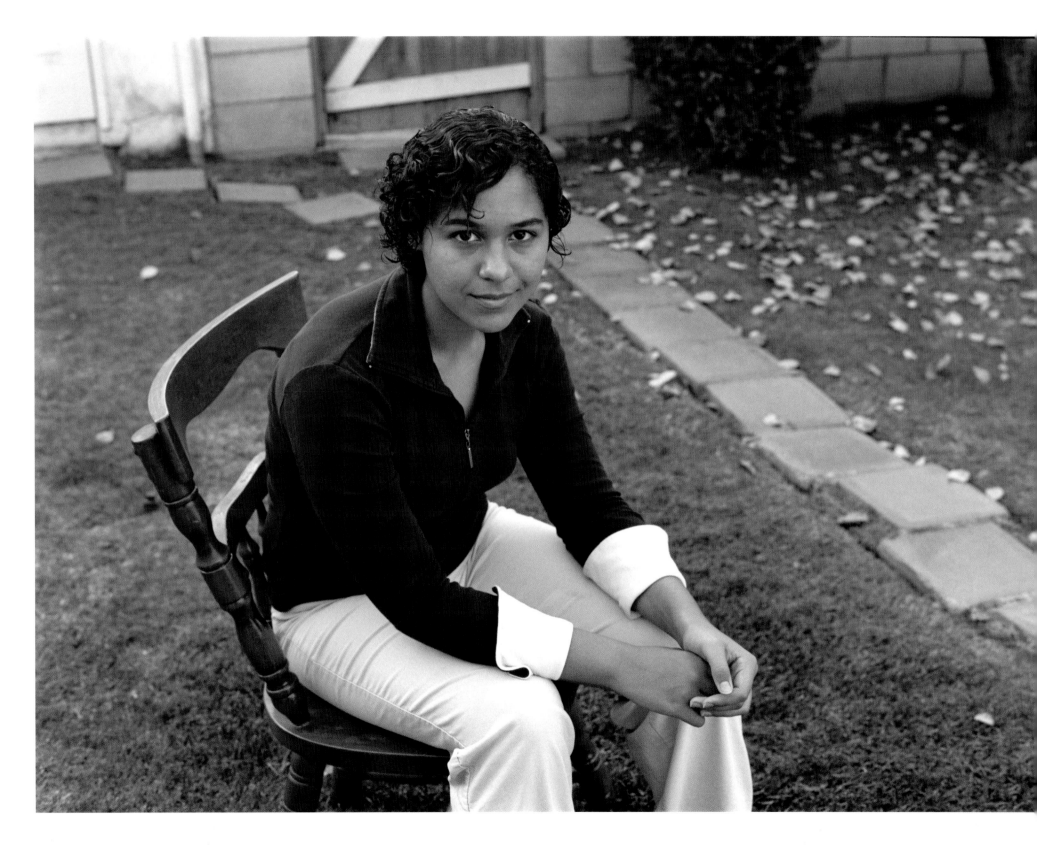

Less than Half Black (includes Creole), Quarter Asian (Korean) and more than a Quarter Native American

Brandon Scruggs *Photographed in Alhambra, California*

My whole family is different colors. When I was a little kid colors didn't matter to me. I noticed a difference between some people but didn't think that it had any significance. After all I was being raised in a house with a multicolored family. I mean, my grandma was Korean, my grandpa was Creole, and my sister was half white. When I finally learned that there was such a thing as racism and racial prejudice, it didn't quite sink in how it would affect me. It wasn't until I started to learn about the history of the country that I actually started to see and feel the effects of society. By the time I hit high school the pride of my people had begun to mix with the hormones. Over the four years that I was in high school, I learned a lot of things about exactly what is and isn't different about the US we live in now and the US we read

I do see myself as being Korean. However, the part of me that has been most active socially and politically has been my African-American heritage…spiritually I am a Native.

about in class that existed 200 years ago.

I can't stand standardized tests that ask you about your cultural background and then ask you to only circle one. To seriously think that the majority of the kids taking that test today have one cultural background is, at least to me, extremely and incredibly retarded. Me, I know what I am. I always check other. I know what's in my blood, and when people get it twisted I untwist 'em. Besides I don't feel like it matters what someone is, but who someone is. The only time I'm worried about what someone is, is if I'm just curious. They might look a lot like a friend I have from Europe. Maybe somewhere in their family tree someone was from that country in Europe. Maybe someone will have mocha brown skin and light blue eyes. It isn't really relevant to anything but one gets curious as to where they got those eyes.

Well, the only Korean people who ever really took to me were my family, their friends, and my Tae Kwon Do instructor. Still though I do see myself as being Korean. However, the part of me that has been most active socially and politically has been my African-American heritage. When my

blood runs hot, my belly and my eyes burn with 400 years of fire. The same 400 years of fire that makes today's black man the way he is. The fire that fuels the wars on the streets against "The Man." The fire that fuels the lyrics on the CDs or the unparalleled intensity of the athletes. Even though I may identify closest with black people socially, spiritually I am a Native. My spirit calls to the land and the natural world around me. When the wind blows, I take a deep breath and listen to the trees whisper to each other. I always feel a deep connection to the Earth and to the spirit world and a deep connection between the two inside and outside. That's probably why people think that I'm such an oddball.

Nowadays there are many different mixtures of people. You can look at someone and tell when they are mixed. Especially anyone who is mixed with a dark skinned race. But, see, even though people are changing, there are still a lot of people who see things as being the same. These people do everything they can to keep things the way they want them and don't realize that instead of preserving the past and saving the present, they are cutting themselves out of the future. Progress is inevitable.

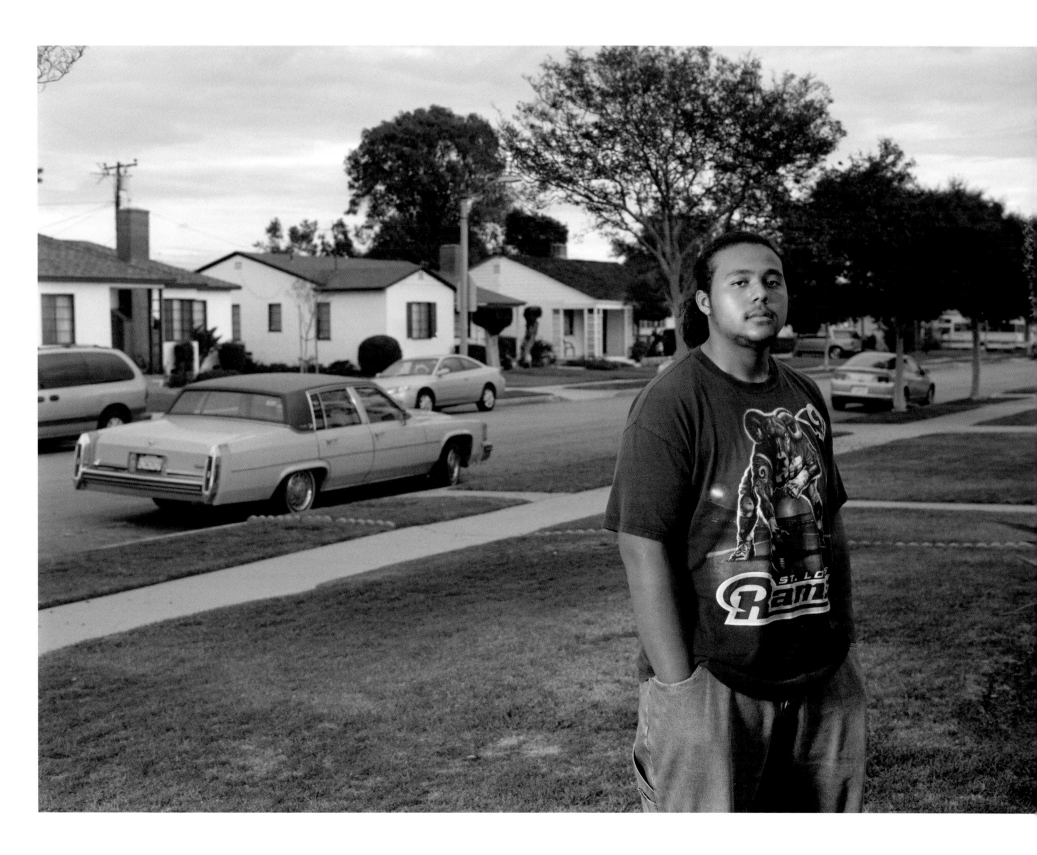

Half Asian (Vietnamese), Half White (French, German, Irish, English)

Kim Sauvageot *Photographed on Fishers Island, New York*

My parents met in Saigon during the Vietnam War in 1969. My mother was working for the U.S. Government, my father was looking for an assistant and she was recommended to him. After working together for a few months, they started dating and fell in love. My mother's family did not approve of her relationship with a non-Vietnamese man. In fact, he was her parents' worst nightmare: an American GI. They considered it a horrible reflection on their family. My mother was devastated but continued to date my father in secret and they married each other March 4, 1970. I was lucky that by the time I was born my mother's family had come to love and accept my father.

Most people cannot tell that I am half Asian when they

> I don't think I view myself as Caucasian, instead of Asian. However, I do view myself as American as opposed to being Vietnamese.

first look at me. They always assume that I am Caucasian. I've heard many racial slurs made against Asians because the person saying them has had no idea that I have Asian blood in me. I don't think I view myself as Caucasian instead of Asian. However, I do view myself as American as opposed to being Vietnamese. I read, write, and speak Vietnamese, but I feel that's just a part of who I am, not necessarily something that makes me feel Asian. I've never really considered myself one particular race. I've always lived in multi-cultural areas where race wasn't something that was a focus.

The four years I spent in Charlottesville, Va., at the University of Virginia, I experienced a definite division of the races. There were two Greek systems: one predominately white and one almost 100% African-American. One night I was out looking for a friend of mine who was at a fraternity party. When I walked up to the door, the drunk Caucasian boy standing there put his hand out to block me and drawled, "We don't let your kind in here!" It was the first time in my life I had been viewed as Asian. I experienced

an odd mixture of anger, fascination and guilt. Anger towards this young man's ignorance, fascination for being recognized as Asian and guilt for not ever facing any of the prejudices that many people hold against half of my heritage, simply because of how they look.

I think the largest impact I've felt from being biracial has been on the home front. Being exposed to two such different cultures has been an invaluable experience. Speaking two languages, celebrating both Vietnamese and Christian traditions, and watching how being raised in both countries has contributed to making me the person I am today, are all things that I have recently come to appreciate.

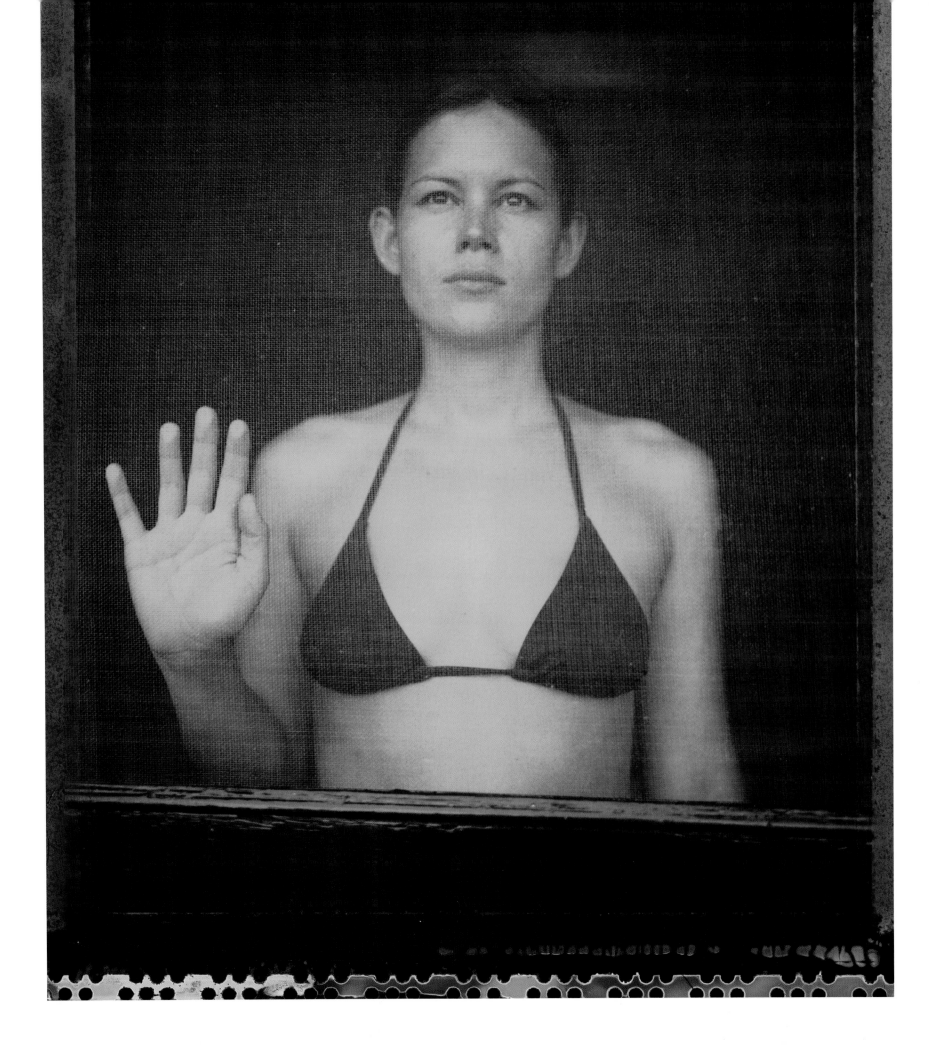

Half Asian (Japanese), Half White, Some Native American (Choctaw)

Amanda Hashimoto

Photographed in Seattle, Washington

Being Yon-sei, fourth-generation Japanese-American, I'm an American raised by Americans who were also raised by Americans. Though each generation has its own identity and developed in a different stage of American culture, we are all nonetheless Americans. There is no Japanese way of life to compare my experiences because my family has lived here since near the turn of the 20th century. I am part of the first multiracial generation of my Japanese-American family and in being so I believe I represent a new stage of my family's American history. This generation of my family is one

I most identify with being Japanese-American. Not because I choose to ignore my other racial heritages, but because those other heritages have been for the most part lost in the many generations of my mother's family.

that is not struggling to fit in, not outwardly discriminated against, and not alienated because of my family's history.

Being a person of mixed race has led me to seek out others with multiracial backgrounds and aid in the fight to educate others about mixed-race identity. I have a degree in American Cultural Studies and currently work in Human Resources. My long-term career goal is to become a Director of Diversity for a major corporation.

I most identify with being Japanese-American. Not because I choose to ignore my other racial heritages, but because those other heritages have been for the most part lost in the many generations of my mother's family. I recently learned that I am part Native American, Choctaw, through my mother's lineage. This is a new and exciting discovery, but not one that I identify with because I was not raised with the knowledge of Native American life.

When someone asks, "What are you?" I understand they're simply curious about my background, but that is a personal question. People don't realize how complex

the question is to a person of mixed race and how long it would take if they were truly given a full answer. My short version is that I am fourth generation Japanese-American. This is the majority of my personal make-up. Not by pure genetics, but by my own identity. I was raised in a Japanese-American family and identify best with those loved ones.

Society and media have taken a sharp turn in the past five years to embrace both multiracial individuals and multiracial couples. These days you see multiracial babies and adults in Gap ads and multicultural couples on billboards advertising new condominiums. It seems the media is embracing that which makes us individual and different, even if only via outward appearance. I understand that these ads are using a multiracial identity or lifestyle to promote their equally "unique" products. Some people would say this is negative exposure to use multiracial identity for such consumerism. Others would say some exposure in the media is better than none. It's an age-old debate that every race and identity struggles with in America.

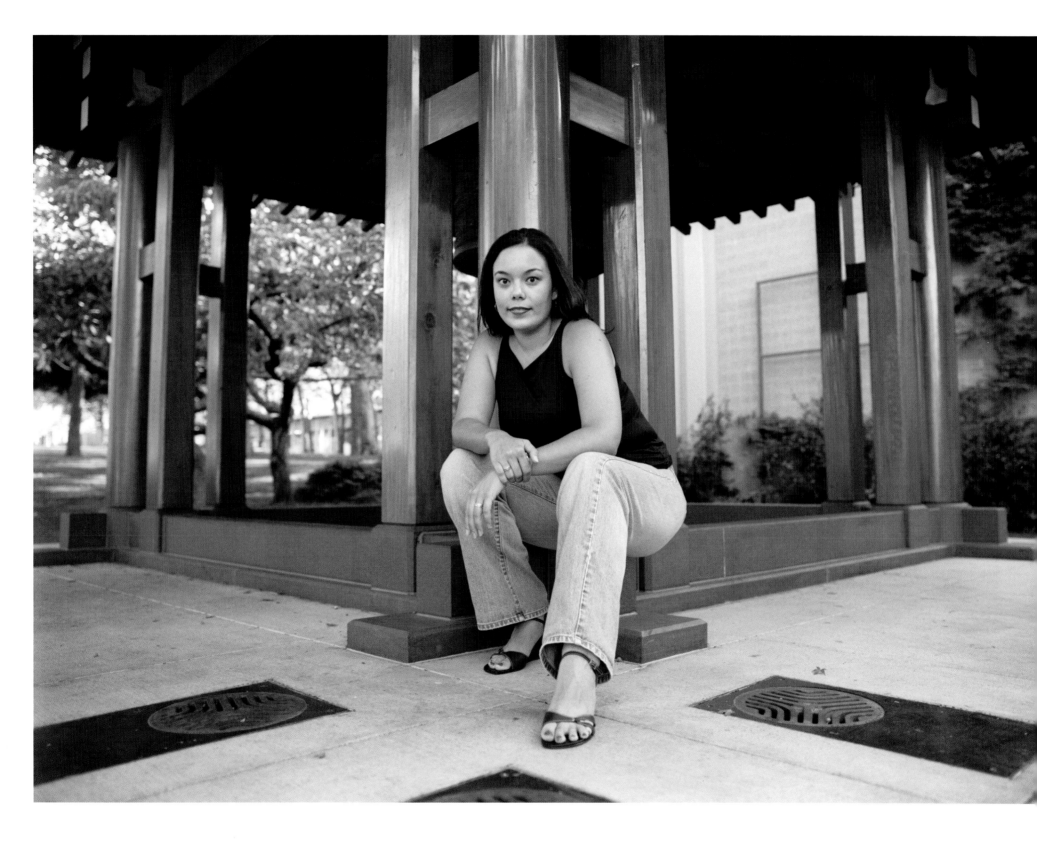

Half Pacific Islander (Samoan), Half White (German, Irish), Some Native American

I'm very proud to be biracial, and feel blessed to have the opportunity to experience two different cultures. My mom's side of the family is opposite in every aspect to my dad's, but both are loving, supportive and fun to be around in their own ways.

I was fortunate to grow up in Hawaii where almost everyone is of mixed race, so I never felt different or out of place. My mom's side of the family is from Washington State, so that played a big role in me choosing the University of Washington for school. I've never felt pressured to choose one race or the other and have never felt discriminated against because of being half-Samoan. I love being different and unique. I like when I tell someone I'm Samoan, they tell me about the numerous Samoans they've known, how nice (and big) they were and then proceed to ask me if I know them. It's nice not to just blend in with the crowd; it makes me feel special.

Culturally I feel like I'm more White than Samoan. I don't speak the language, and don't participate in a lot of the traditions. However, I hope someday to travel and live in Samoa to truly learn and understand my heritage.

Sionna Stallings-Ala'ilima

Photographed in Tacoma, Washington

I've never felt pressured to choose one race or the other and have never felt discriminated against because of being half-Samoan.

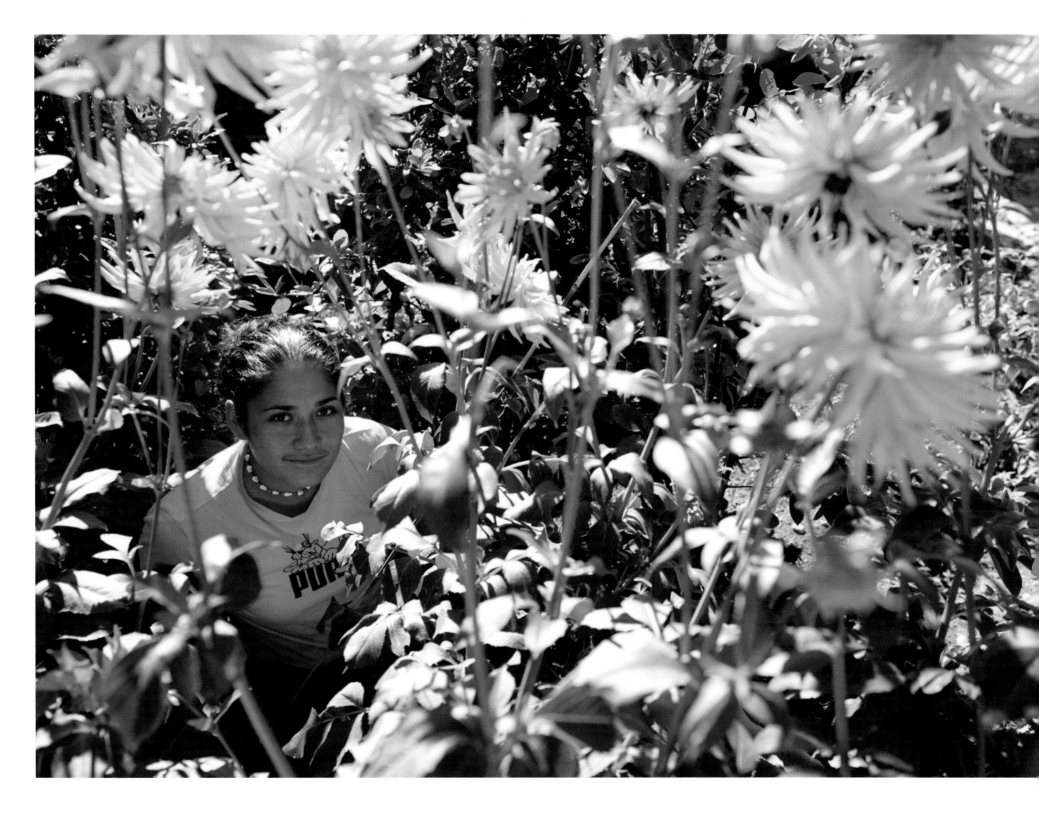

Joel, Carey, Carla & Jeremy Saulter

Photographed in Seattle, Washington

Joel : Early on, being a mixed-race child was confusing because I wasn't exposed to many other children that were anything but Euro-American. At that time I didn't realize that I was physically different, so when it was brought up it surprised me. I wanted to do anything to fit in. It might be cliché, but I had a bit of an identity crisis because I was 'black' to white kids and 'white' to black kids. That constantly made me wonder if I would be shunned from the racial categories that represented me. Although I experienced very little blatant racism, I knew that people were aware of my differences and some were more inclusive than others. Not everyone was or is going to accept me simply

Being black, for me, is about a political statement and a social choice, but more than anything, it is about an emotional connection to a group of people. I'm black in my spirit and my soul.
– Carla

because my skin is darker than theirs and that's fine with me. I love being multi-racial because it has taught me to be more compassionate and accepting of those who I cannot identify with.

I always accept all aspects of my racial background, although society considers me black. I have been discriminated against because I look like what a person considers black, so how could I not identify with black people? No person has ever referred to me as white, so intuitively, I do not identify with white people in that respect. Society has definitely been a huge impact on how I view myself. It's hard to accept all of my genetic make-up (namely my Native American heritage) when I am considered black.

Carla: This is probably pretty cliché, but I think that [being multi-racial] has made me more open to differences. There are so many different kinds of people in my family (not just black and white) that I never expected people to be a certain way and therefore had an easier time relating to and accepting others, no matter what their backgrounds or lifestyle choices. I pride

myself on being able to blend in almost any group. The flip side of that, however, is the fact that I'm also never 100% at home in any one group; there is always a part of me that feels like an outside observer. Because of this, I am blessed to have (and to have always had) many biracial friends and three siblings who understand exactly what it is like to be me.

I identify very strongly with being mixed, but if you asked me to pick one race with which I identify most strongly, there would be no contest: black. Being black, for me, is about a political statement and a social choice, but more than anything, it is about an emotional connection to a group of people. I'm black in my spirit and my soul.

Carey: I identify with both races, but if I have to choose, I would say black. I am constantly flat-ironing, relaxing, and oiling my hair, something Caucasian people don't have to deal with. Also, I have always been listed as black in school. I happily identify and ally myself with the black community, but I don't allow anyone to define my race for me. I am mixed race, and

if you ask me to check only one box on a form, I just might check three.

Jeremy: I have made a conscious and quintessential decision in my life not to side with simply one race. Reason for my decision: I'm much too complicated. I appreciate myself in entirety, and know that if I did not, and if it were not for my mixture, I would not, and could not be who I am today.

My parents have been very supportive of my multi-racial experience. Being multi-racial himself, my father always made an effort to educate me on all of my history. My mother was also a very accepting person, of all races and creeds, and would chastise me for being prejudice, or making degrading comments towards any race or person.

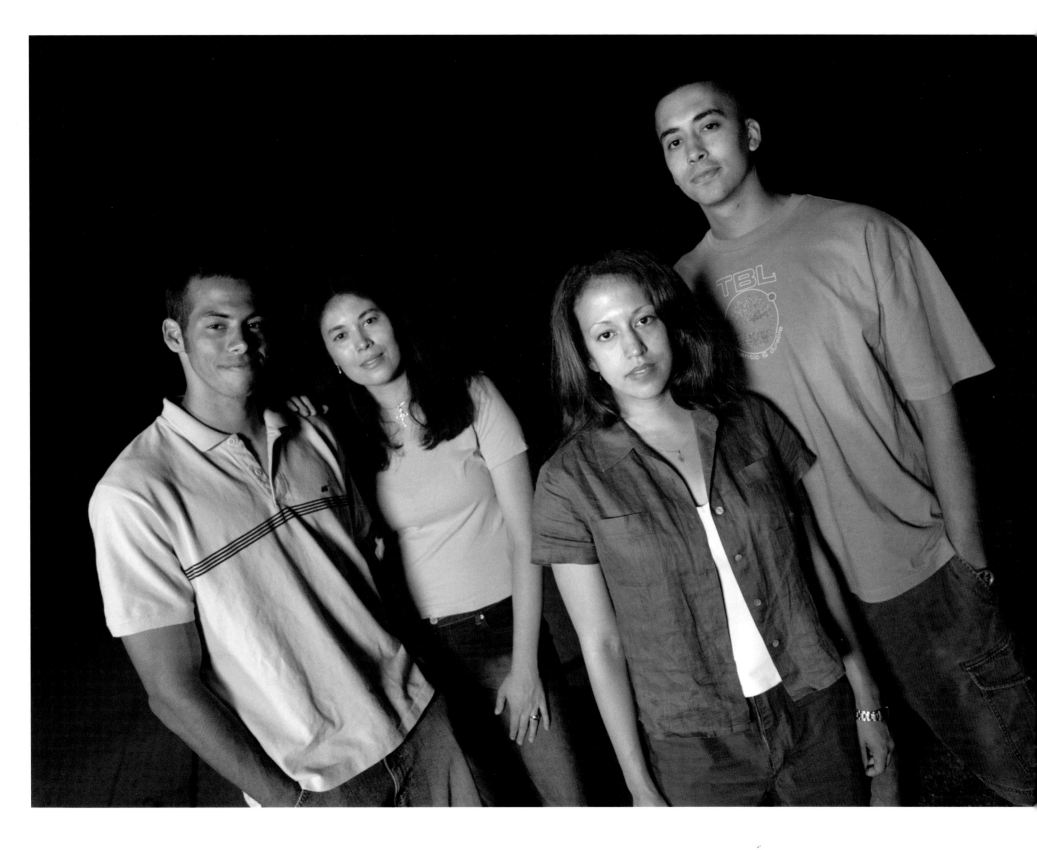

Half African American, Half White (Sicilian, Irish)

Lisette Austin *Photographed in Seattle, Washington*

The first time I heard about the "American melting pot," I knew I contained many of its simmering ingredients. As a child, I remember being mesmerized by Schoolhouse Rock's cartoon version of the great American story, with people of all races (including one Statue of Liberty) happily ending up in a large cooking kettle. I was a living example of that culinary experience – black, Italian and Irish. I was the color of hot cocoa, which I decided meant I was sweet and delicious. I was living proof that everybody could get along.

I was happy in my cultural fondue for many years. I grew up in Seattle, the adopted daughter of a black man from Virginia and a White French-Canadian woman. I thought it normal to have one light-

The more I tried to figure out how to be acceptably black, the more depressed I became. I didn't know many in my situation, and I felt isolated.

skinned parent and one dark-skinned one, to speak French as well as English, to travel the world, and to live in a funky, colorful neighborhood filled with artists, gays, and transient youth. I didn't think it strange that my community didn't include many people of color.

But in my early twenties something started to feel wrong. Maybe it began when a black teenager approached me and some white friends and kicked me in the shin. "Don't forget you're Black," he hissed. Or it could have been the Spike Lee movies about the inexorable separation between white and black. Or perhaps it was the black man who, upon discovering my boyfriend was white, notified me that as a black woman it was my duty to carry on the black seed (I had no idea black people were on the endangered species list). Whatever it was, I was no longer feeling good about being an unofficial representative of the melting pot. What was it going to be: white or black?

The more I tried to figure out how to be acceptably "black," the more depressed I became. I didn't know many in my situation, and I felt isolated. I wanted out of the melting

pot, wanted to have just one heritage and be done with it. I fantasized about leaving my boyfriend, running away, and immersing myself in a black community where I could raise a nice black family and disappear into normalcy. But I could not imagine carving away most of my life. And when, in a fit of distress, I admitted to my boyfriend my thoughts of escaping his skin color, he sat down and cried. "Then racism really will have won," he said. Relief came in my late twenties when I stumbled across a web site called Interracial Voice. Hundreds of people posted their thoughts about being multi-racial, living in interracial relationships, and having interracial children. They shared the challenges and joys of transcending color lines. "Identify with love," one woman wrote. "Don't categorize yourself, even if others do." I had finally found others who had tried to identify with one race over another and had given up, finding strength in embracing their unique identity as mixed-race people.

This helped me let go of the need to choose one racial identity. I could embrace all of my flavors again. I realized I had myself internalized a form

of racism, thinking I should act a certain way because of the color of my skin. I now envision a day when our country will be less race-obsessed and divided. I hope for not only the end of racism by whites, but also racism by minorities against whites and other minorities who don't fit stereotypes.

Today I am married to the man I almost ran away from. Although I sometimes fear that my son will be pushed to categorize himself according to how he looks, I hope to show him a way free of boundaries and limitations. He heralds what is possible with the next generation – that perhaps someday the concept of race as we now know and experience it will cease to exist.

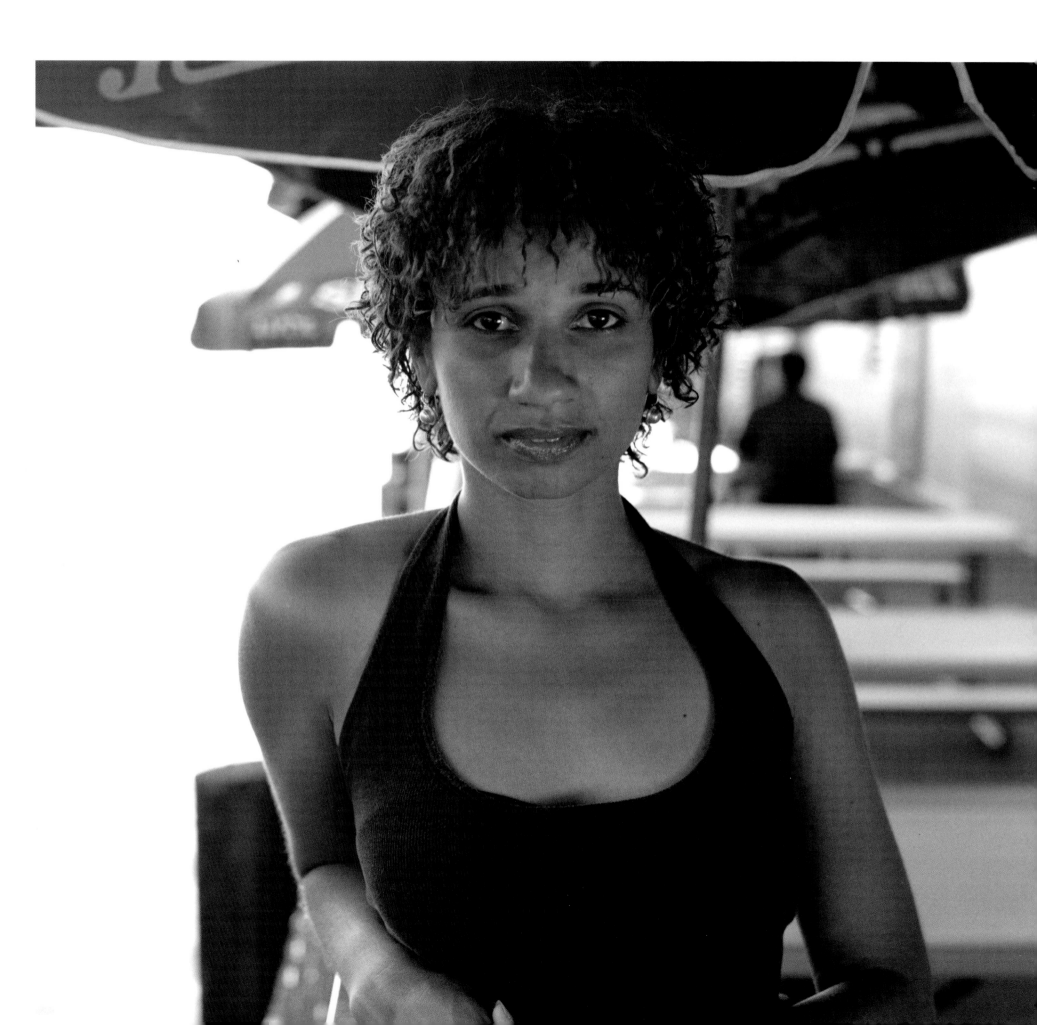

Half White (Irish, English), Half Black (some Native American)

Photographed with her daughter at home in Seattle, Washington

Erika Payton

I grew up in Cleveland, Ohio. My neighborhood was comprised of large Catholic families, and Jewish families. There were some families of color, but I remember only one family that was biracial. I had a pretty "normal" childhood although I often wished that I was a part of just one ethnic or racial group. I was often asked "What are you"? I did not have the language to describe myself or my family. As a result I felt bad about myself. The only words I had to describe myself were slurs. I never told my parents about these feelings or experiences, and they never talked to me about them. To compound my isolation I also never felt accepted by my mother's side of the family, and never met anyone on my father's side.

I would like things to be different for my daughter. I believe that because of my experiences growing up, I will be very intentional in my actions and conversations with my daughter in regard to her racial make-up, and where her family is from. I want my

I have experienced my share of racism by Blacks and Whites.

daughter to know both sides of her extended family.

We live in Seattle, Washington in a racially diverse neighborhood. There are many people of mixed race here. I hope that she will find comfort in her community. I classify myself as a person of color of mixed race. However, growing up I identified with the "white" community. My mother is white, and my brother and I were primarily raised by her. I wasn't necessarily accepted by the white community all the time though. I have experienced my share of racism by blacks and whites. I am also aware of preferential treatment I have received because I am a light skinned person of color.

Unfortunately, my parents did not talk to me about racial identity. When describing myself in the past, I would overlook the racial part, unless asked. It has been a long, hard road to get to who I am today: someone who is proud and confident to talk about my personal and racial identity. I still feel my face get hot when someone asks me "What are you?" but it is acceptable now to just say mixed. Most people don't question me after that.

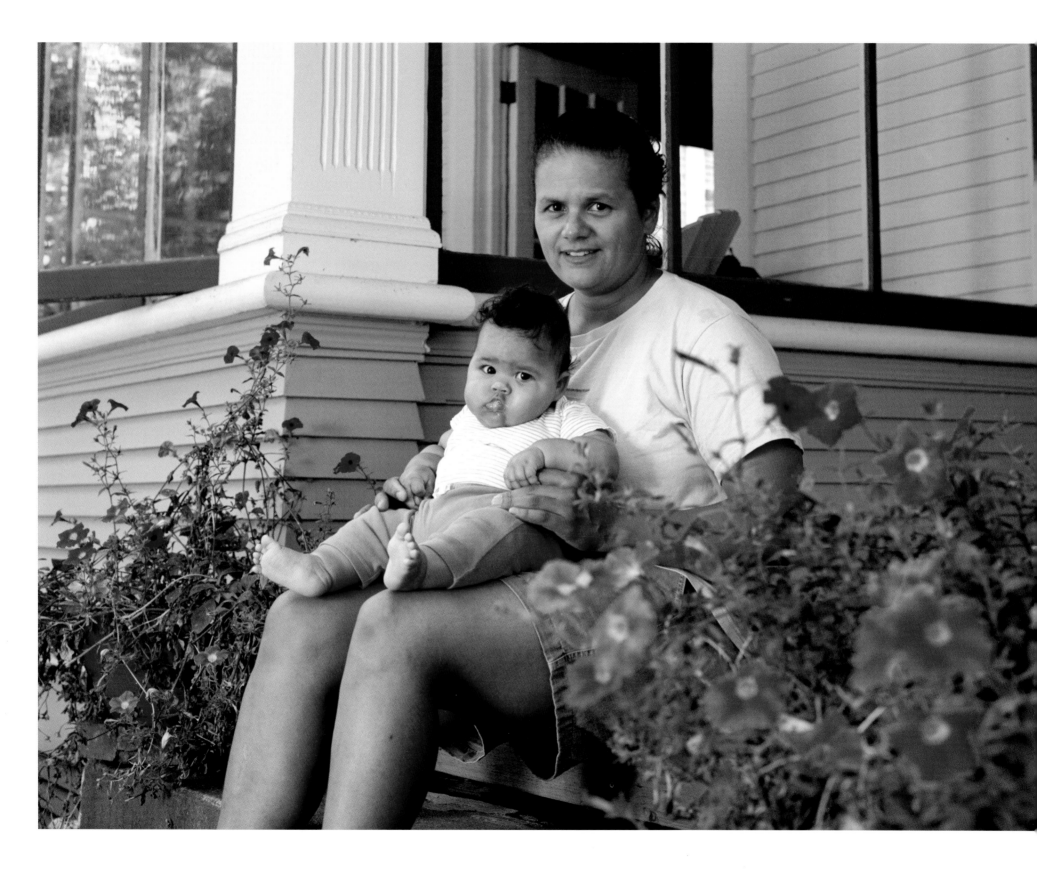

Quarter American Indian (Okanagan), Three-Quarters White (Irish, Swedish)

Darla Lewis

Photographed in Seattle, Washington

I grew up in a small town where everyone knew me and my family and didn't have to ask me questions about why I look the way I do. Then I came to college. I go to a private Christian college where most of the students are upper white middle class.

Curious acquaintances ask "So, what are you?" I have fun asking them to guess. I get Hawaiian, Latina, Italian, and

Everyone, including myself, has this ingrained view that you can only be one or the other. I'm not White enough that they don't have to ask "what are you?" and I'm not Indian enough that they know without asking. It makes me feel a little disconnected from the White side of me, but even more so from the Indian side of me.

"exotic" most often. While they can be flattering, I'm always a little disappointed they don't know by looking at me. Only once or twice has someone ever correctly guessed. I grew up in a white community and spent more time with the white side of my family, so the white culture is dominate in my life, but a lot of the ways I was taught to act come from my American Indian ancestry, the way I treat people – always serve others before serving yourself, do what's best for the community as a whole, be hospitable no matter what – things like that are what have gotten me farthest in life. But society has also taught me that "the majority rules" and the "majority" of me is white. And because of the "pigeon holing" I always feel awkward, no matter the situation, when I have to explain my racial identity. Everyone, including myself, has this ingrained view that you can only be one or the other. I'm not white enough that they don't have to ask "What are you" and I'm not Indian enough that they know without asking. It makes me feel a little disconnected from the white side of me, but even more so from the Indian side of me.

I have such a deep hunger to grab on to my grandmother's culture and language. My grandmother is such a beautiful person; she was taken from her home and put in a boarding school and her mother also died when she was very young. Her native tongue was beaten out of her. She won't teach me – it hurts too much, and it's been so long since she's spoken it, she only remembers a few words. She's worked hard her whole life, and life's been hard to her but she's never complained. If nothing else I want to learn these things to honor her. But I constantly question if it's mine to grab on to. And what about my children? Will being 1/8 Indian be important enough to them? Will they be interested in their great-grandmother's story? And my grandchildren? Will there be anyone around to teach them if they are? People ask me what I will do with the dances and words I learn. I'll hold them close to my heart and hope my children do the same.

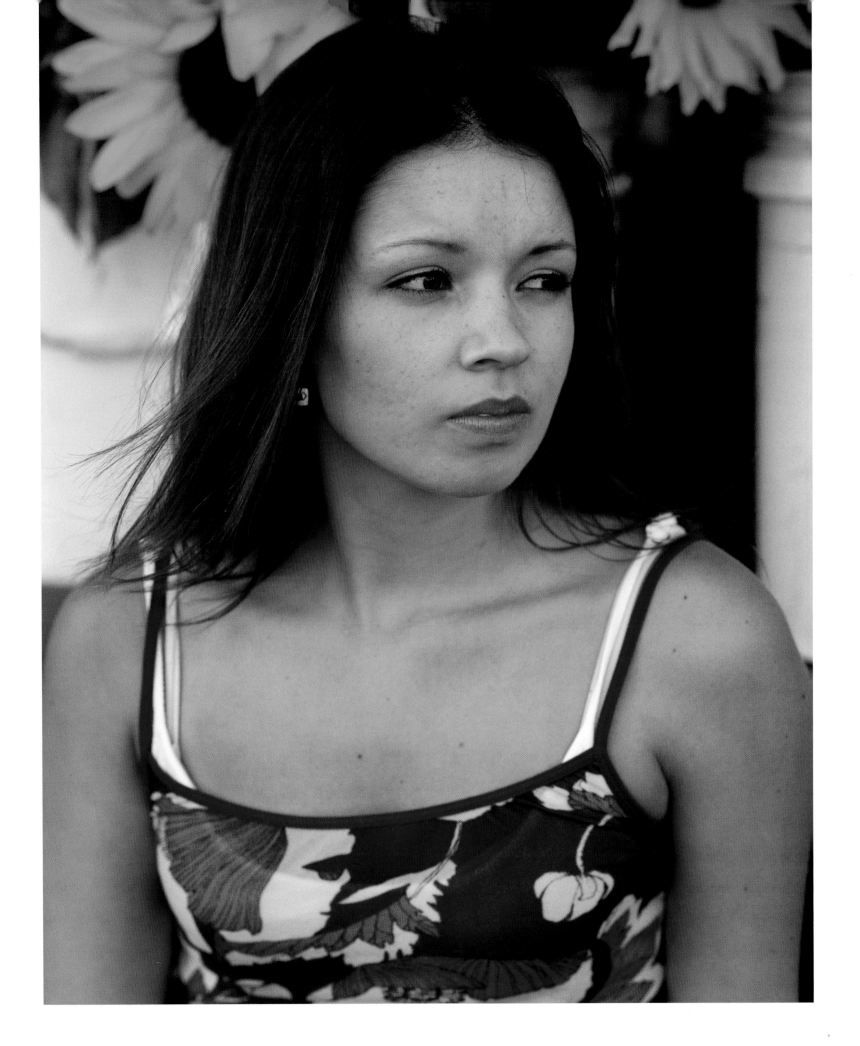

Half Asian (Filipina, with Spanish, Chinese, indigenous influence),
Half Black (with White, Cherokee, African influence)

Luzviminda Uzuri Carpenter

Photographed in Seattle, Washington

I take pride in the fact that I come from two groups of color, African and Filipina American, and that I have struggled and survived in this racist, sexist, imperialistic world with humility, grace, and beauty. I have lived my life in discontent and discomfort in all my environments and spaces. As I learn about oppression, I have come to understand clearly how my body interacts with this world. Both discontent and discomfort have built a deep anger within me that has been my driving force to venture out into the world and the uncomfortable feeling of never being satisfied no matter my success. In a way, I was trying to escape myself and who I was. As an older woman that seeks to fight racism, sexism, and oppression on all fronts, I have learned that I need to run to my inner core instead: not to hide, but instead to shine. My journey to this point has made me into the individual people see today: a unique individual that follows no guidelines and who is not afraid to tell and show

My identity is heavily influenced by both society and my parents.

them the truth about who I am. They can either take it or leave it. They can be left in confusion or except the fact that I am two races and that it is humanly possible to embrace both willingly and openly. I do not defend who I am for there is no need. I let people have the truth of who I am and make no excuses or explanations. I believe that the racial environment of the United States has affected my personal development and identity deeply. In my childhood, I would say that the impact was negative, but now as an adult, I realize that everyone has obstacles to face and that God designs everyone in a specific manner in order for them to interact with this world for his specific purpose.

I identify as Filipina and black. I do this to give honor to the struggles both my Filipina mother and my black father have had to endure. I give respect by learning both heritages and never denying one or the other. My identity is heavily influenced by both society and my parents. Both influences intersect to make me who I am. I feel that both my parents have endured a great deal due to society's

conscious and unconscious views on race and class. The way society works has developed my parents into hard working people that took the only paths offered to them. For my father, it was entering the military and escaping the harsh life of Jacksonville, Alabama. For my mother in the Philippines, it was working at an Air Force base. Their paths would cross and they would marry and have four children of which I am the youngest.

My parents are still together and talk openly about racial issues that they have to deal with. The funny thing is that they do not connect their struggles. My father understands about black oppression, but not about Asian and Pacific Islander struggles and vice versa for my mother. While my mother is coming to a certain consciousness about not wanting to be called "Oriental," my father has to be gently reminded that the term is rather offensive.

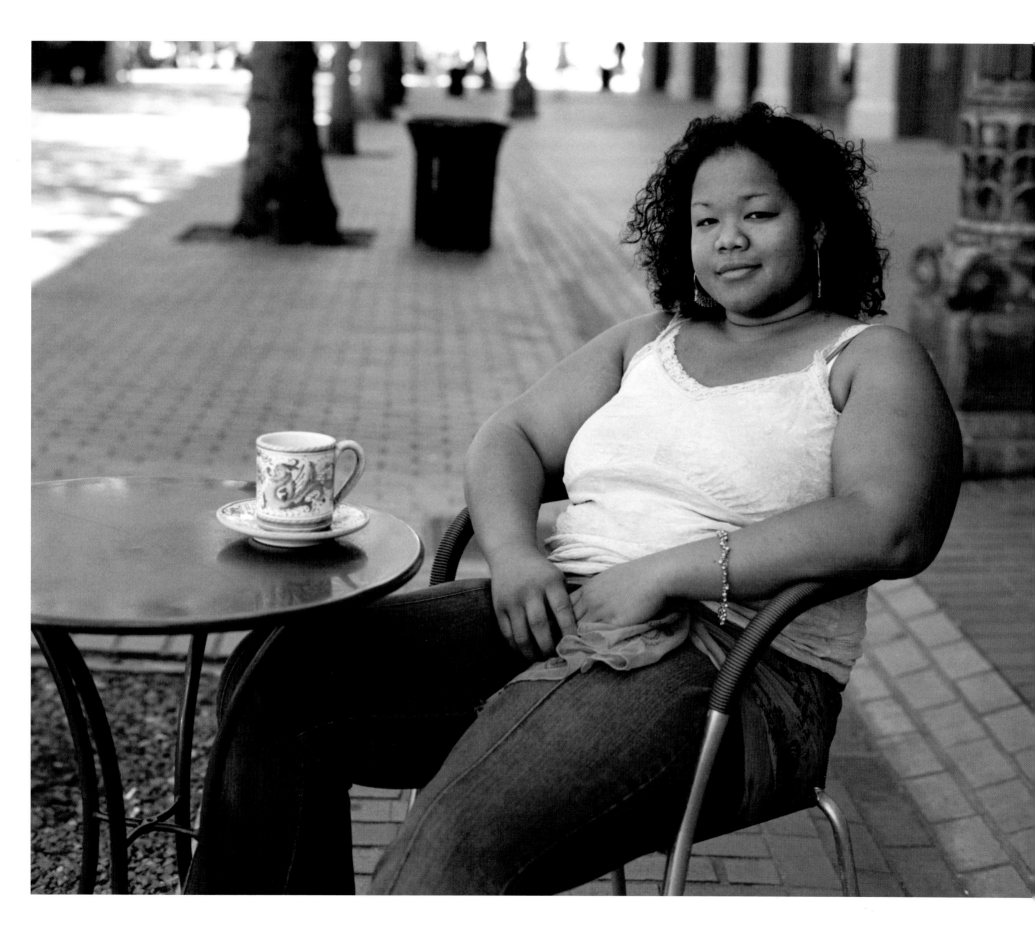

Half African American, Half White (Italian)

Rudy Crew *Photographed in Brooklyn, New York*

Being biracial, I believe, is as easy—and as hard—as being any other minority in America. The main difference is that most racial segments of society don't see it that way and subscribe heavily to the notion that having the "best of both" worlds must be great. I think it takes a lot of inner strength to actually realize that notion and its true reality isn't anything close to what people think it should be. A lot of times the

I once asked my father "do you ever get nervous or frustrated at what people might say/do when they realize you married a white woman?" His response was succinct and lasting for me. He said, "Rudy, I don't much care what people think about who I love. That's my business and for people who have a problem with it, that's their issue to work out."

"best of both worlds" actually ends up being the worst thing because your existence is either invalidated, illegitimate, "not as bad" or "just as good" as mine.

I identify with being black and that's definitely been a result of growing up in a time when having the ability to be more inclusive of all (or mostly all) of one's racial cast members just wasn't as popular. I grew up in a household where my parents' friends were mostly African American and the kids on my block were either Hispanic or African American so it was not only a physiological characteristic, it was also a cultural one. When you're young and growing up in the 80s, and your friends see you as they see themselves...one or the other...and they know your father is black, then you're black, simple as that. My family moved all the time so I was constantly in a new school. The only times I felt extremely uncomfortable in a new school were when I went to one that was overwhelmingly white, and that wasn't because I had a complex about it. For much of my life, I lived in California. The most prominent groups in my schools or other surroundings were black, white, Asian, or Mexican. Most kids

knew that I was mixed with some sort of combination of black/white parents. When I moved to the East Coast some years later, most people just assumed that I was either Puerto Rican, Dominican or from some other Spanish-speaking country. Either way, I felt accepted and embraced almost immediately. There was a shared, almost intrinsic understanding that "the new kid" is a lot like "us". When I went to a predominantly white school, however, I didn't get that immediate acceptance. Instead I got a lot of stares, a lot of confusion, and a lot of "Are you good in sports?" which I guess could be construed as an embrace, but not really the type I felt comfortable with. The delineation between "us" and "them" became a lot clearer and a lot more uncomfortable.

I learned a very valuable lesson my Italian mother (my father is African American) taught me many years ago. She told me that people in this country would look at me sometimes with love and sometimes with hate. Some will think I'm Latino and some will think I'm Middle-Eastern and others might even realize that my father is black and my mother is white. In any case, America will not see me as

"white" and that, she told me, is most of what I needed to remember. My father taught me about terms like "the black man's burden" and "my skin is my sin" and he also taught me that there are many different faces that ignorance and hate wear, and they're not always as visible as we'd like them to be. So my path in life, while unimpeded by my race, has definitely been traveled by those ahead of me whose lives and dreams have been interrupted as a result of how America views people of color.

My parents' story has always sounded so interesting to me but I'm sure it's very much the norm for people who married outside of their race in the 60s. Italian girl meets African American boy in high school during the late sixties and they fall in love. They keep their relationship a secret for a long while so as not to cause a stir, until they realize they want to marry each other. That news gets Italian girl kicked out of her family until the mixed couple has a child. At that point, when all parties concerned actually meet, they find more similarities than differences and in time the African American boy and the Italian father of the daughter become best friends.

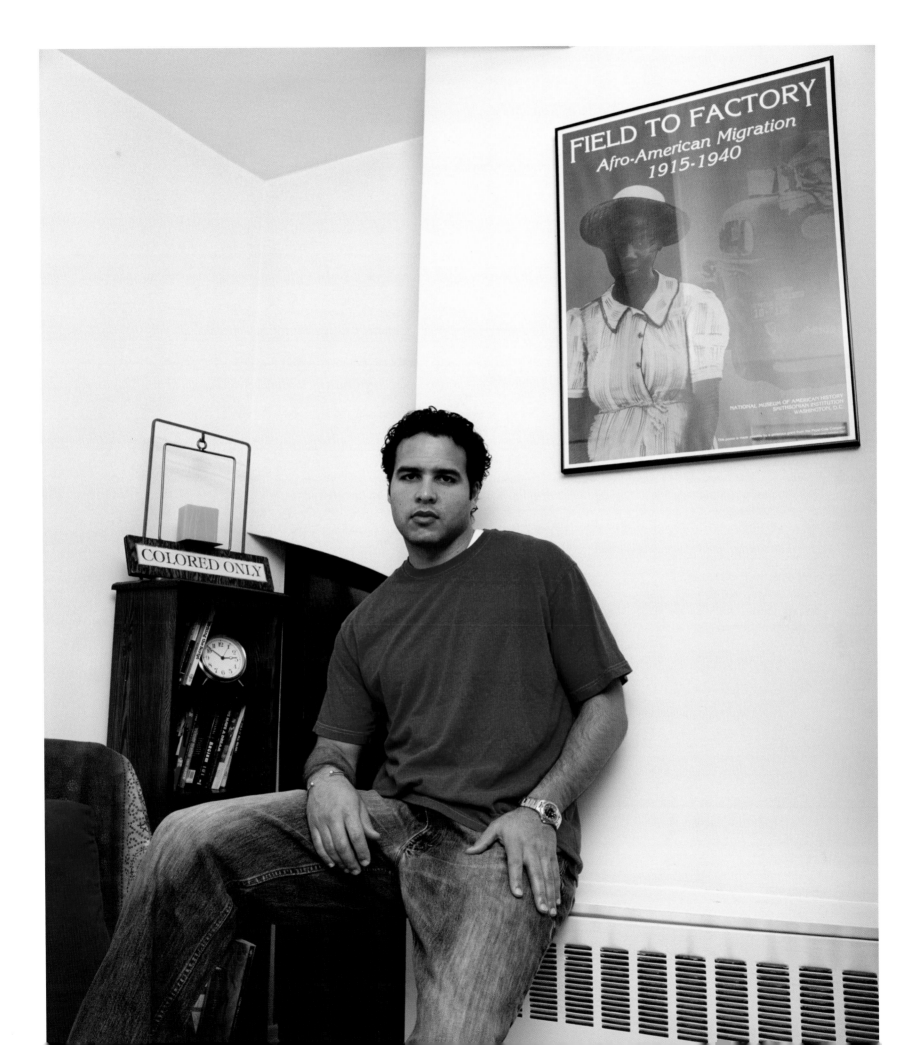

Black, White (Welsh), Asian (Korean)

LaTanya Spann *Photographed in Los Angeles, California*

I didn't know until sometime in middle childhood—say around seven or so—that I was mixed. It was when I was referred to as a "light-skinned girl." I didn't know what that meant until one of the school kids put his arm next to mine and showed me how I was "black, but not really black." I didn't think much of it then.

Not until 10th grade did I see what being multiracial was really about. Since I'd attended public schools my entire life, I took it for granted that diverse, multicolored faces would always surround me.

In 10th grade I enrolled at a private school. Suddenly, I was a statistic. I was black, and labeled as such by the administration that then told

I chose to join a Latina-founded multicultural sorority [in college]. I found that the culture I'd created for myself was a fusion that benefited from me not pigeonholing myself.

my classmates. I was paired with another black girl to show me around. Her excitement at not being the only black girl in our class was amazing. Though gradually she and I became friends, and keep in touch to this day, it was clear to me that I was there to bolster their quota and it was simply a plus that I was smart.

In college, I found myself weighing the pros and cons about joining a sorority. I could have joined an Asian sorority, proudly boasting my Korean heritage. I could have joined a white sorority, falling in line with my fellow Americans. Or I could have joined a black sorority, getting in touch with my darker roots. I chose to join a Latina-founded multicultural sorority instead. I found that the culture I'd created for myself was a fusion that benefited from me not pigeon holing myself. And so I had to remain true to that. I decided to travel a path I was not ethnically born into and so began a wonderful world of discovery.

I live my life without labels. I'm not a dash-American. I do prefer not one color to another. I am simply ME. I'd always seen my heritage as built-in diversity. I couldn't really oppose anything

because I was everything. My mother is half white (her father; the family tree originates in Wales) and half Korean. My biological father is black with bits and pieces of everything else thrown in (some sort of Indian, possibly Cherokee).

I can't help what the next person chooses to see in me. But I will tell them the truth if they ask what I'm mixed with. And more often than not, if they ask me how I identify myself, I say "as Tanya." There's no other me in the world, and I'm not going to let the boundaries of color determine my limits.

I think it is important that we stop trying to pigeon hole people into what we want them to be and start asking them what they are – how they choose to define themselves and how they choose to live their lives. Our focus should be on principles, morals, ethics and beliefs – not on skin color. I love being ambiguous in that sense, because if someone really wants to know what I am, they must ask me. At that point, I understand that I have the opportunity to educate someone with the experience that I have. This question of "Who are you" is one I now readily take on.

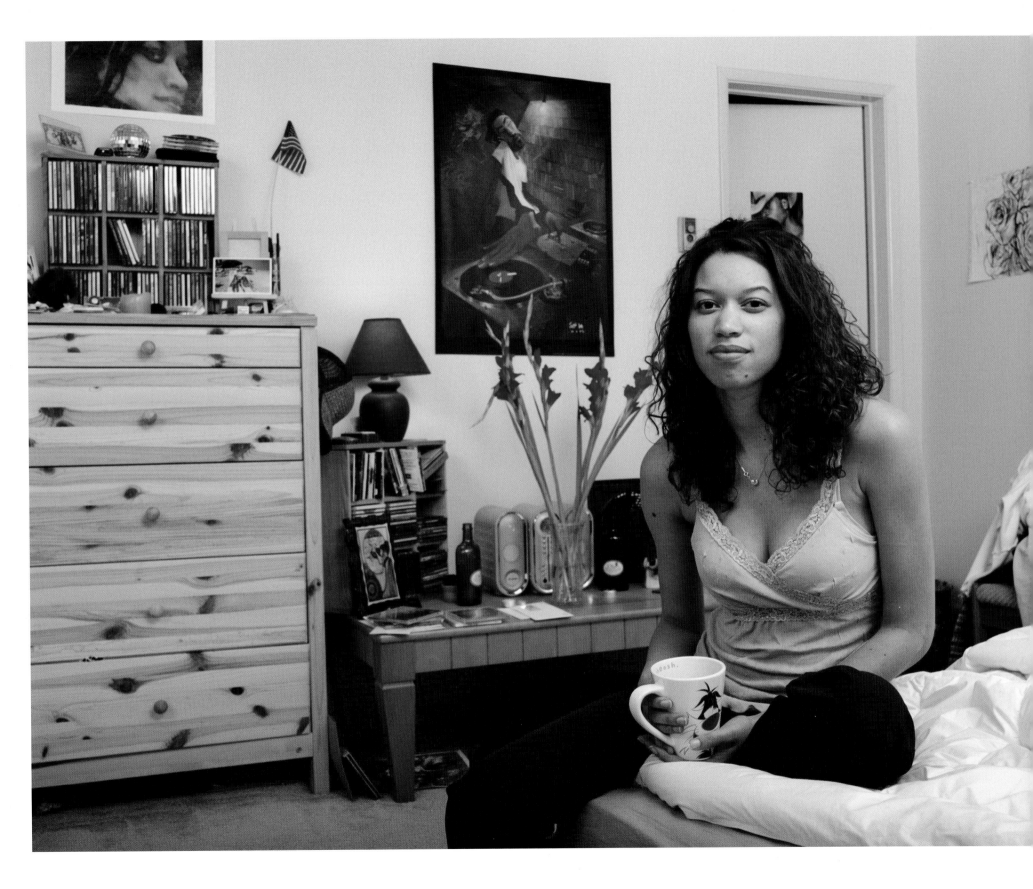

How is Race Real?

by Alan H. Goodman, Ph.D.

We are obsessed with race, yet deeply uncertain about what race is and what it is not. Is race part of nature and our primordial genetic souls or, as these glorious photographs suggest, are we an ever-changing bio-cultural jumble? Do we human beings naturally divide into three or so racial types or are we each a unique mix of the same basic genetic stuff? If race is merely a human invention, how do we explain the deplorable racial differences in wealth and health?

You are not alone if you are confused about how race is real. Many scholars – individuals who spend their lives studying race – have also been dazed and confused. Hold on. A paradigm shift about how race is real offers surprisingly liberating lessons.

Our eyes and our limited experiences once led us to believe that the world was flat. Then, sailors began to see a curve in the Earth's surface and soon after, explorers and scientists discovered that the curve continued and that the Earth was actually round. This change in paradigm as to the Earth's shape profoundly increased the pace of trade, exploration, and discovery, leading to our interconnected, global world.

Today, we are witnessing a similar paradigm shift in regard to the terrain of human variation. Our eyes once led us to

believe that the idea of race and human variation was the same and that race explained biological and cultural differences. However, like the shape of the Earth, we now know that human variation is far more complex than originally conceived. The simple idea of race does not explain human variation. In this genetic respect, race is not real. It is a flawed, meaningless, and counterproductive concept.

Race is as useless as the drawings of the sea monsters on ancient world maps once imagined to haunt the waters beyond the navigable horizon. The concept of race, like these ancient chimeras, is more and more revealed as a sociopolitical idea anchored to ignorance and fear. Race, in the flat Earth genetic sense, is dead.

Race, having died in the genetic sense, frees scientists to explore the curves and valleys of human cultural and biological variation. And all of us are free to remove the genetic blinders and more vividly admire the craggy range of human experiences and variation.

We are also free to see race as lived. Race – and racism – still lives all around us in our thoughts, institutions and actions. Lived experiences explain those differences in wealth and health. What is liberating is that we control the

future of race. The individuals photographed for this beautiful book have transcended human created color lines.

Race ≠ Human Genetic Variation

From the 18th through most of the 20th century, pretty much everyone took for granted that the idea of race was the same as human variation. The idea of race, and let me emphasize that race is an idea, incorporates two fundamental errors: that humans are divisible into racial types and that these types differ in worth and abilities. Races were seen as natural, hierarchically arranged, and forever. European scientists, as part of the group on the top of the heap, worked to prove that races were real in the above sense. They had a vested interest in doing so as racism justified colonization, slavery, and other forms of racism. Race became reified: made to seem real by constant use. However, this notion of race could not be proved simply because it was false.

This typological view of race is flawed beyond repair. Race does not fit the facts of human genetic diversity. There is no line that divides one race from another. Knowing something like skin color does not predict deeper genetic traits. Less than 10% of genetic variation is statistically explained by race so

humans fail the test for genetic races.

The problem of substituting race for human variation is that one tends to forget about the 90% or greater variation that race fails to explain statistically. But the problem is even deeper. The problem with race is not merely statistical but conceptually fundamental. It is paradigmatically wrong. Racial definitions and boundaries change over time and place because race cannot be biologically defined. Thus, race is an inherently unstable and unreliable concept. The importance of this point is that a bio-racial generalization that appears true at one time and place is not necessarily true in another time and place.

Racial differences in health change and we cannot predict from genetics how they will change. One of the first lessons of science is not to base a generalization on a shifting concept, which is exactly what race is. Because race is used in medicine and other fields as a way to categorize individuals by both genetics and lived experience, what passes as the result of genetic difference may actually be due to some aspect of lived experience. In medicine, as an example, the two meanings of race – genetics and lived experience – are conflated. Thus, a serious error is to think that what is due to lived experience is actually due to genetics. This is a subtle

form of scientific racialism.

Geographic location is the best single explanation for human genetic variation. There is no more powerful piece of information for predicting the genetic makeup of either an individual or a group than knowing from where on the map they originate. Furthermore, the degree of genetic variation between any two human groups is almost entirely explained by the geographic distance between them: genetic and geographic distances are almost perfectly correlated.

Although highly correlated with genetic variation, geographic location is not in itself an explanation for genetic variation. The beautiful and complex human diversity that is all around us, and so brilliantly captured in this book, is the end result of two complexly interrelated and fascinating processes: evolution and history.

For example, one might ask, "Why do some individuals have sickle cell trait? Is it because of their race?" The answer to this question is clearly "no." Race is a poor explanation for the distribution of sickle cell trait, which occurs in high frequencies only in particular regions of Africa while also occurring in high frequencies in parts of Asia and Europe. Rather, sickle cell trait can be understood as a fascinating history involving agricultural intensification,

clearing of lands, breeding grounds for mosquitoes, and so on.

Similarly, why does skin color appear to vary so much? Skin color has nothing to do with race and everything to do with location, and by location I mean how much solar radiation one has been exposed to, because light skin is useful when sunlight is limited and dark skin is useful when sunlight is plentiful.

Sickle cell and skin color are results of the profoundly biocultural processes of evolution and history. If we think race is an explanation or even if we use it as a statistical proxy, we are less likely to conceptually understand how variation arises and is distributed. I advocate for de-racializing biological variation simply because there is always a more precise and meaningful way to characterize and explain those myriad variations.

Race is Lived

We Americans and nearly everyone else in this global culture have been conditioned to think of race as a fuzzy jumble of behavior, culture, and biology: a deep and primordial mix of a bit of culture and a lot of nature. Thus, to say that race is not real in one way (as shorthand for human biological variation) and is real in another way (as a way to group

and track lived experience) is indeed confusing. Isn't race simply real or not?

Even though race was invented and made to seem real by social humans, and even though we now know that race makes little sense on the genetic level, this does not mean that it is not real in other ways. Racial practices – simply living in a society that sees races in the old hierarchical fashion – as well as more virulent forms of racism, come together and have enormous and powerful consequence. The individuals who are pictured in this book know all about the power of race and racial classification. The accumulated wealth of the average white family in the US is over eight times the average wealth of a black family. Babies born to African American women die at a rate that is twice that of babies born to white women. These differences result not from genes, but the lived experiences of race and racism. These experiences accumulate in bank accounts and bodies.

Race Is and Race Isn't

There is no scientific justification beyond convenience and maintenance of the status quo to continue to racialize human biological variation. Moreover, doing so may cause harm. In this way, using "race" as shorthand for biological variation

is a form of ideological iatrogenesis: the concept causes harm. Just as surely as knowing the world is round helps one to navigate the globe, knowing race is not genetic helps one to understand the consequences of race. Real human suffering may result from poor conceptualization of human variation. Yet, race is real as lived experience.

The participants in this book are members of a new blended nation, one that seems possible with globalization and tolerance. What is interesting from the perspective of science and evolution is that we actually have always been blended. From slavery to miscegenation, laws and ideologies of race got in our way. The question is not whether race is real, but in what ways do we make it a reality?

Half Alaska Native (Haida, Tsimpsian), Half Pacific Islander (Samoan)

I had the opportunity to travel between two very different environments and climates – physical and social: Alaska and Samoa. I've learned of many of the traditional values of two indigenous nations, more so my Alaska Native side then my Samoan. People often mistake me for other ethnicities or even can't identify what I may or may not be. When I was young in elementary school, I felt like I wanted to be white and have blonde hair. As I got older, and society became more accepting, even inviting to ethnic looks, it became easier to explore who I really was/am.

My mother taught me to value all and treat everyone fair. My dad taught me that "Samoans are the best and we're tough!"

Leilani Finau *Photographed in Seattle, Washington*

My mother taught me to value all and treat everyone fair. My dad taught me that "Samoans are the best and we're tough!"

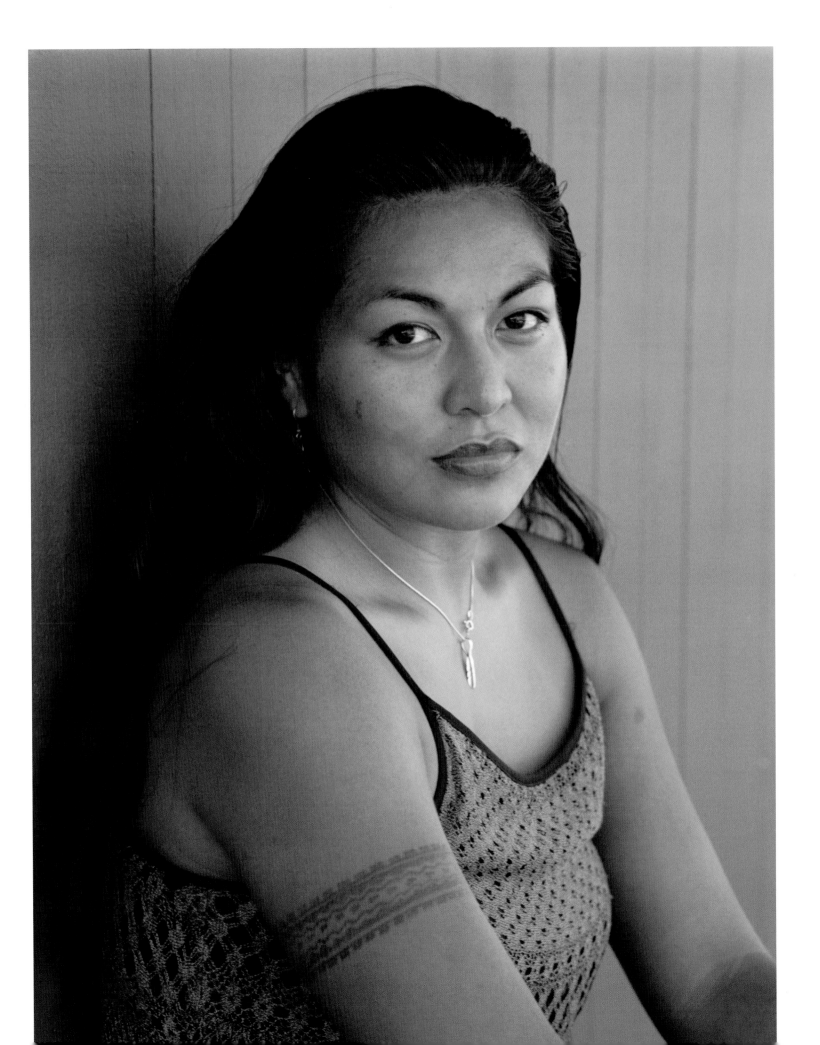

Mikle: Half African American, Half Asian American (Korean)
Jon: Half African American, Half Syrian
(brothers)

Mikle: As a young child I felt that maybe I didn't belong to any "one" group and that made me different from other children. I really felt this in school, because I attended a school outside of my neighborhood. The school was mainly African-American and at a young age I looked more Asian than black. I honestly don't think that students or teachers treated me differently because of my looks, but internally I felt a little strange because I hadn't personally defined my own cultural identity. The time I felt the most weird about it was on open house nights, because I was also adopted by white parents. I was asked on more than one occasion "You're Black, Korean, and your parents are White?" While I was never ashamed of who I was, I would kind of hide my identity because I would never just tell people even though I could see in their eyes that they wanted to know "what I was." Looking back, it was more of an issue for me internally to

I was asked on more than one occasion "You're Black, Korean, and your parents are White?"
– Mikle

come to grips with who I was than other people. Once I became more comfortable with defining myself, people became more comfortable with it.

I was fortunate to have grown up in one of the few racially mixed neighborhoods in the city of Milwaukee in the late 70s and early 80s. At home it was never an issue because my neighborhood friends knew of my upbringing and I never felt a reason to "hide" who I was. In my life outside of my neighborhood, I would feel a sense of being uncomfortable due to my multi-racial makeup. As a society we seem to have a culture that is very aware of one's racial makeup and then people like to make judgments/connections based on a person's race. I don't know why, but it seems we want people to have "one" race so it will be easier for others to relate to or because as a society we feel that that is how it should be.

I identify more with being a Black American than with my Korean side. I didn't grow up in a society that was culturally "Korean." By that I mean, I didn't speak the language, eat the traditional foods, or know the cultural norms of that society. Growing up my experiences were more in line

with many other black men: I listened to rap music, played basketball, had hair styles that were common with other blacks.

My parents never encouraged me to go with one or the other racial background while growing up. They wanted me to identify myself as I saw fit. They were always supportive, but gave me the freedom to become the person that I've developed into today. Since my parents are White, they were very aware of the history of discrimination against Blacks in this country and wanted to protect me from such issues as much as possible. They would often talk about how I needed to tell them if police or people in our community treated me unfairly because of my racial makeup. By high school we moved to an all white suburb of Milwaukee. Just before we moved into our home, a real estate agent asked our yet to be neighbors if they wanted to sell their homes because a "black family" was moving in. Actually, we weren't a Black family at all, but a multi-racial one. The neighbors actually were mad and went out of their way to make us feel welcome. My parents never tried to hide what happened, but instead were always open about these issues.

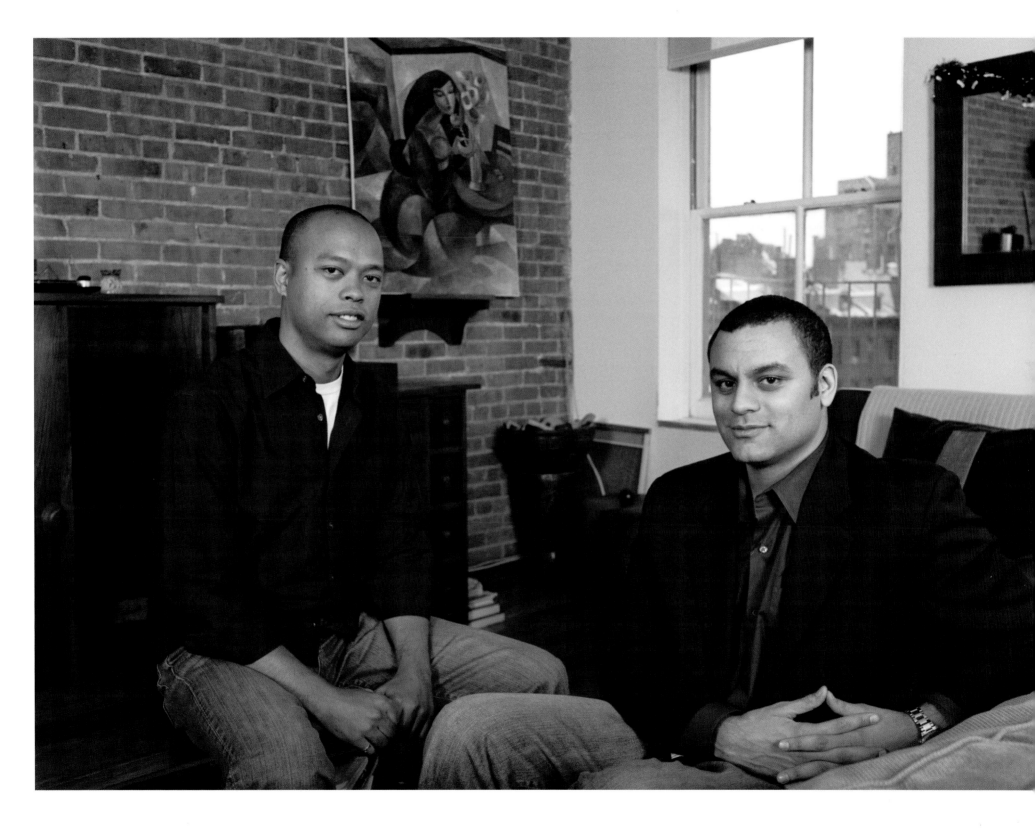

Half Asian (Tibetan), Half White (Canadian)

Deyden & Lhadon Tethong

Photographed in New York City

Deyden: It's not an exaggeration when I say that someone asks what my ethnic background is once a day. Constantly answering these questions and reflecting on my answers reminds me that I'm of two very distinct cultures and people. From a very young age I remember just wanting to fit into our suburban and very white neighborhood. I didn't like having such a different name. I didn't like looking different. I didn't enjoy the ignorant and

Looking different and having a unique name makes me feel more Tibetan in my western surroundings and with my western friends and family. On the other side, when I am with my Tibetan family and people I can feel very Western.
– Deyden

In some ways I feel a little bit alienated from both the Canadian side and the Tibetan side of my background. I'm Canadian but I'm not white and I choose not to live there. I'm Tibetan but I don't speak Tibetan, I don't really look Tibetan and I didn't grow up in Tibetan society.
– Lhadon

immature remarks kids in the neighborhood would call us. At the same time I adored the culture of my father and his family, there was nothing we enjoyed more than our Tibetan relatives coming to visit and just hanging out in Victoria.

I identify with both [aspects of my heritage]. We are really close with both of our families and though extremely different in both religion and culture I can say that, in retrospect, we have drawn from the best of both. Naturally, when one of your cultures is being persecuted and destroyed, you want to help. It is because of this that I sometimes define myself as being a bit more Tibetan. Also, looking different and having a unique name makes me feel more Tibetan in my western surroundings and with my western friends and family. On the other side, when I am with my Tibetan family and people I can feel very Western. It's the paradox that you learn to live with and not question too much.

In the early 60s, dad was working for the Tibetan Government and mum was working with CUSO, the Canadian equivalent of the Peace Corps. She was originally suppose to work in Calcutta with the poor but at the last minute was reassigned to north India to help the Tibetan Government in Exile deal with the thousands of Tibetan refugees that were flooding into India. They were following the Dalai Lama

after his escape. Mum was put in charge of the teachers college. This was a college set up to train learned Tibetan monks and lamas to create curriculums and implement them in schools for the refugee children. In her fourth year she met my father and was engaged. She spoke Tibetan fluently at this time. They were married in Canada and returned to the jungles of south India where my father was head of a massive resettlement project for Tibetan refugees. My mother headed up the hospital on the administration level. They lived there for 8 years and Losel, my brother, and I were born there. Lhadon was born in Canada.

Lhadon: I draw strength from two cultures rather than just one. I feel like I am more able to see both sides of a story/ situation and understand that things are often not as they seem. I feel very closely connected to both sides of my family but once I get outside of them it's different. Obviously, the issue I'm most concerned and passionate about, and the path I'm on, is all about Tibet. When I meet other Tibetans there's this common understanding and incredibly strong feeling for our country and our people and the suffering that they have gone and are going through. On the other side, I grew up in Canadian society and feel comfortable in it. In some ways I feel a little bit alienated from both the Canadian side and the Tibetan side of my

background. I'm Canadian but I'm not white and I choose not to live there. I'm Tibetan but I don't speak Tibetan. I don't really look Tibetan and I didn't grow up in Tibetan society.

When I was really young I thought my mother was Tibetan – probably because she spoke Tibetan. It was strange to realize that she was not Tibetan and that people didn't think we were her kids because she's white. This made me question who I was in relation to my parents a lot earlier than I think the average kid with parents of the same race. Living in a community that was mostly white we stuck out. As a kid this always came home to me when I had fights/arguments with other kids. Usually, the first or second thing they'd attack was my skin color – often times using racial slurs that didn't even apply to me like "nigger" or "chink." Having experiences like this at such a young age, along with the reality of the Chinese occupation of Tibet, I think that my sense of injustice is heightened. I ended up doing a lot of multicultural/ anti-racism leadership training programs through my school and because of my mum's involvement with this work. On the whole these experiences helped me be more constructive about the way I channel my energy and also helped develop my leadership skills. Now I work full time organizing students around the world.

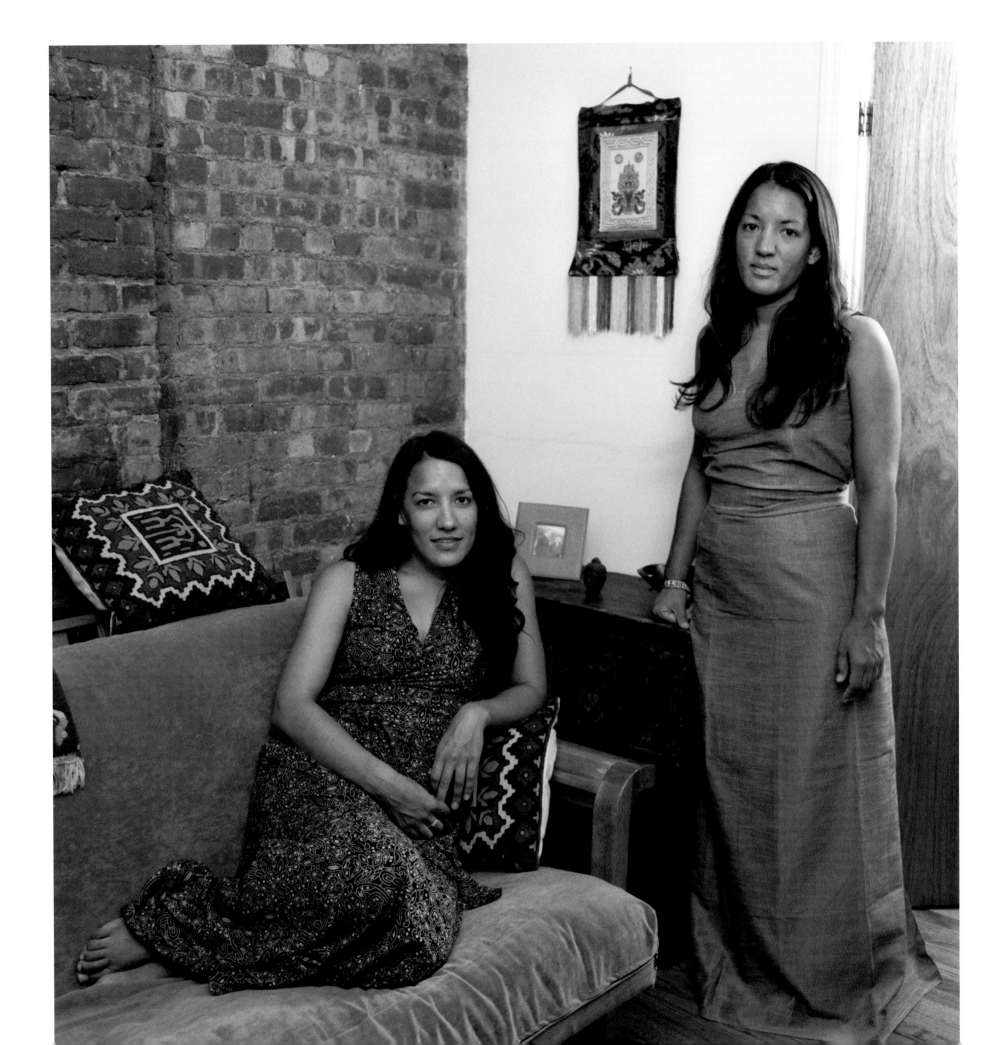

Daughters: Half African American, Quarter Native American (Cherokee), Quarter White (French)
Rachelle: African American, Native American (Cherokee), White
Richard: White

Rachelle & Richard Blake,
daughters Angelique & Ashleigh

Photographed in Issaquah, Washington

Rachelle: I have always considered myself blessed and fortunate to have been born into a multiracial (African American/French/Cherokee) family. I feel I can identify with many different people, and I feel I have a unique connection with America as well as the world.

I most identify with African American, as this most closely identifies by outward appearance. I know, and all

The most shocking thing to me was that after I became involved in a relationship with an African American woman, I found out that people I used to think were friendly, great people, were in fact, racist, and their opinion of me dropped precipitously, some cut off their friendship.
– Richard Blake

my friends and family know, however, my background and, I hope, view me as a multicultural/multiracial person.

I used to be more confused about my racial identity (I did not particularly identify with my African American heritage) when growing up, but as I have grown and aged, I now really identify primarily with this group. I often feel upset, however, when someone tries to classify me as being part of the "African American community" or "Black Community" as I feel no values or opinions are so alike that they can be shared by a large group of people, so actually this offends me when I hear this "label."

Richard: The most shocking thing to me was that after I became involved in a relationship with an African American woman, I found out that people I used to think were friendly, great people, were in fact, racist, and their opinion of me dropped precipitously, some cut off their friendship.

In terms of parenting biracial children, I attempt to protect them to the extent possible from negativity but I do tell

them the facts of life. The Seattle area is probably one of the most socially liberal areas of the country and blatant racism is almost unheard of, (I am told that over a sixth of Seattle children are considered biracial or multiracial) so that the racism which does exist is a lot sneakier and harder to spot.

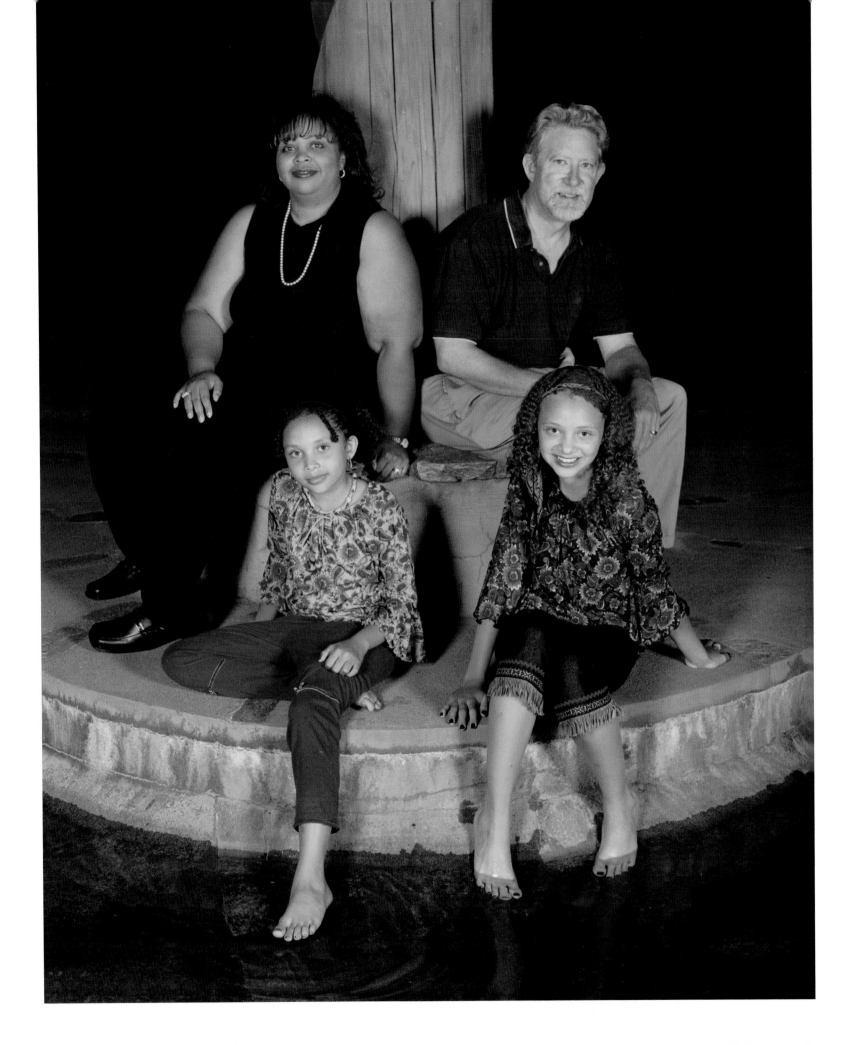

Whitney Moses Photographed at home in Oakland, California

I know for one thing that [being mixed] has been a source for understanding the fluidity of identity. People make a lot of assumptions based on visual appearances and I am proof that things are not always what they seem. Depending on how I focus my intentions I can fit into very different racial communities. I look pale enough to pass for white most of the time. Because of this people reveal their racist thoughts to me far more often. I can also mention my mixed heritage to gain acceptance in people of color-only environments. POC folks will talk trash about white people in front of me and treat it as though my mixed-ness somehow excludes me from their references.

I've come to really appreciate the term "person of color" because I feel more at ease identifying as something other than White than I do specifically with any of the parts of my mix.

People often treat me as if I'm special once they find out I'm mixed. It's something exotic to them, like if I had some secret skill or knowledge because of it. Often folks will use my mixed heritage to explain things. I sing and have been told I "sound black." Others will then bring up my heritage as a way to justify this confusing trait.

My sister is older and darker than me. When she graduated high school I noticed that they had her down as black on her transcript. When I transferred schools the following year I noticed mine said white. It took a lot of arguing to change mine and I don't think we ever got my sister's changed. Internally there has been some struggle. Because I am so pale, people rarely ask "What are you?" to me; they just assume I'm Irish, what with all the freckles. I spend more time trying to assert my mixed-ness then trying to appease the usual confusion that other mixed people get.

I've often felt as though I don't have a full right to claim my black heritage because I've never been treated like black folks are and was raised largely by my white mother. I've come to really appreciate the term "person of color" because I feel more at ease identifying as something other than white than I do specifically with any of the parts of my mix.

My dad was mixed as well and he was darker than his sister. When they were growing up she was allowed to drink from the "Whites Only" water fountain and he wasn't. He grew to be a pretty angry man, feeling rejected by the world both for his race and his sexuality as a bisexual man. [My mom] loved my dad because he was exciting. While that came from a lot of things about him, most specifically his sexuality, I can't imagine race wasn't also a part of what made him so exciting to her. I know her parents weren't too thrilled when she told them she wanted to marry a black man. The fact that he went to Harvard softened that blow for them, and that speaks volumes about their class/race assumptions and issues.

Moving to the Bay Area from the Northeast Coast has been an interesting addition to the development of my racial identity. On the East Coast there weren't nearly as many folks who identified as mixed and the majority of those folks were black/white/Native American variations. Here it seems as though there are so many mixed folks that the concept is no longer novel. It is also a lot less surprising to people to find out that I'm mixed. That and the variety of mixes are huge here, including Asian, African, Hispanic, Caribbean, along with the ethnic groups I was previously used to. It's been eye opening and refreshing to be around so many mixed folks. The down side has been that people are so used to it that they forget that the rest of the country isn't like this.

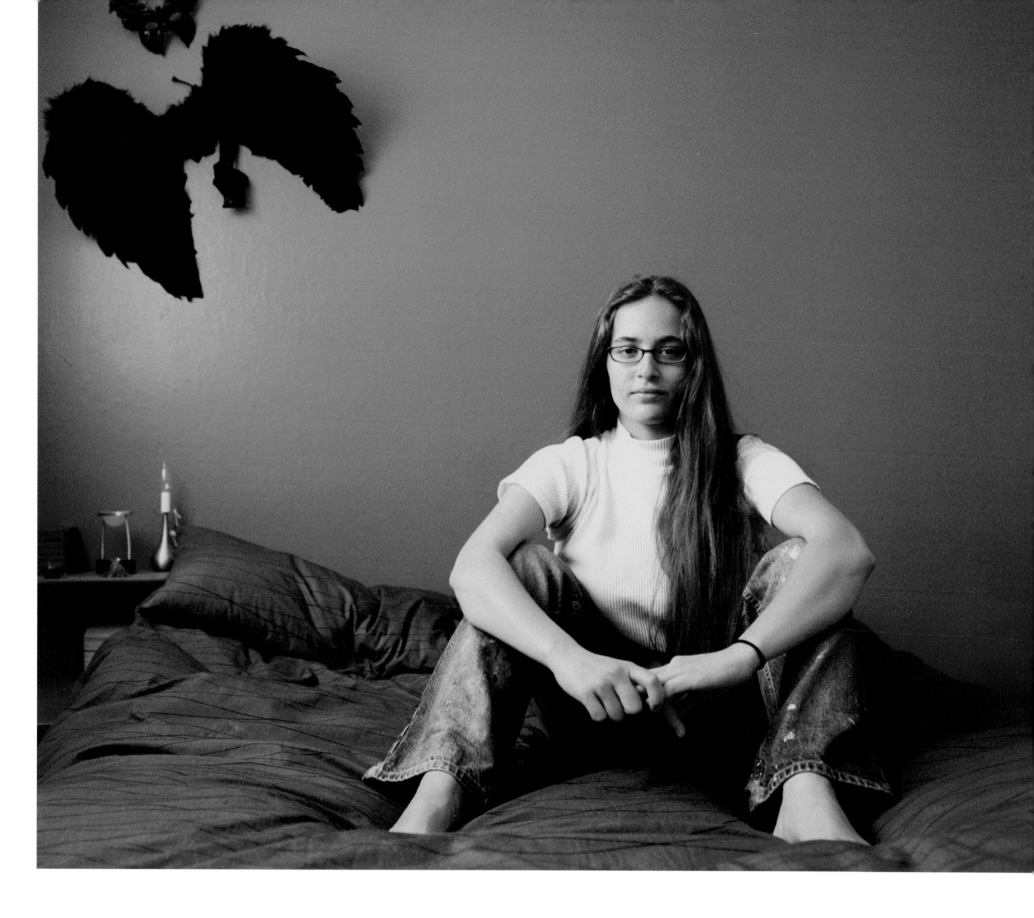

Half Asian (Japanese), Half White (Norwegian, English, Dutch)

Cristalle Stutrud

Photographed in Queens, New York

When I moved to New York, I experienced for the first time people really aggressively wanting to know "where I'm from." Everyday, I'm asked "where are you from?" and my initial reaction is to say California. I've learned that what they mean to ask is what ethnicity I am. Some days when I'm feeling especially insolent, I'll pretend not to understand what they're asking, and just keep insisting, "I'm FROM California. I was born there, my dad was born there, I lived there for 22 years until I moved to Queens. I'm CALIFORNIAN."

I think growing up in a mixed household, we were more exposed to variety—my dad played music in a Portuguese band and my mom loves all nationalities of food. I think my childhood experience was more international than a lot of other mixed race families —even most of the Japanese kids we knew from language

I've had people tell me I look Mexican, Columbian, Argentinean, Peruvian, etc... and am constantly spoken to in Spanish!

school ate Japanese food at home—my mom loved Indian, French, Italian, Thai. We grew up trying all foods and exposed to all music, never knowing other cultures to be "weird." Moving to NY was the first time I ever really experienced people setting up communities by race or culture—having a Polish neighborhood, a Jewish neighborhood, a Columbian neighborhood. Growing up, I had a Filipino family on one side, Chinese on the other, Black next to them, and Indian next to them. We had an Indian fabric store next to a Mexican grocery in the same shopping plaza as a Chinese bakery. I feel that in New York, there are a lot more 1st and 2nd generation immigrants, while in California, people's families have been living in the States for many generations.

My brother and I are both often mistaken for being of Latin decent, which I find interesting. I've had people tell me I look Mexican, Columbian, Argentinean, Peruvian, "etc.," and am constantly spoken to in Spanish! I've also had people (not to sound horrible, but I think 7 out of 8 instances have been middle-aged White males) assume I'm FROM Japan and are surprised at my English diction.

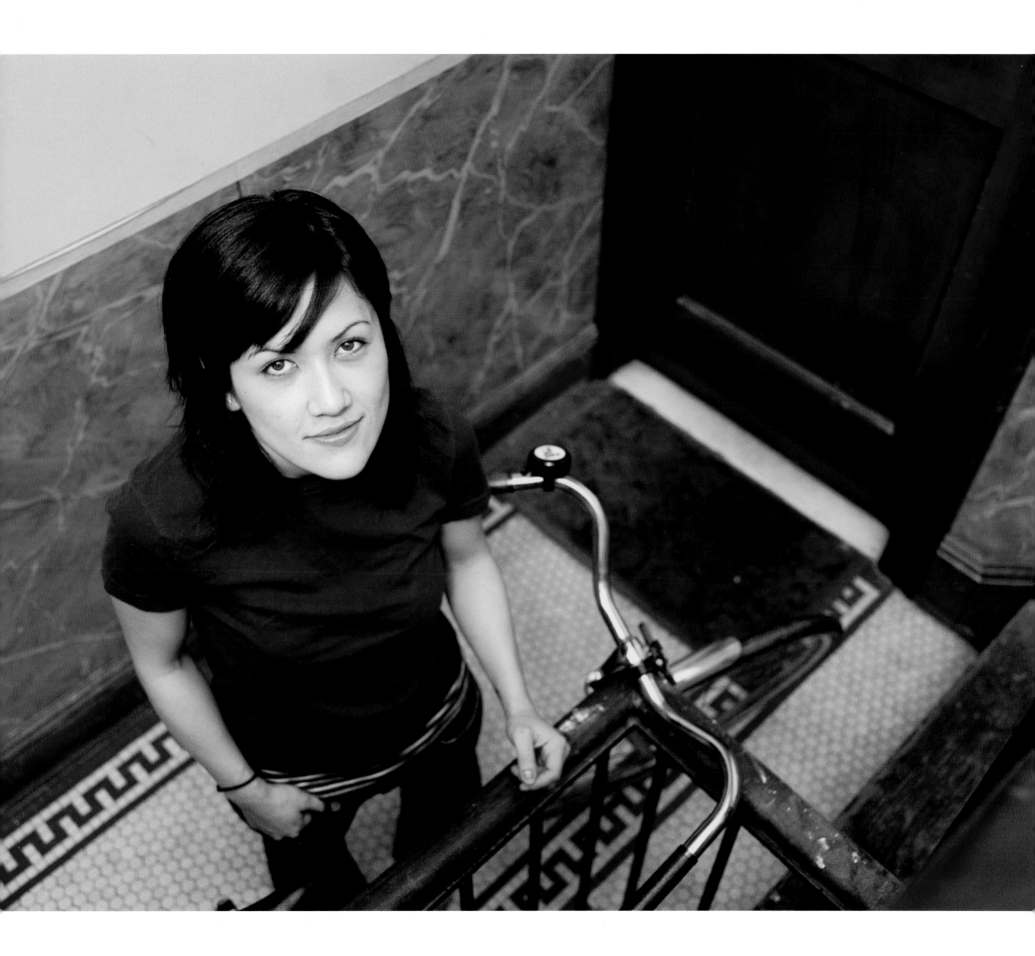

Half White (English), Half African (Mchaga from Tanzania)

Adia Tatania Siyaruwa Mbuya Hoag

Photographed in Long Beach, California

Being biracial or bicultural or mixed (I've used all the terms at some point or another) is a part of me that I cannot leave at home when I am out in the world. It is reflected in my classroom as a teacher, in my choices in life, and in life-mates. I, like most mixed people I know, grew up in a white community, Huntington Beach, CA. It is Surf City, U.S.A. I had a pretty average childhood. Grew up with my mother and younger sister in a quiet community across the street from the Huntington Harbor. The haves and the have nots. My mother's family is sixth generation Californian and genealogy being a family hobby, I can trace my ancestors back to the Mayflower. However my father is from Moshi, Tanzania and

came to the States in 1967 for a chance at the American Dream and to complete his advanced degree at Pomona College.

I've had arguments with friends and even some strangers about my "blackness" whatever that is. And I have broken up with boyfriends because they can't see beyond my "white nose." I have also forged friendships that are stronger because we may not be the same mix, but have a mutual understanding of the unique life tangents that being mixed throws your way. I don't think it's made my life more difficult or has caused me to endure the life of the "tragic mulatta," a syndrome often discussed in popular culture. In fact I feel like it has been the source of my strengths. I have an easy time adapting into just about any social situation and relating to all different kinds of people. I have a wide variety of friends.

The first vivid experience I remember dealing with being boxed in is in the eighth grade. I was taking some standardized test and of course you have to mark one box and one box only. I don't really remember what had happened prior to math class, but the next thing I remember

is my teacher walking me out into the hallway as I cried about how life wasn't fair. Now I have more options on those lame forms. I have to point out that on the three censuses I have been recorded on I have been three different things. In 1980 I was white (at under a year old I had no real pigment yet, so my mother figured in race, like religion, you are what your mother is), in 1990 I was black, and in 2000 thanks to a lot of lobbying I was finally me: mixed.

I identify with both [my races]. I look black and will always be black to the world, but culturally I identify with my white culture. Because I am first generation Tanzanian, Chagga to be specific, I don't think I really fit into the African-American culture or the hip hop culture, although I can appreciate them and relate to them on my own terms. In fact the inside joke with my close friends is that I am American-African.

> In 1980 I was white (at under a year old I had no real pigment yet, so my mother figured in race, like religion, you are what your mother is), in 1990 I was black, and in 2000 thanks to a lot of lobbying I was finally me: mixed.

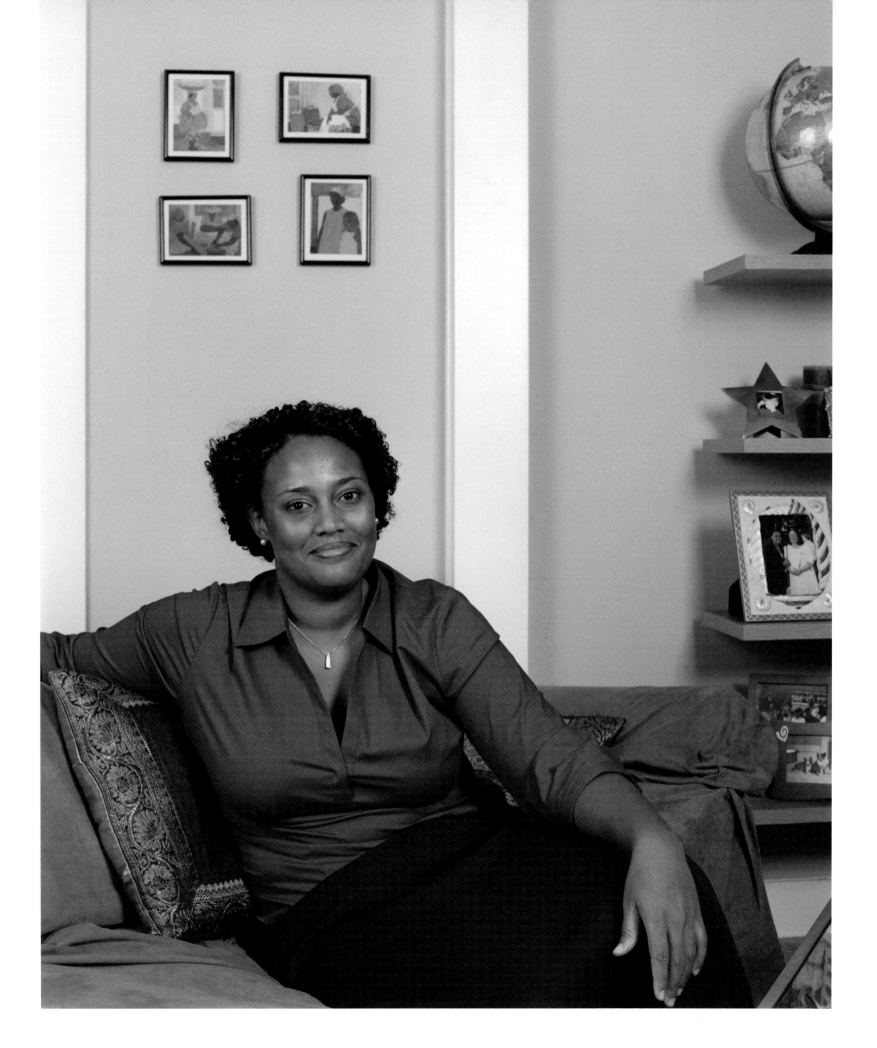

Half Black American, Half Asian (Korean)

Jungmiwha (Jummy) Bullock

Photographed in Los Angeles, California

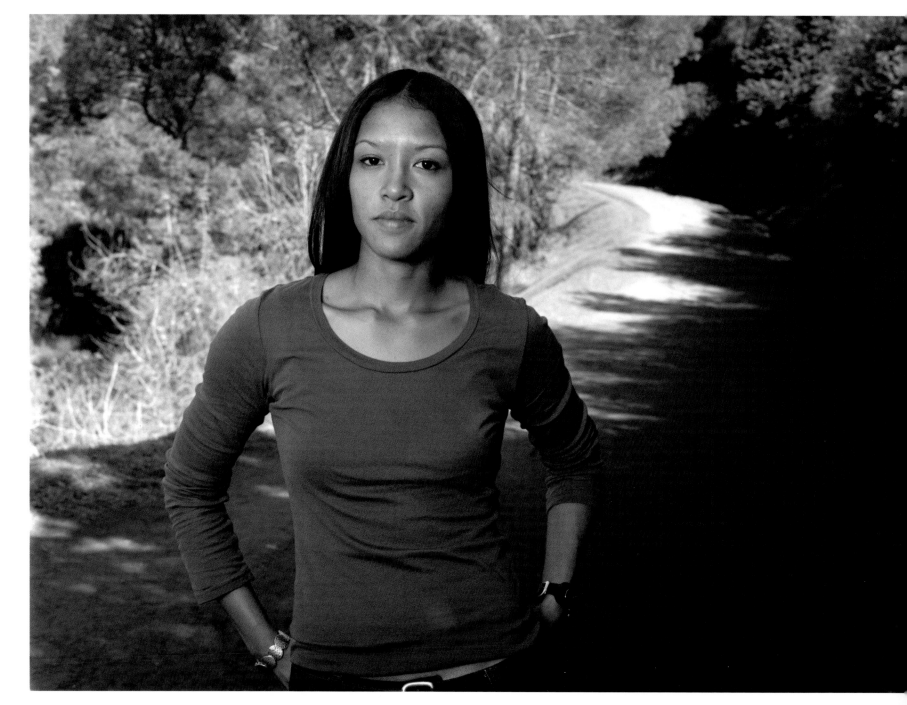

Half Asian (Chinese), Half White

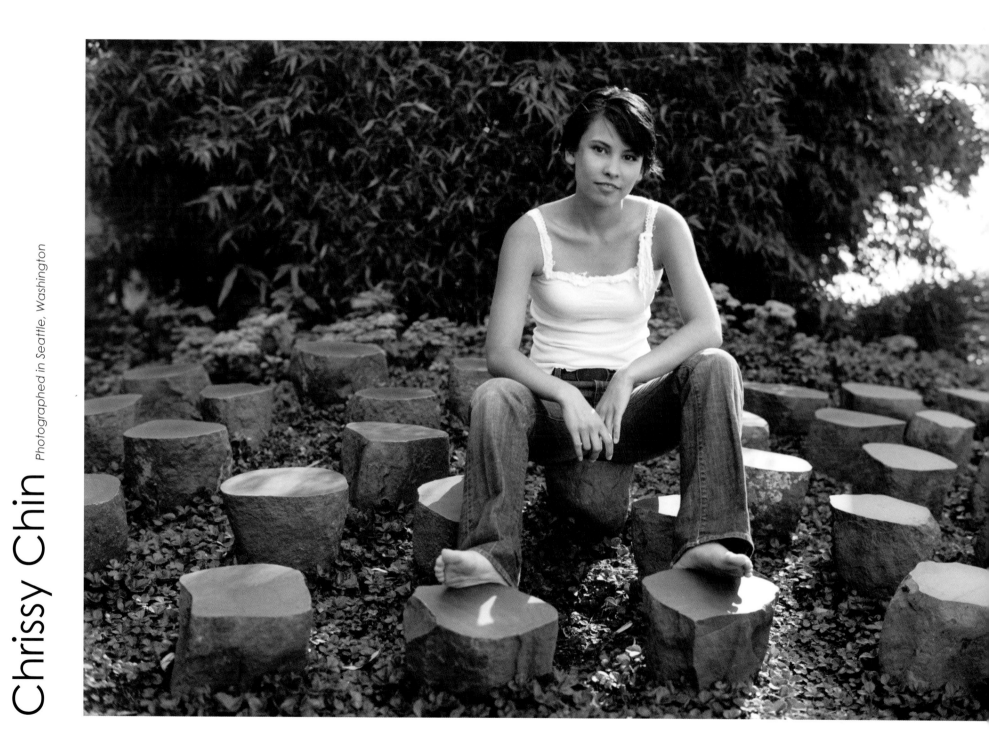

Chrissy Chin *Photographed in Seattle, Washington*

Puerto Rican, Iranian

Everything was okay until middle school. When I wanted to go out with girls, their parents had problems "cause I'm Black." I live in a small White town. As long as I was 'just' a friend I was accepted. I get mad but I move on.

My [adoptive] parents are White. My birth mother is Puerto Rican and my birth father is Middle Eastern. Information is limited because I'm adopted. I'm not Black and I'm not White. I just try to fit in.

[I identify] right now as Puerto Rican. My parents let me choose to a point. If I act too hoody or gangster, they put a stop to it.

My parents and family love me, but they don't understand all the issues I deal with. I express myself through music and writing. In that they are supportive. My mother signed me up for drumming lessons when I was seven years old. It opened up a new world for me.

My parents and family love me, but they don't understand all the issues I deal with.

Timothy Merli *Photographed near Squam Lake, New Hampshire*

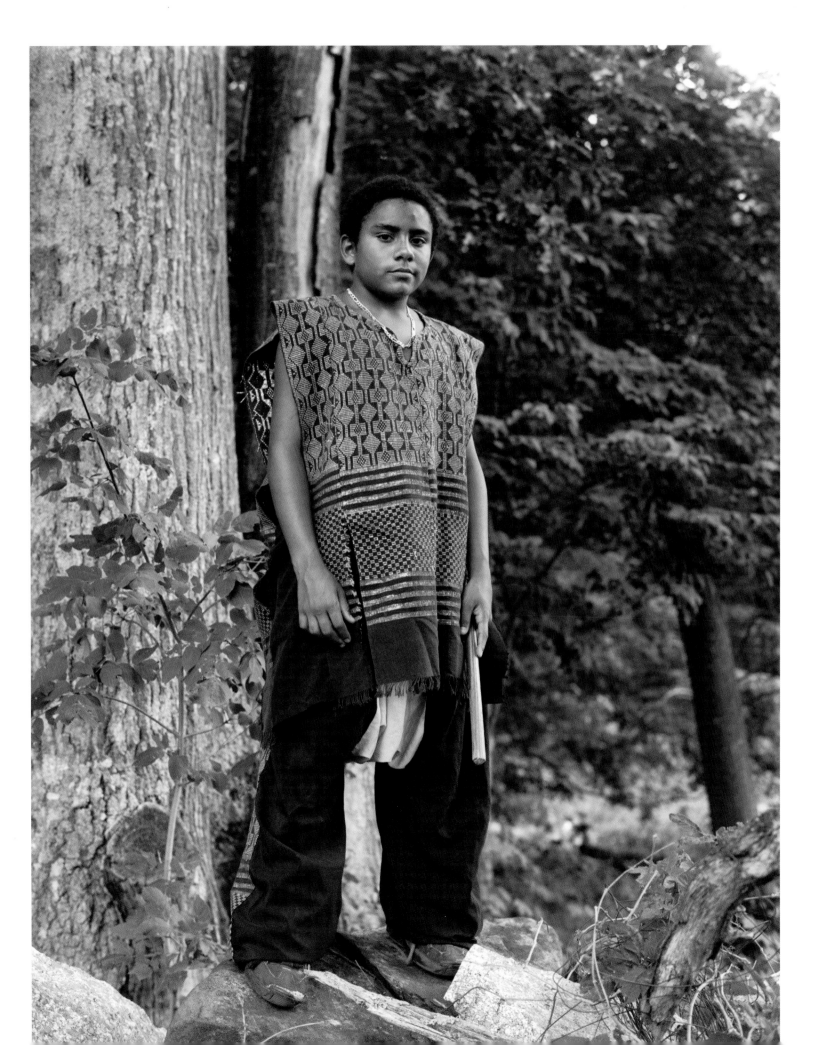

Jade & Perry Sharify

Photographed in Seattle, Washington

Jade: When I was younger, I used to be ashamed or embarrassed of being half Chinese and half Iranian. I was constantly being asked what nationality I was. It frustrated me because many of the responses I received were, "What's Iranian?" (Pronounced wrong) or "Is Iran like Iraq?" and "Are you sure? You don't look like it. I thought you were…" These questions embarrassed me. I felt different. I wished I were White so everyone would just stop commenting about my nationality. I dreaded responding to these questions. However, over the years I came to accept my heritage. When people ask me "What are you?" now, I proudly say, "I am half Chinese, half Iranian." I don't blush, put my head down, and mutter uncomfortably.

Being biracial has also made me more aware of racism in general. For example I can't even count the times

Being biracial has made me more aware of racism in general. –Jade

someone has said to me, "Oh, Chinese and Iranian, that's an interesting combination. How did that happen?" Now when people make those comments I laugh to myself at their ignorance. It happened because my parents were in love. That's all. It had nothing to do with their nationality. Love shouldn't be based on the color of one's skin.

I am American. I don't feel attached to any particular culture. In my family we don't emphasize either culture or embrace any particular customs or traditions. I know about Iranians from my relatives on my father's side, and I know a little about the Chinese culture from my mother. I don't identify more with one than the other.

Perry: While I was growing up, I was always asked, "What are you?" I would answer, half Chinese and half Iranian. They would then mispronounce Iranian and say "I-rain-ian" and make fun of me sometimes. I am proud of being biracial. I identify with both my parents' ethnicities and am proud of both. I don't "side" with either side. I think society has allowed me to speak more freely about being biracial.

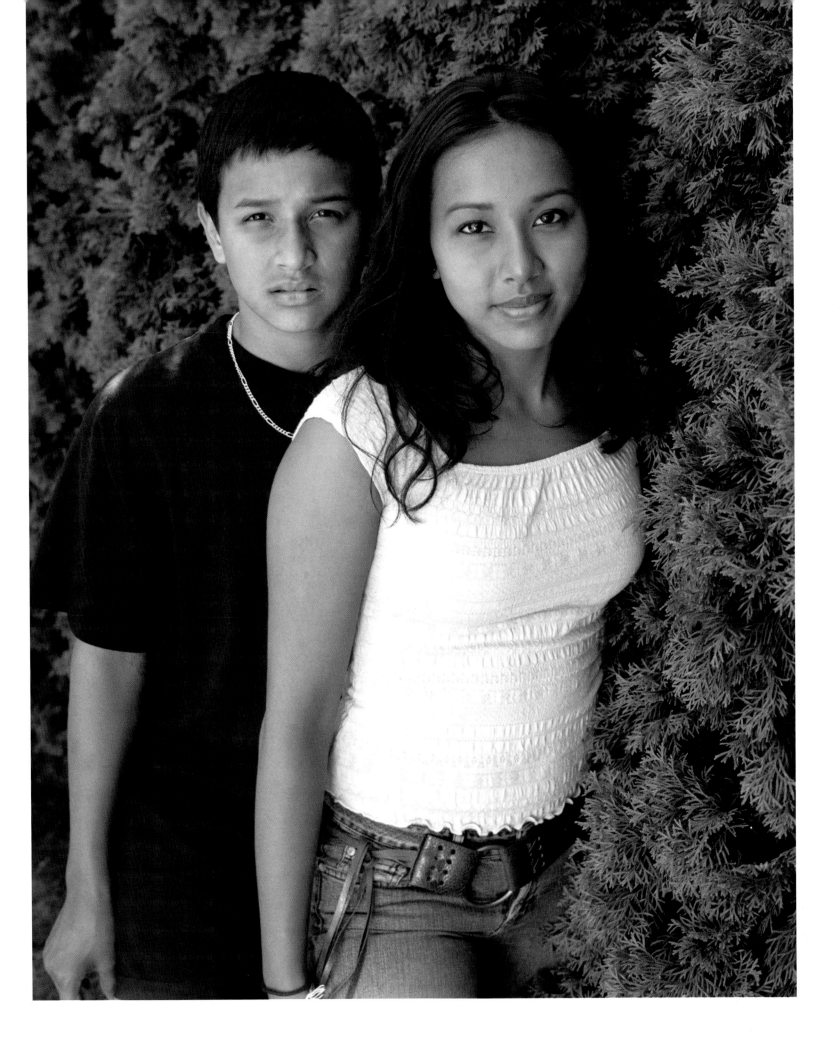

Half Asian (Japanese), Half White (French, Irish)

Katie Yamasaki *Photographed in New York City*

I know who I am, even if everyone else thinks I am Puerto Rican.

I grew up in a working class suburb of Detroit, primarily white and conservative. There were a lot of people of Polish descent who would always ask me "Yamasaki—What is that... Polish?" But I guess you could say that being Japanese in a town of people primarily employed by one of the big three—Ford, Chrysler, and GM—was notexactly in vogue. You can't tell by looking at me, however, that I am Japanese and my mother was the one mostly involved at school. I was always proud of my heritage and even as young as four and five years old I can remember telling people that I was "half Japanese, quarter French, and quarter Irish." I would tell people proudly.

Once at summer camp when I was six I saw for the first time two Japanese girls chattering away in Japanese. I approached them excitedly and asked if they were Japanese. They said yes and thrilled, I replied "I'm Japanese too!" They exchanged confused glances and began talking again in Japanese... hmmmm... I was confused too.

Maybe I wasn't as Japanese as I had thought. Nevertheless, I always was proud to be mixed. A teacher asked me on Dec. 7 to tell the class what happened on that day in history, so I told him and the class that after the Japanese bombed Pearl Harbor, the FBI arrested my great grandfather and hundreds of other Japanese and Japanese-Americans from the west coast and detained them for four years at internment camps in the desert where he was later joined with the rest of my Japanese family. The racism always made me mad, but never made me feel bad about myself. If anything, it made me feel good because I remember feeling that my parents must have been somewhat enlightened (they would laugh if they heard me say this), (but able) to marry out of love, not worrying about what society has to say about that type of marriage is quite admirable.

My mother's family is of French-Canadian descent. Between her siblings and their kids, my cousins, we have a family mixed with Chinese, Japanese, Hawaiian, Dominican, Indian, African, etc. The funny thing is that all the mixed cousins look like we could all be Hispanic. My father's mother is Okinawan, born in L.A. and my grandfather's family is from Tokyo. The Okinawan makes sense and makes me understand why I don't look as Japanese as other half-Asians. My cousins on that side are all half-Japanese.

I always check biracial or multi-racial in the surveys. It doesn't bother me that much. I understand that for whatever reasons they make their categories and there are plenty of things to be bothered by in this world. I know who I am, even if everyone else thinks I am Puerto Rican. People always approach me speaking Spanish—good thing I can speak it—and even when I tell them what my background is, they often forget and think that I am half Puerto Rican, half-Japanese. People in stores ask me if I am married to a Japanese man—if that is where my name comes from. That is always funny. But all in all, I love being mixed because people can't really put you in a box and that is beautiful. There are always assumptions and stereotypes that people have of specific races. People have problems with everyone, but no one knows where to put the mixed kids and that seems to be fine with them. I have had great times with the black people in Detroit, the white people in the suburbs, the Puerto Ricans in New York, the Mexicans in Mexico, and all of the west coast Asians – where everyone is mixed Asian something, and I am always glad that I am who I am.

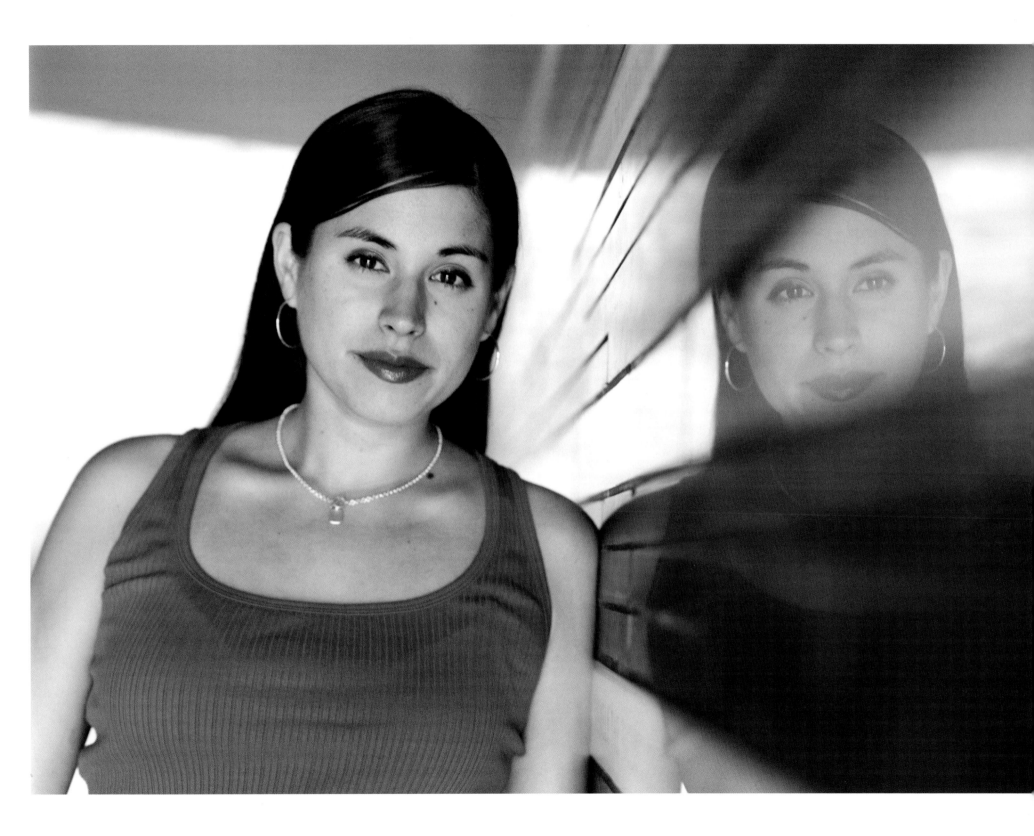

Half White (Irish), Half African American (with some Native American)

Stephen Maher *Photographed in Alhambra, California*

Because of human nature and my negative experiences, instead of openly embracing another human being, I have had to build walls to screen people I meet. The hurt and pain caused by more "solidly ethnic" individuals had taught me not to like other people growing up. But I have learned that there are a few individuals of every race who make up for all the hurt and pain I've experienced. They make life worth living.

In dealing with women, there always seemed to be an issue of racial mixing in regards to children. Also, there is sometimes a sexual taboo that is viewed as both positive and negative in relationships. The tendency to put me in a racial column or slot comes more strongly from dealings with other men.

I have often been asked, "What are you?" After 38 years, I still haven't identified solely with one race. There's still a question and always will be. It's easy to take offense and reject one's heritage. However, I have had to simply teach each individual how to understand what I am. I have embraced all aspects of every race. I personify all the races that I am.

I've often thought about writing a book about my experiences growing up. It would be titled, "Too Black to be White, Too White to be Black." My father is Irish; my mother is African American and some American Indian.

I've often thought about writing a book about my experiences growing up. It would be titled, "Too Black to be White, Too White to be Black."

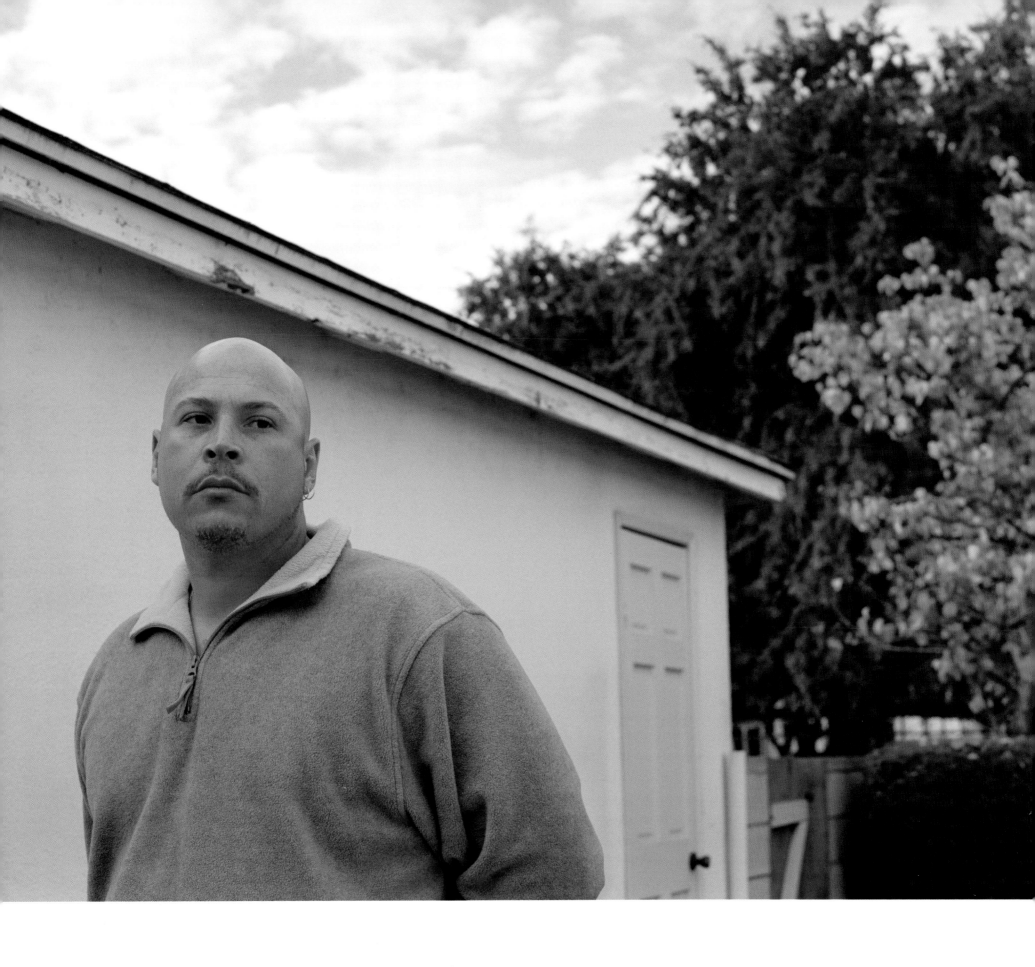

Asian (Half Korean, Three-Eighths Chinese), One-Eighth White (French)

Growing up in a small town in Delaware, I never associated myself with being Asian. There were very few Asians in my town and the ones that were there tended to only hang out with each other. Now that I think about it I don't think they ever considered me Asian as well. It wasn't until I came to New York that I realized that I should be proud of being "different."

The ["What are you?"] question use to really annoy me. I would look at them and say, "I'm American, and you?" I would really make them work for my answer. "No, I mean where are you from?" I'd say, Delaware. "No but I mean your ethnicity." Then, I would give in and tell them.

If I had to choose, I would say my Korean side. I was born in Korea and came here when I was one year old. My mother was born and raised in Korea whereas my father who is Chinese and French was born and raised in the United States.

I'm grateful for my multiracial heritage. I feel it gives me more layers. I've had the opportunity to experience a mixture of cultures in my own home. It definitely has shaped who I am today and I'm proud to be a Korean-Chinese-French-American.

Linda Woo
Photographed in Queens, New York

Growing up in a small town in Delaware, I never associated myself with being Asian.

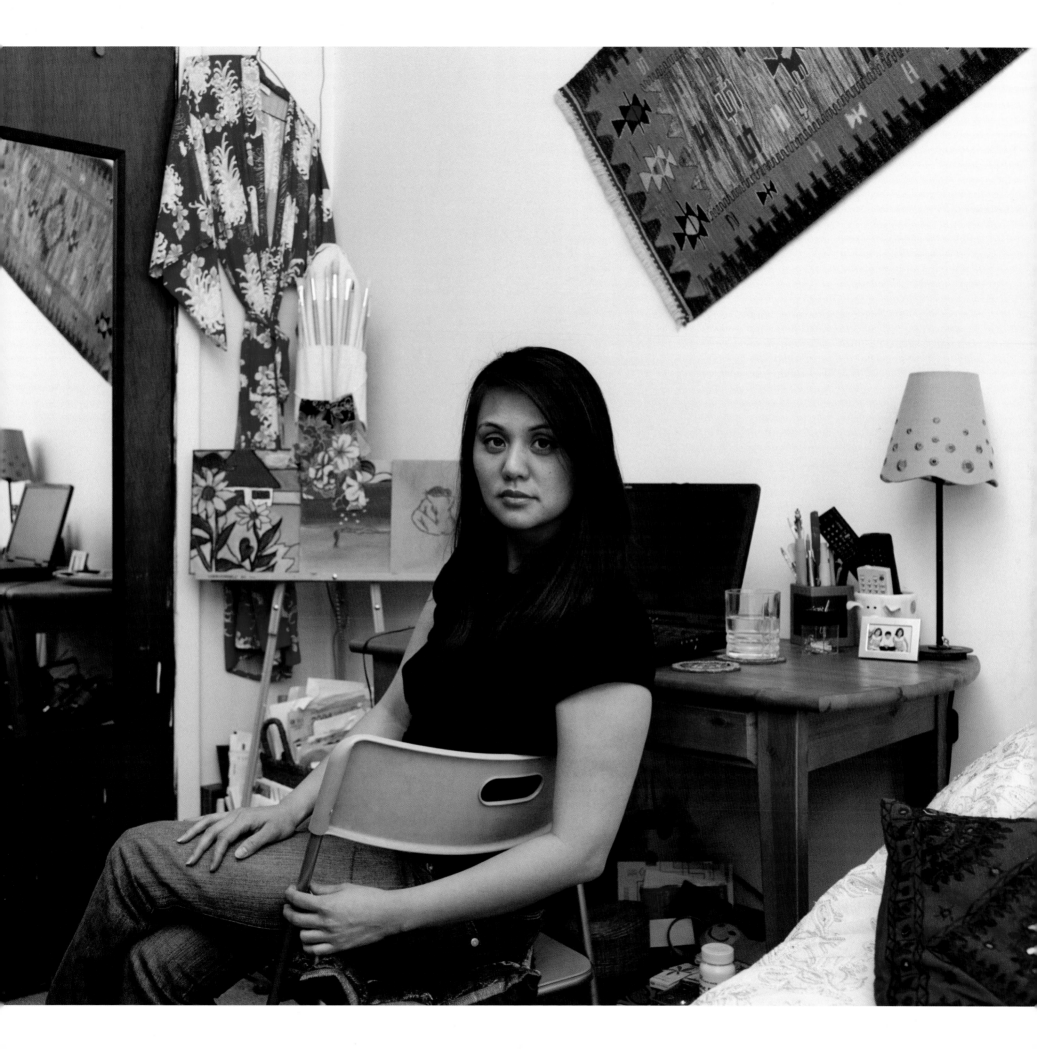

[I identify with] both black and white, but I guess I would have to say I can identify with white culture better because that's the environment I was raised in. I was raised in a white environment by my white grandparents, so it's really all I have known for most of my life. Only recently have I become more aware of and interested in what it means to be black or biracial.

I would say both society and parental influence has played a role in my sense of identity. Because of the way I was raised, I identify more with white culture, but society assumes I identify with black culture for the most part because of the color of my skin.

I was raised by my grandparents on my mother's side who are both white and I really don't think they were aware of the impact being mixed race and raised by white people would have on me. I don't even think I was aware of it until I was in college. I am very grateful that I have such wonderful grandparents, but I do wish they would have been more aware of some of the issues that may arise for mixed or trans-racially adopted individuals. I wish they would have made more of an effort to embrace both of the cultures that make me who I am.

Cyndy Snyder *Photographed in Seattle, Washington*

Because of the way I was raised, I identify more with White culture, but society assumes I identify with Black culture for the most part because of the color of my skin.

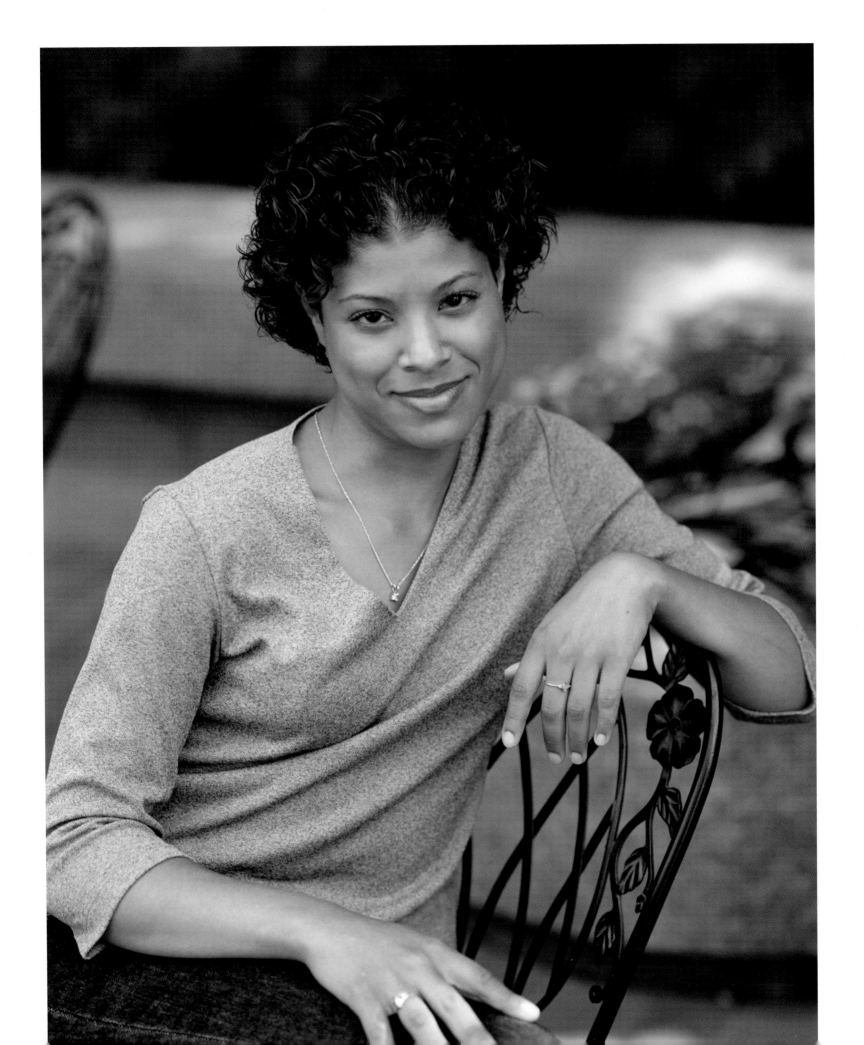

Aja: White, Jamaican, African American, Native American
Guy (Aja's Father): Black American, Native American, Jamaican
Veronica (Aja's Mother): White (Italian, Irish, French), Native American
William: Puerto Rican, White (Italian, Irish), Native American
Margaret: White

Veronica, Guy & Aja Campbell;
Margaret Thomas & son William Chaparro

Photographed in Queens, New York

Veronica: Overall, [being in an interracial relationship] has been a very positive experience. It has given us a realistic and unique perspective on American life. It's helped us to understand and know each other's race and has also allowed us the opportunity to share that with people we love. We are always learning from each other and appreciate not only what makes us culturally different but what makes us the same.

As we raise our daughter in a multi-racial environment, it's been our duty as parents to bring to her attention the best aspects and positive contributions of our respective races. We want her to be a credit to the human race and hope her generation will think

We are always learning from each other and appreciate not only what makes us culturally different but what makes us the same.
– Veronica

in the broadest of terms when it comes to race relations.

Aja: Being multiracial has affected me in the way I look at others. Because of my mixed background I try to be less judgmental of others, especially because of their race.

During different stages of my life I feel that I identified with one side more than the other. This was in order to fit in or be popular. Now that I am a young woman, in college and not so much into being "popular" in school and what not, I don't really identify with one side more than the other. I am who I am and if the people around me don't accept it, they don't have to be involved with me.

William: Being a person of mixed race has not had a major impact on my life. It only has made my life richer, open-minded about new experiences and [more aware] to treat people equally and with respect. I've dealt with (pigeon-holing) in school where you have to fill out papers and they ask what race/ethnic background you are. When I mark Hispanic, one woman said how can

that be when you don't speak Spanish? That to me is being pigeon-holed.

I identify with both sides [of my heritage]. When I go visit my dad, it's just visiting him and things he shares with me about his family and the same with my mom. My parents are not together now, but they still share raising me and they teach me to be a good person and respect people for who they are, not what they are.

Margaret: The positive side of being in an interracial relationship is that you can share and experience new things about each other and different customs. My family was brought up where you treat people with respect. It wasn't based on what someone's race was. Mostly the character of the person is what mattered.

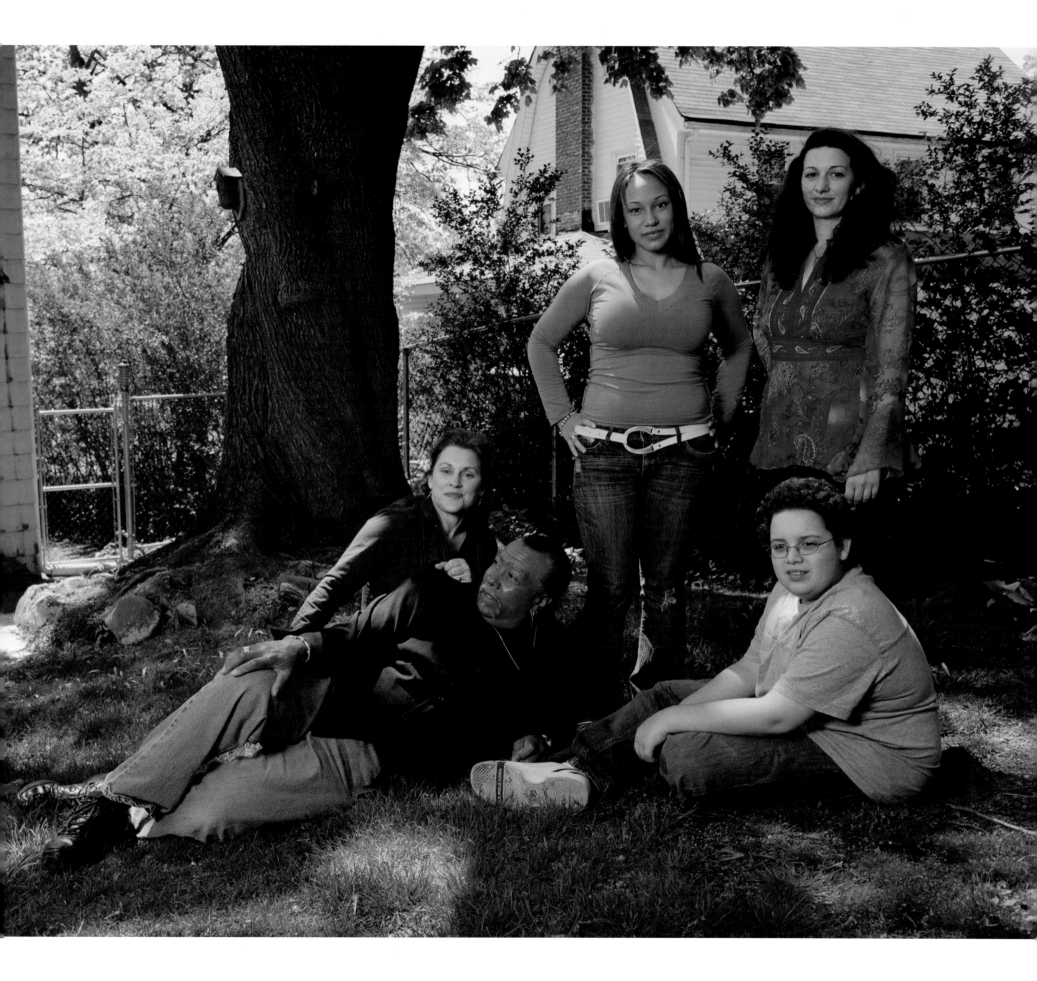

Half White (Norwegian, English), Three-Eighths African American, One-Eighth Native American

Shelby Cooley
Photographed in Seattle, Washington

One advantage of being mixed is having a ubiquitous racial status. Though I prefer to be identified as multiracial, I still find the ability to register as a minority or majority for school applications based on the racial needs of the school or program, advantageous. Many disadvantages of being mixed I came across in social situations in my elementary and middle school years. At times I remember feeling like the extreme minority in the classroom. Though I went to a racially diverse middle school I sometimes felt as though I had to pick sides and choose one racial affinity. Furthermore, even within a racial group I could never be black enough for the black kids and at the same time white enough for the white kids.

Though I rarely found myself in this "racial limbo," being pulled

In a majority White environment I am assumed to be Black or at least a minority, whereas in a majority Black situation I am normally recognized as mixed.

towards either racial affinity, I later exposed these social situations to reflect both the friends I keep and my career interests. Today I find myself with a racially diverse group of friends. I think I subconsciously dealt with the racial tug-of-war through my friendships. Because I do not identify as black or white, my friends are, likewise, not limited to a single racial group. Through my trials of discovering my own racial identity within a society that creates its own perceptions of who I am, I have recently taken interest in fields that deal with social issues and matters of race: both unavoidable topics that define myself and the world around me.

I choose to identify myself as African American, Native American and Caucasian. I have been labeled by both peers and strangers who have misperceived me to be anywhere from Indian to Filipino and everything in between. Though I admit the "What are you?" question is demeaning, I would rather correct the person with my true racial affinity than have them continue assuming everyone to have a monoracial identity. I have found other's interpretation of my racial ambiguity to change with the environment that I am in. In a

majority white environment I am assumed to be black or at least a minority, whereas in a majority black situation I am normally recognized as mixed. Besides other's fluctuating interpretations of my racial affinity I have never chosen a monoracial identity. In identifying with a single racial affinity I would feel as though I am denouncing a part of myself and denying an aspect of my heritage.

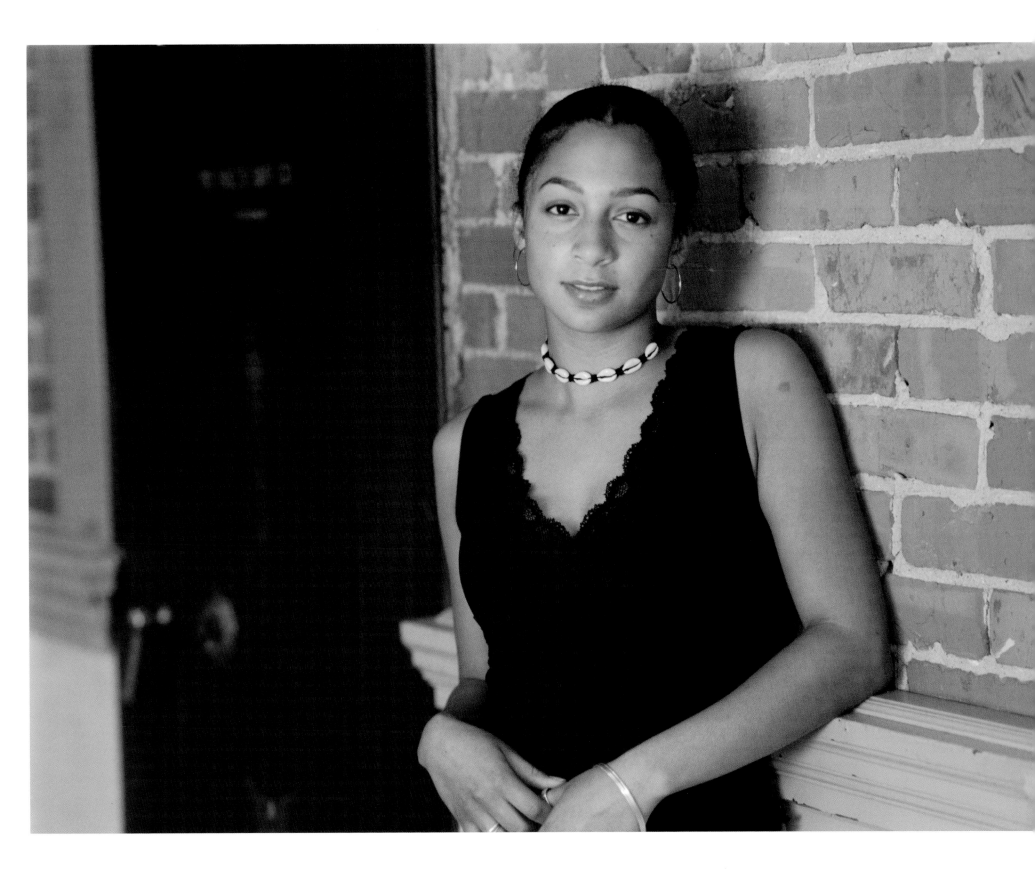

Half White, Half Black

For the most part I try not to recognize any part of my so-called heritage if the inquiry is solely based on pigmentation. I think it's a waste of time. I have never really been pigeon holed. I think you reflect what's going on internally by attracting people that are living a similar dream.

Clive Tucker *Photographed in Los Angeles, California*

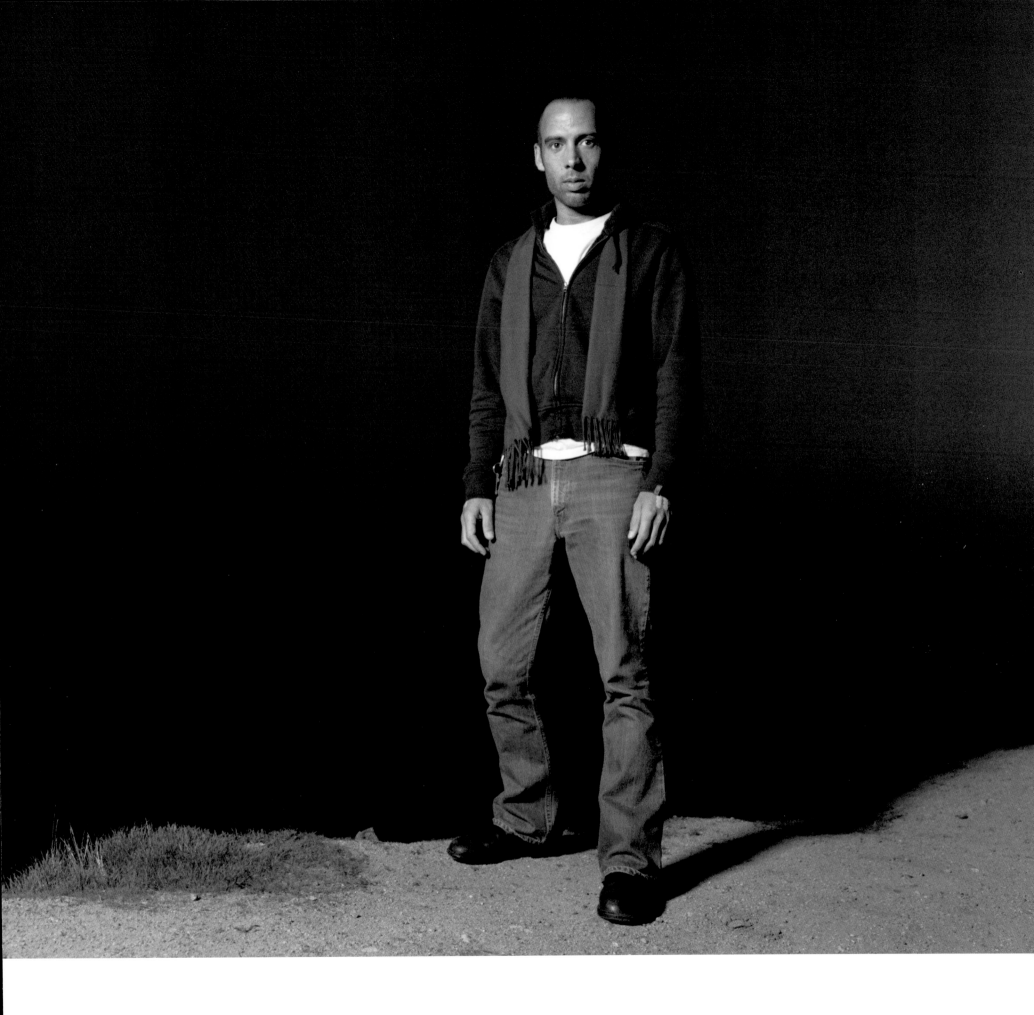

Half African (Ethiopian), Half White

Elizabeth Mekuria *Photographed in Seattle, Washington*

I do not identify as black or white, Ethiopian or Anglo. I am the duality integrated into one skin. I feel blessed. I believe that I understand a multitude of different experiences because I have two very distinct cultures living in my body.

Usually I let people guess [what I am]. Sometimes I believe people have good intentions when they ask, other times I believe it has to do with people's comfort level and the racist history of our nation. Sometimes I tell people my mix and if they really want to know I explain my experience. The question with the weight of unknown intentions, does make me uncomfortable.

I do not identify as black or white, Ethiopian or Anglo. I am the duality integrated into one skin. I feel blessed. I believe that I understand a multitude of different experiences because I have two very distinct cultures living in my body.

Growing up I remember wishing I was only Ethiopian, than maybe I would be able to fit comfortably into a box. Now I realize no matter how one identifies, it isn't always comfortable. Being who I am (very possibly shaped by my mixed race/culture) I have always been different than white people, different than Ethiopians, different than African-Americans, but I find similarities in our humanness. I think that being mixed pushes false boundaries (that have been formed in the US out of necessity at times). Being mixed is a sort of sub culture, sub to everything ...there is the opportunity to create a more encompassing culture that draws from a multitude of experiences. It is a sort of global culture reaching beyond the narrow boundaries society has provided.

Growing up mixed has taught me to be more critical of narrow cultural confines. My father is Ethiopian Orthodox Christian, my mother was raised Catholic. I was never baptized or raised within the church (again I feel blessed). I have the freedom to draw what I find true from the multitude of religions to create my own spirituality. I am a spiritual being, not religious. My parents both surround

themselves predominately with people from their own respective cultures, and I have grown up with lots of live-in relatives from both sides of my extended family. I have learned many of the customs of my father's culture throughout my life (but never the language) and my mother's culture is a dominant influence in this country, so I have learned many of her customs as well.

Family is like a quilt made up of many patches and my experience sews two very unique and beautiful quilts together becoming a new quilt with all my ancestral patchwork creating me. Society wants to identify me. I choose to create myself new everyday.

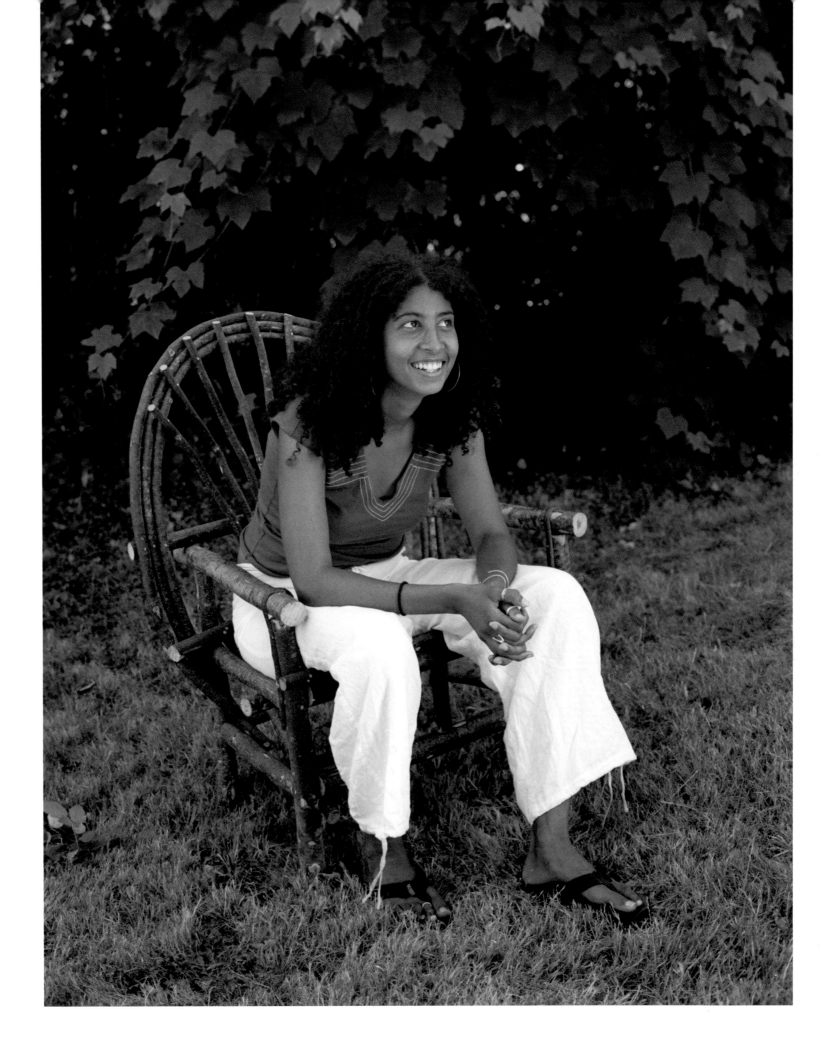

American Indian (Acoma Pueblo), White (Irish)

Bridget Ann Wilson

Photographed on the UC Berkeley campus, Berkeley, California

Growing up with two opposite, sometimes opposing heritages has been mostly a positive experience. I was fortunate not to be raised entirely in America and experienced many other cultures not my own. Growing up, I never focused on myself as being different. I identified with many people and I can now relate to others easily. I don't feel that I have developed any stereotypes; I adjust well to many environments and I maintain a world-view.

Most people here in California, on a daily basis, see me as Hispanic and try to speak to me in Spanish, while most of my formative years I spent in Hawaii and people often tried to guess my ethnicity. They have guessed that I was mixed Hawaiian, Chinese, Filipina or Tahitian. This may have been mostly because I was a Polynesian dancer for many years. Very rarely do people

> My grandmother once told me to be sure to wear the turquoise jewelry she gave me so people would know that I am an American Indian.

guess that I am American Indian. For the most part, I enjoyed being unique but I have made a point to identify with my Native background and have resisted total assimilation with American culture because of my socio-political views and cultural perspective. My grandmother once told me to be sure to wear the turquoise jewelry she gave me so people would know that I am an American Indian.

My first response to general inquiries about my heritage is to tell people that I am Acoma Pueblo from New Mexico. Of course then they ask what that is so I tell people I am American Indian rather than Native American. I also sometimes mention my Irish heritage since I am proud to be both. My upbringing has always been Indian first because of the strong close relationship with my mother, then I identified as being American since I lived mostly outside of the United States.

My parents met while they were both in the Navy. My mother attended an Indian boarding school and was recruited right out of high school along with a friend of hers. She met my dad when they were both stationed in

Boston. I tried to ask them how and why they got married but by that time my father had divorced my mom and both were bitter about the divorce. They never spoke to each other or about each other after that. My Irish grandparents still tell me how much they loved my mother. She passed away several years ago.

As I grew older I would sometimes feel different from everyone else and alone. I feel that this made me more independent. I still try to seek out others who can identify with me but so far I have not found any one like me except my sister. I feel that I have my own unique style of relating to others, of expressing myself and I form opinions on a case-by-case basis. I rarely tend to generalize but rather personalize each relationship or experience.

I took a course in college on mixed racial heritage and thought I might be able to understand myself better but the course taught me in general that mixed race people had serious issues and problems that would sometimes cause them to be unstable and go nuts. The course based its information on the extreme cases of the

offspring between white owners and their slaves and early explorers and indigenous people. The readings were about how mixed race people are not accepted fully by either side. I thought about this and then began to wonder if this was my story. As I became more sensitive I took notice of my interactions and what people would say to me. Maybe there are some members of my family on either side that have never accepted me or may misunderstand me. Maybe I'll never know but I don't see that as my problem; I see that as theirs. I feel confident in being who I am. I am never afraid to be myself or insecure about my identity.

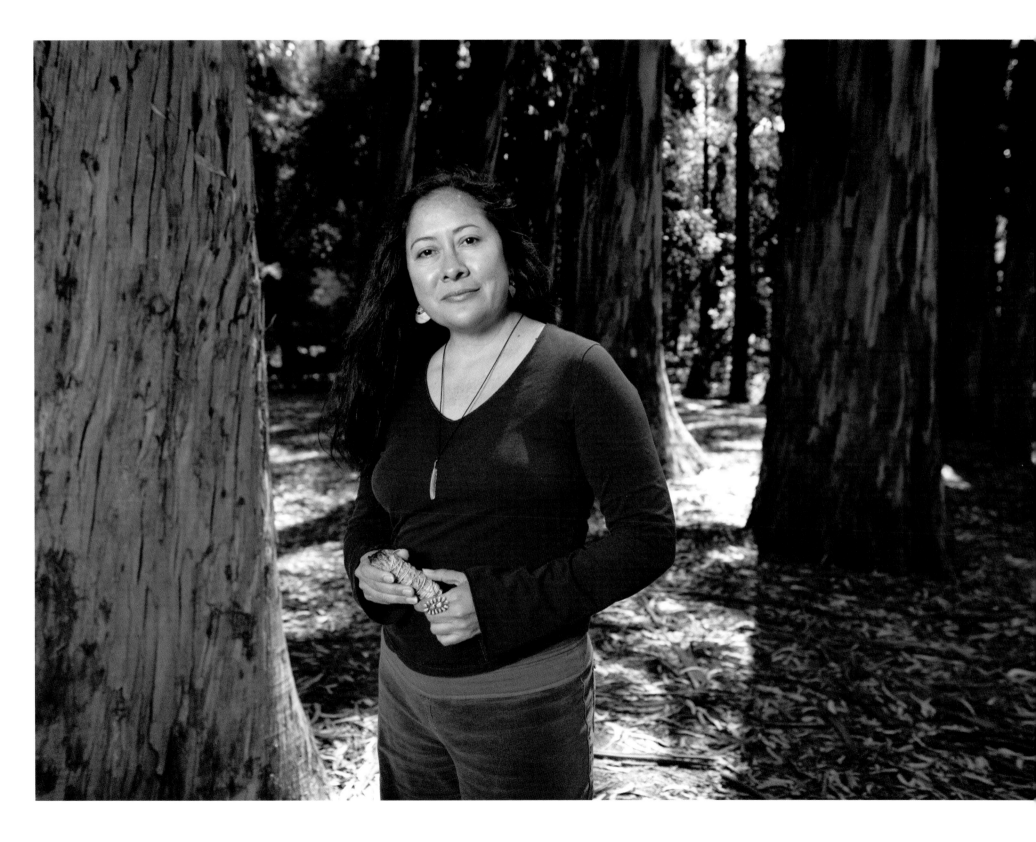

Quarter Asian (Indonesian), Three-Quarters White (Dutch, German, Lithuanian)

My family doesn't have one ethnicity, so I have always been aware that my family history is different than most American's. As a child, I was unsure as to where I belonged because I didn't look quite like a "typical" Caucasian (if there is one), but no one could really tell what else I might be. Now that I am an adult, people think it's cool that I am of mixed race, but when I was a child, I didn't know with which group I fit.

I have heard speculation on my ethnicity ranging from Russian to Hawaiian, as well as disbelief that I have any racial variance at all. I am glad that people cannot so easily define me, but I find it sad that society perpetuates the need to fit people into narrowly defined categories. I am proud to have my Indonesian blood. I embrace my racially diverse background in life through defining my own culture: a blend of European and Asian traditions. Additionally, I am studying to be a teacher, with a focus on multi-cultural education so that others can learn about racial tolerance and celebration of diversity.

I [identify as] Dutch-Indonesian because I feel that gives credit to my European origins as well as my Asian heritage. I can't sever one part of my race for another. I am proud to have that history attached to me and I honor it. My family has played a strong role in encouraging me to honor my blended identity, through celebrating cultural traditions and educating me on my family history.

Sarah Haas *Photographed in Seattle, Washington*

I am glad that people cannot so easily define me, but I find it sad that society perpetuates the need to fit people into narrowly defined categories.

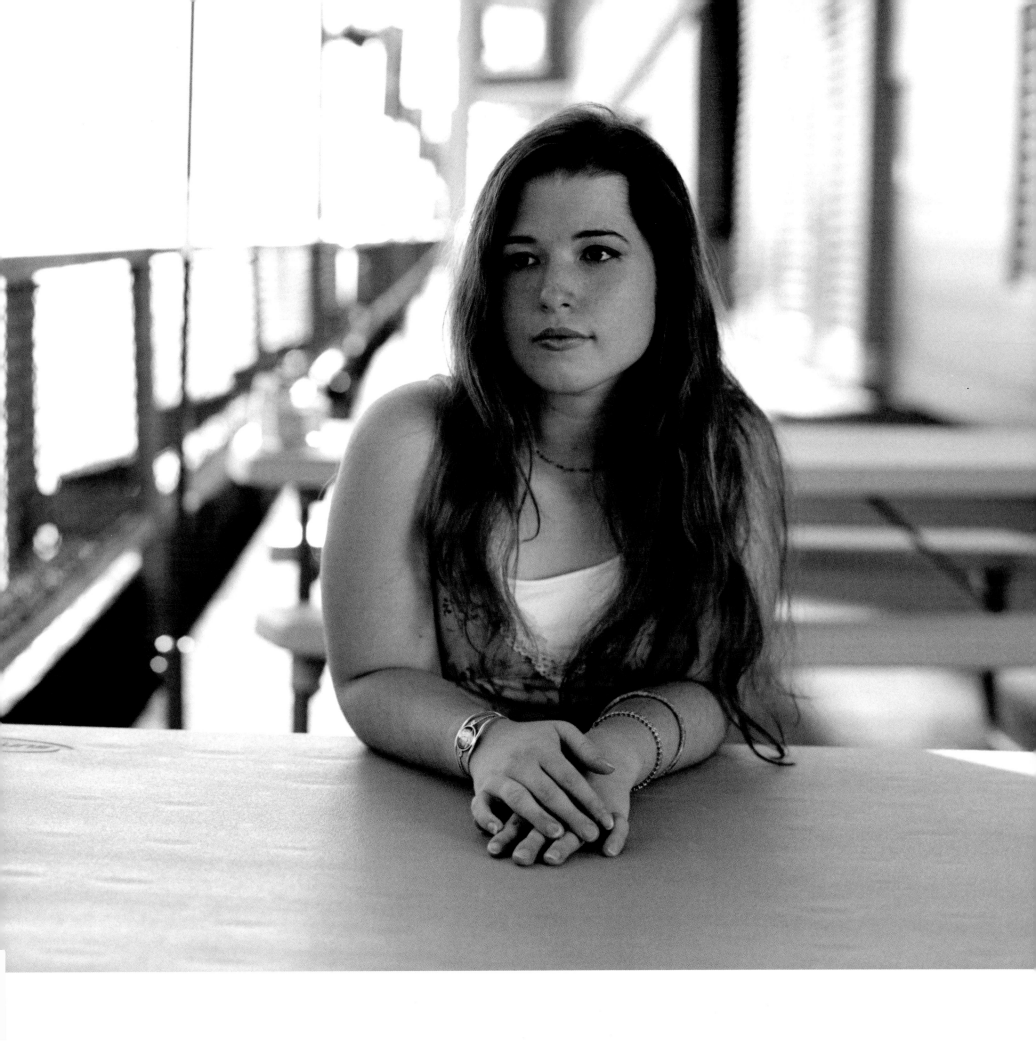

Victoria: Half Pacific Islander (Chamorro), Half White (Spanish)
Christopher & Ariel (grandchildren): Pacific Islander (Chamorro), Native American (Cherokee), White
Rossiter (Victoria's husband): Pacific Islander (Hawaiian)
Virginia (Victoria's mother): Pacific Islander (Chamorro), White (Spanish)

Christopher Kaapunikealoha, Victoria Navarro Oana,
Ariel Soleil Hokulani Overton, Rossiter Kamealoha Oana
& Virginia Aguon Aflague *Photographed in Seattle, Washington*

Victoria: I have a vivid memory of attending first grade at a Catholic School. My mother's family has been Catholic since Magellan invaded Guam centuries ago, so this was a given. When I responded to the nun's question with a Chamorro phrase I was slapped across the face. I was stunned, embarrassed, as it happened in front of my peers. I was in the dark about why. It just didn't make sense to me. It was probably my first lesson in "you're not okay." I wish I would have had a clue then that it was the nun's issue and not mine. Multi-ethnic people learn to internalize hurt and confusion. Sometimes some of us don't ever learn that it's about the other person not ourselves.

My maternal grandparents were descendents of the Native Micronesians that populated Guam and the Spaniards and Mexicans that sailed with Magellan, centuries ago.
– Victoria

I am half Chamorro/half Spanish. My maternal grandparents were decedents of the Native Micronesians that populated Guam and the Spaniards and Mexicans that sailed with Magellan centuries ago. Our island history states that the Mexican men were Spanish-labeled criminals that were exiled to the islands. The ship's crews slaughtered the native men and took the native women. A generation was made up of conquering and conquered people.

My father, I was told, is Spanish. As an adult I traced his parents back to Albuquerque, New Mexico. I assumed that his family was Native American and Hispanic. I don't really know. My mother vehemently stated that he was not Native American, giving me the message that somehow being Native American was not as okay as being Spanish.

There was a time in my adult life, around age 25, that I struggled with the conviction that I was Native American. I immersed myself vocationally and personally in the Native American world, becoming a teacher in a Native educational center and taking up fancy war dancing and drumming. My mother and

stepfather were dumbfounded with my "new" identity.

I identify with several ethnic groups. The first are Chamorro people because I was born and raised some on Guam and I was raised by my mother who spoke, cooked and lived in the Chamorro ways. I also was raised by an African American stepfather, who was married to my mother for 43 years. I was three when he came into our lives. He was an undereducated black man from the South, raised by a single, poor mother who was a wash-woman. She needed his help to financially survive so he did not go to school. He died not knowing how to read or right. He grew up when the Ku Klux Klan ran the town. He told us many a story of torture, death and injustice. I was also impacted by the fact that my father was Spanish. I took Spanish in high school and believed in my heart that I was connecting with a deeper self. Then I went through my five years thinking my father was Native American and went to Pow Wows to compete in fancy war dancing competitions with my two small children. I moved to Hawaii and married a Hawaiian man so now I am very much Hawaiian at heart.

I see all parts of myself as essential to the whole person that I am. To have to choose is like being asked to give up an arm or a leg.

My mother was a young island girl in the South Pacific. My father (Spanish-American) was a married man with several children sent to Guam as a Naval advisor just after WWII. He saw a pretty girl, courted her and married her in the church. Well, he was already married so a year later, after many incidents of domestic violence and my mother finding out he was married, my parents' marriage was annulled. That's my mother's version anyway.

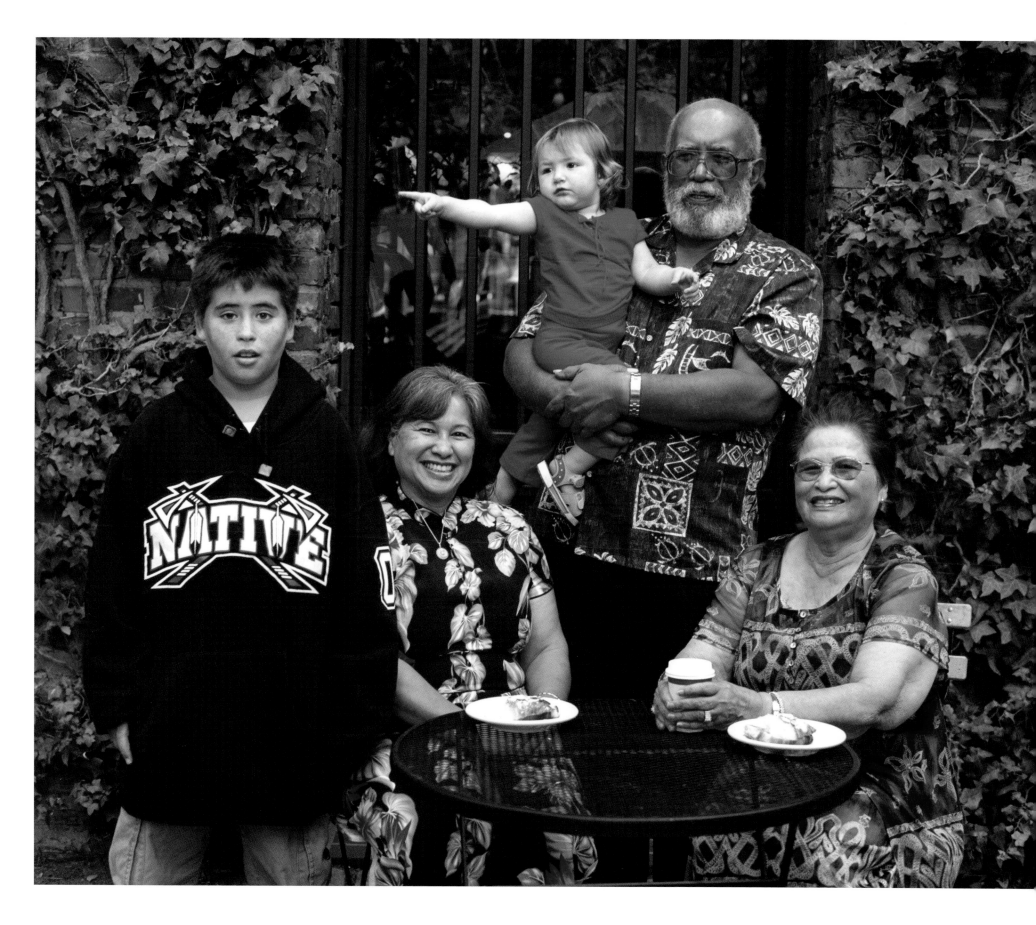

Half Asian (Filipino), Half White (Scottish, Irish, German)

Nicolette Lewis *Photographed in Seattle, Washington*

I wasn't sure how I fit in when I was younger..I still don't know. At my high school, Asians were a small minority that tended to group into cliques. I was never a part of those cliques. I didn't dance hip-hop. I didn't wear gangsta clothes. I thought I wasn't 'Filipino enough' to be a part of that crowd. I felt I had to prove that I was 'Filipino enough', so (at my mother's urging) I participated in a local pageant: the Miss Filipino Community of Seattle Seafair Princess pageant. Only after winning the Miss Filipino pageant did I finally feel like I had a right to claim my Filipino identity. I learned so much about the Filipino-American community and even more about the Filipino culture through my year of service in the Filipino Community of Seattle (FCS). I discovered a deep love for Filipino societal issues and have stepped up to some advocacy roles locally, which have geared my future career plans around East Asian economics. I will go to the Philippines this winter for an internship with the

United Nations Development Programme as part of my major program at Seattle University.

Before the pageant, I said I was Filipino when people asked. Now I proclaim that I'm a Filipino-American. I learned how to be a Filipino-American as I got more involved in the Filipino community. I learned about my Filipino roots, including why my family came to America. It helped me appreciate my country. Whereas some critics say educating yourself about your non-US background is divisive, learning about my cultural heritage taught me about being American. So, now I can say I'm a Filipino-American and appreciate each part of me.

At my high school...
I felt I had to
prove that I was
'Filipino enough'...

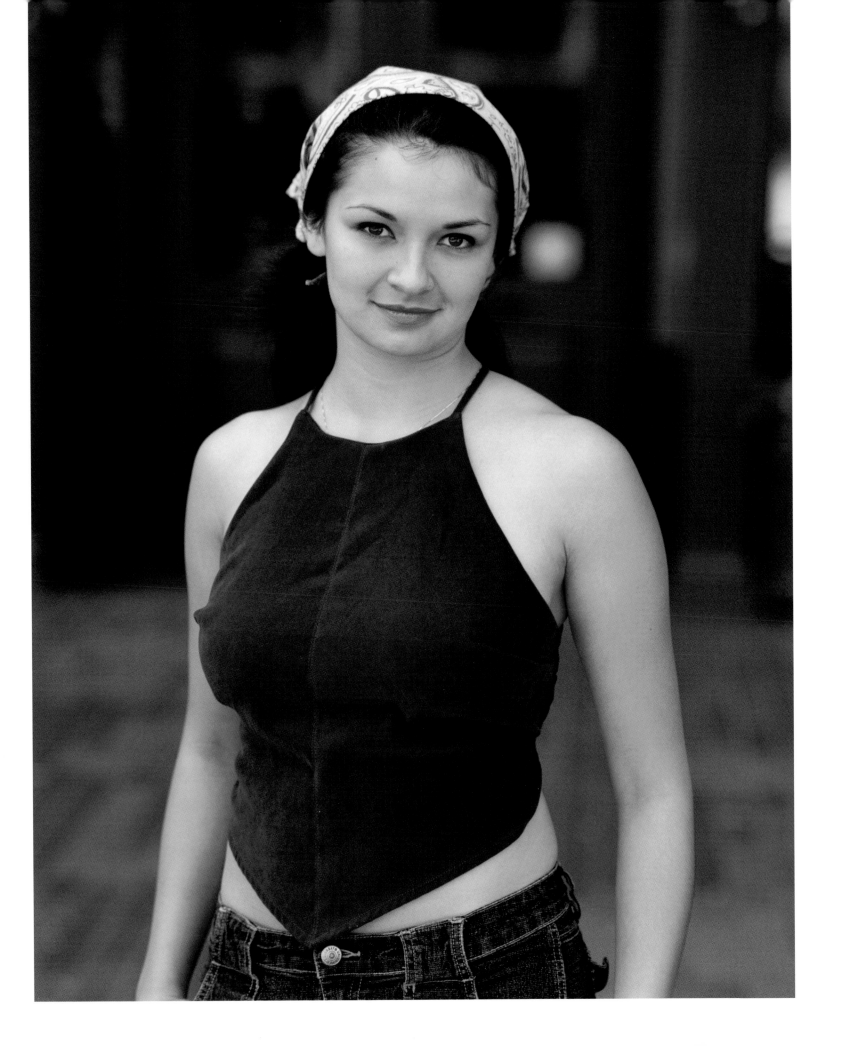

Katie: Half South Asian (Sri Lankan), Half White
Jenisha: South Asian (Sri Lankan), White, African American

Katie Gerard & daughter Jenisha

Photographed in Seattle, Washington

Katie: Most people think I am Hispanic because of how I look. I often have people speak to me in Spanish. Usually when someone asks what I am, I ask them to guess. I take these opportunities to educate the person, as many people hadn't heard of Sri Lanka before the Tsunami of 2004. I value both sides of my heritage and feel blessed to have such a wonderful family. There were times I would get upset, mostly in high school. People would make comments like, she only got that because they needed to give it to a person of color. I came to the conclusion that I was and had to be proud of who I was and all of my accomplishments. Being mixed race has helped me see individuals for who they are and not what race they are. Race is a social construct that has little to do with the things that are important in life.

I most identify with my Sri Lankan heritage because I have more family on that side and have had more opportunity to learn about it. Even though the learning has been from people, family and friends, I still feel a closer connection because I have

Most people think I am Hispanic.

taken the steps myself to learn and experience the culture and tradition. I have never lived there; I don't speak the language though I have tried to learn it, but it is what I have been drawn to since I can remember. My father is a Tamil from Jaffna, Sri Lanka and my mother is an American from Omaha, Nebraska. While I have some similar features, it has been hard for people to look beyond skin color. I remember hearing people ask if my mother was really my mother and others ask if my dad could speak English. At a fairly young age, I had a strong interest in my Sri Lankan heritage. I looked for ways to be around Sri Lankans. I was also impacted by the civil war that has been occurring in Sri Lanka for many years. I believe it is that exposure that got me interested in wanting to help people. I studied international relations in college and I plan to one day live and work abroad.

My first trip to Sri Lanka was a very memorable one. I traveled with my father, who hadn't been home in thirtyfive years, and my daughter who was nine at the time. We went to attend my cousin's wedding. Some of my experiences and feelings were unexpected. I felt right

at home with my family who live there. However, there were some times where I felt very out of place and just like a tourist. It took some time to get used to being there, but overall the experience is one that I will treasure for a lifetime.

One of those life-changing moments happened to me at a young age; it was the first time I remember feeling different and bad about who I was because of my skin color. I was at a friend's birthday party and we were getting in the car to go somewhere. I think I was in the second grade, I remember another little girl said that she couldn't sit by me because my skin was dirty. I felt terrible and used to try to wash my skin extra hard so that it would look white. Needless to say, I have come to love all of who I am. Now that I am the mother of a multiracial child, I notice how some things have changed. There are definitely more multi-racial families, to the point that I don't even think my daughter is as aware. I tell her, it isn't what race you are that matters, it's who you are on the inside that does.

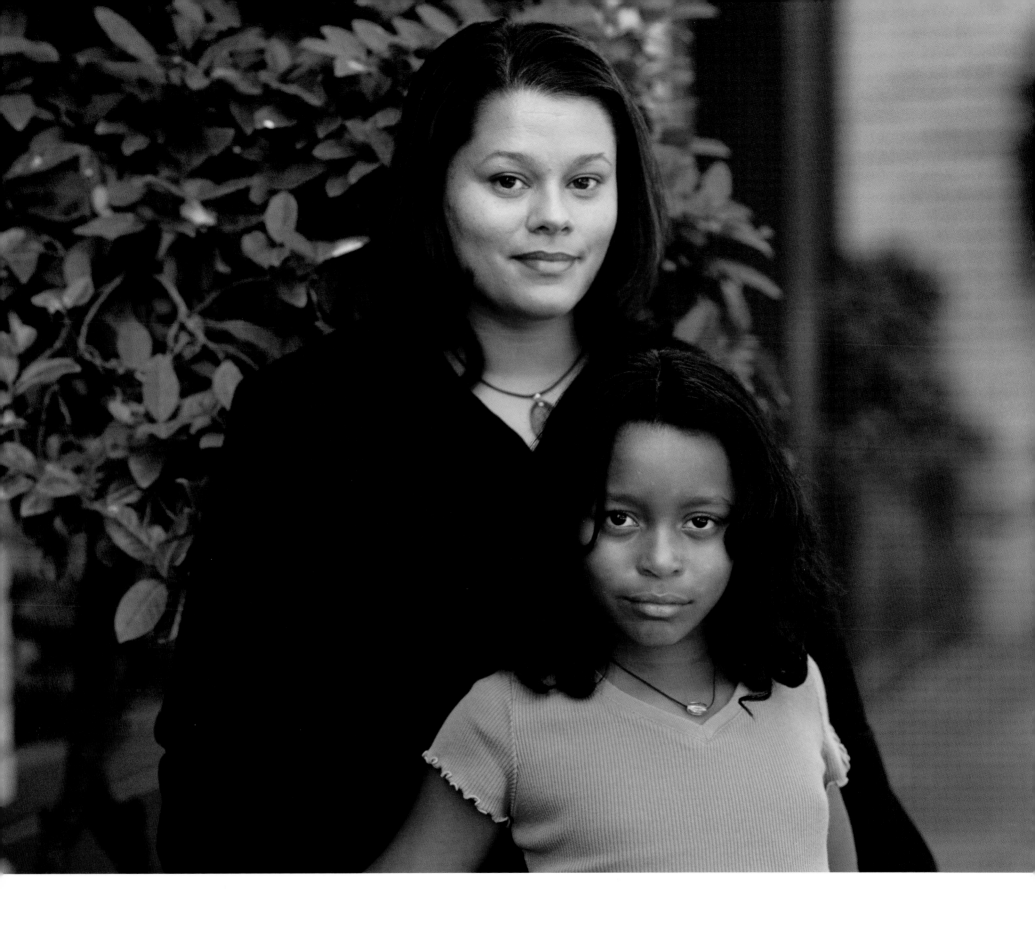

Leigh: Half Black, Half White (Italian, Greek, German, probably Jewish)
Paul: Half Asian (Filipino), Half White

Leighkaren & Paul Labay

Photographed in Brooklyn, New York

Leigh: I never knew my dad and was raised by my mother's Mediterranean family. It was not something that was ever discussed. I think most of that was because they didn't want to make me or my mom feel bad, but I would have been so much better off if I knew the truth from the beginning! I had all these questions and unidentifiable feelings that I couldn't make sense of, UNTIL they told me I was mixed. I felt that I had a lot of catching up to do to my black side, and learning about it so late in life made it kind of hard to do.

I identify as mixed. I feel that there are aspects of both my Mediterranean culture and my black culture in me. Aspects of both cultures overlap and are the same. I cannot truly say I am one thing or another because that would be negating a whole half of myself.

My mixture was the yardstick for measuring myself and other people. I have always felt like

My family kept the fact that I was mixed hidden from me until well into my teens.
– Leigh

an "other" in a world where it seemed like everyone else belonged. I think that is why I am a loner in large part, and why I don't have a lot of very close friends. It has taken me a long time to shake off that feeling of otherness, but I have worked hard to do so. The otherness was/is a self-fulfilling prophecy. I couldn't accept myself when I was younger and that influenced my life choices. I didn't feel good about myself and didn't always make the most positive choices for myself. Being mixed has also made me very sensitive to other people's feelings of alienation and anger and has helped make me a very considerate person. I can always identify with those feelings of alienation and rejection, so I make sure to help others to not feel that way.

Paul: Growing up I didn't really think much about race. My dad was Filipino and my mom was white, but I just thought about them as Mom and Dad. So you can say I was essentially colorblind for most of my early years. I did know that my dad knew about things that other kids' dads didn't know about, like "weird" foods and Filipino dances like the Tinikling. But I didn't think much about "What I was." I did get that

question from so many people "What are you?" that maybe that was the biggest impact growing up multiracial had on me. It got to where I could either respond with a stock "My dad is _ and my mom is _" or I would just say "human" if I wasn't in the mood and leave it at that.

I would have to say that now I identify as multiracial —both Filipino and white—but growing up I was usually viewed by most folks as white. And there were lots of times in junior high school and high school that I identified way more with my white friends than my Filipino relatives. Society always wants you to choose one thing or another, so I have decided not to allow those expectations to inform my choice. Now I just say I am both Filipino and white, and proud of aspects of both.

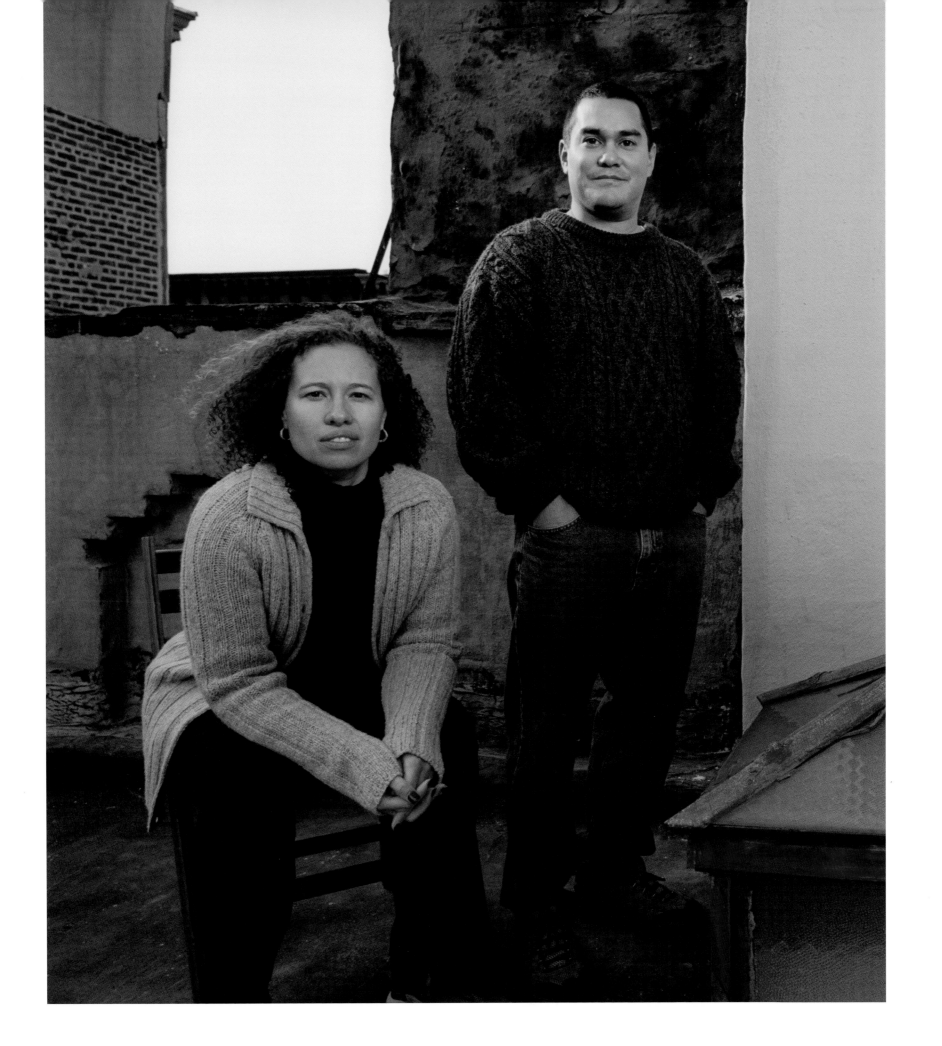

Half Black, Half White (German Jewish)

Marika Hughes *Photographed in Oakland, California*

I have always felt as much Black as I have felt Jewish.

Being of mixed race has been only a blessing in my life. As a child I was incredibly lucky that my parents ensured that my brother and I were enrolled in a racially and economically diverse elementary school: Manhattan Country School. And as a result, I was immersed in a diverse and inclusive educational and social environment. It was only upon entering high school that I was first exposed to an extreme lack of diversity, educationally and socially. I attended a mostly white NYC prep school. This change of school was shocking and a huge adjustment. And typical of so many high schools, the cafeteria was where one could see the racial breakdown of the student body. Tables were mostly full of white students. But there was always a "black" table in the cafeteria as well, although black and white students did interact with one another in classrooms and socially. At 14 years old I understood this minor effort of self-segregation as a survival mechanism as well as a way to encourage a sense of familiarity and comfort for the few black students. Yet I had black friends and white friends, never feeling a pressure to choose which table to join. Coming from a close family with married parents (very rare at the time) I had a core confidence in myself as a mixed-race person. This confidence only enhanced my ability to befriend those I liked, regardless of their race. I have never felt the pressure of being "pigeon holed" in one race or another. Those that were critical of my seeming "whiteness" or "blackness" (depending who you asked) never threatened me.

I identify equally with each side of my racial heritage. I have always felt as much black as I have felt Jewish. I attribute this comfort and pride to the fact that I come from parents who stayed married and created a home that was warm and full of love. Socially conscious and politically progressive, my parents allowed us our independence while creating a home where we always felt safe. As I have grown older my racial identity has not swayed. I know when I walk out my front door I am a black woman to the world that sees me. I have never been mistaken for white. That being said, on the inside I am always black and Jewish. And both cultures have informed my progressive politics, sense of humor and my sense of social justice.

There was a moment during my first year in college, in the early '90s, when the black students and the Jewish students were entangled in a huge dispute regarding a certain speaker the black students had invited to the campus. This black speaker was public about his disdain for Jews. And the Jewish students' protested the right of the black students organization to invite him. I have always been a serious advocate of the First Amendment and so I supported the black students right to have this speaker, despite my disgust with the speaker they had chosen. In the end, I discovered that the Black Student Organization seemed to be disinterested in engaging in a discourse with the Jewish student body, despite the best efforts of the Dean of Studies. I was disheartened and walked away from the whole affair, unable to relate to the hatred coming from each side. Beside myself and bewildered, both the black students and Jewish students were disappointed in me and called me a traitor. I found myself calling home late one night to get advice from my parents. And I will always remember what my father said to me while my mother laid beside him . . . "Kika, we relate to a person's mind, and that's it in the end. Now you make your own choices." And with that I had my confidence back. I knew who my friends were and what I believed in.

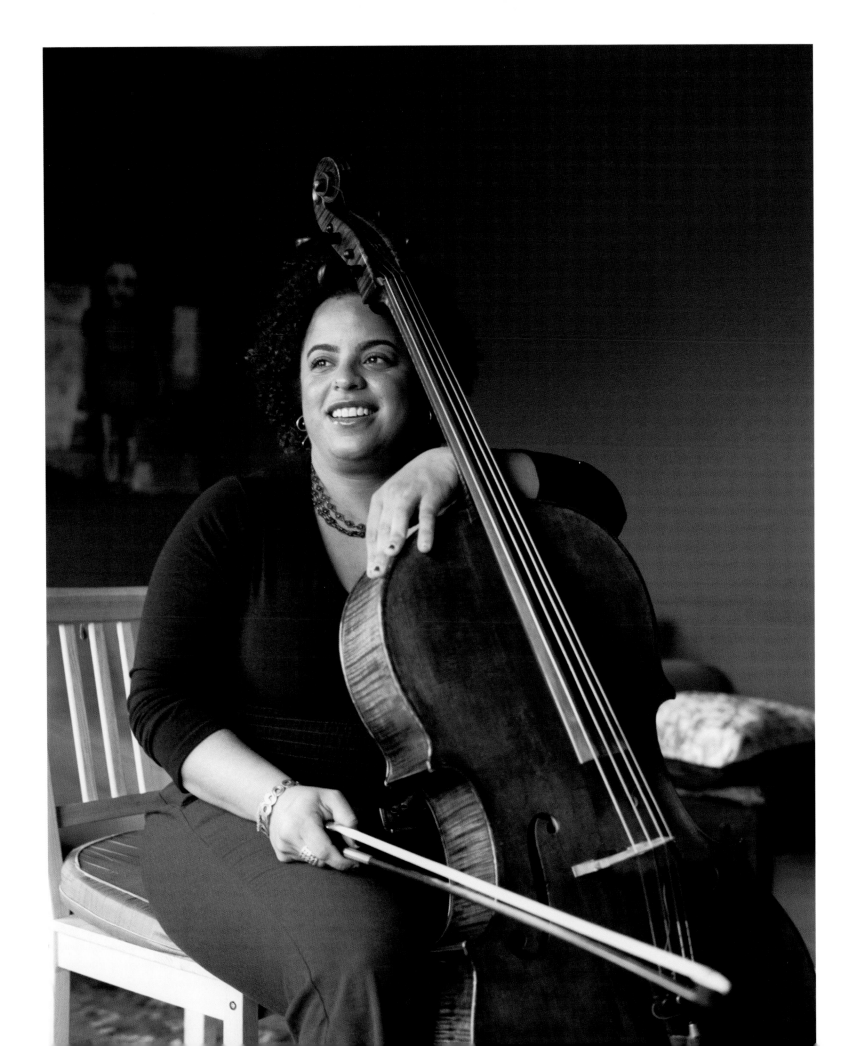

Tamiko & Ryan: Half White (Irish, English), Quarter African American, Quarter Native American
Shannon: White

**Tamiko & Ryan Little
& their mother Shannon Little**

Photographed in Los Angeles, California

Tamiko: When I think about the history of racism and the years spent in reconciling the age-old issue of black vs. white, I see myself as the resolution. I take no sides. I embrace my frizzy curls, Irish eyes, soft-spoken voice, and summer bronze with winter olive skin.

My mom introduced me to Irish Catholic culture as she knew it in her own family and rediscovered as an adult. Irish culture influences my interpretation of family and what it means to live what you believe no matter what others may say. Strange enough, I relate to the troubles in Northern Ireland not as an Irish Catholic but as person, who has been outcast and refuses to let the majority define my way of life. Unfortunately, my father left when I was three, never to speak to my brother

I am nature's answer to racism; I live an adapted life where I can speak many languages and move through cultures like gliding on ice. I am waiting for the world to catch up with me.
– Tamiko

and I again. I am told my father was black, raised in the projects of Buffalo, NY, and has roots in the Iroquois Nation of Native America. My experience of African American culture comes from great literature, films, the inspirations of Black America and how the outside world perceives me as African American.

My experiences of Native American culture are from camping trips in Canada with visits to the Mohawk Reservation, stories from my brother when he lived with the Sioux community in South Dakota, Native American literature, and contemporary films. The traditions of Native American culture remind me that I am a part of a greater existence and my worst enemy is my self.

Shannon: My interracial relationship affected my life dramatically. It turned my world, as I knew it and experienced it, totally upside down. My family's true colors came out and they were racist. My family was prejudice and still is to some extent. They did not want me to date David, marry or even have children by him. It was and has been a horrible experience.

My own family disowned me. It was a very difficult time for

me from the time I met David until just recently. They did very little to help me and it seemed like everything to make my life a living hell from not helping me financially to trying to have me lose my teaching position because of their racism. David and I divorced after of few years of marriage. I struggled those years raising my children. I felt alone, abandoned and betrayed by my "loving family." I am proud of who I am and who I have become despite the hatred of my family and society. We experienced at the rawest stage the fragileness of being human and we have not only survived but have excelled as individuals and as a family.

Ryan: Growing up in America has brought much anger. I grew up in Baltimore in the 80's where everything was either black or white. I was embarrassed to be mulatto. I felt like it was a death sentence. America loves to classify its people and my neighbors and peers were no different. I got it all; "What are you? You're an Oreo cookie. Are you adopted?" Everyone kept staring, trying to find out what or who I was. I didn't relate to my white peers and my black peers didn't know what to make of me. When I got older I learned to better appreciate who I was and what I was capable of.

[I identify most with my Irish American heritage] because I grew up in an Irish American household.

Being multiracial has given me a chance to better identify with other cultures, attitudes and beliefs. My sister and I feel that, because of, though not limited to our racial background, we are more adept at handling people, situations and environment, working with people of various temperaments, living in diverse communities.

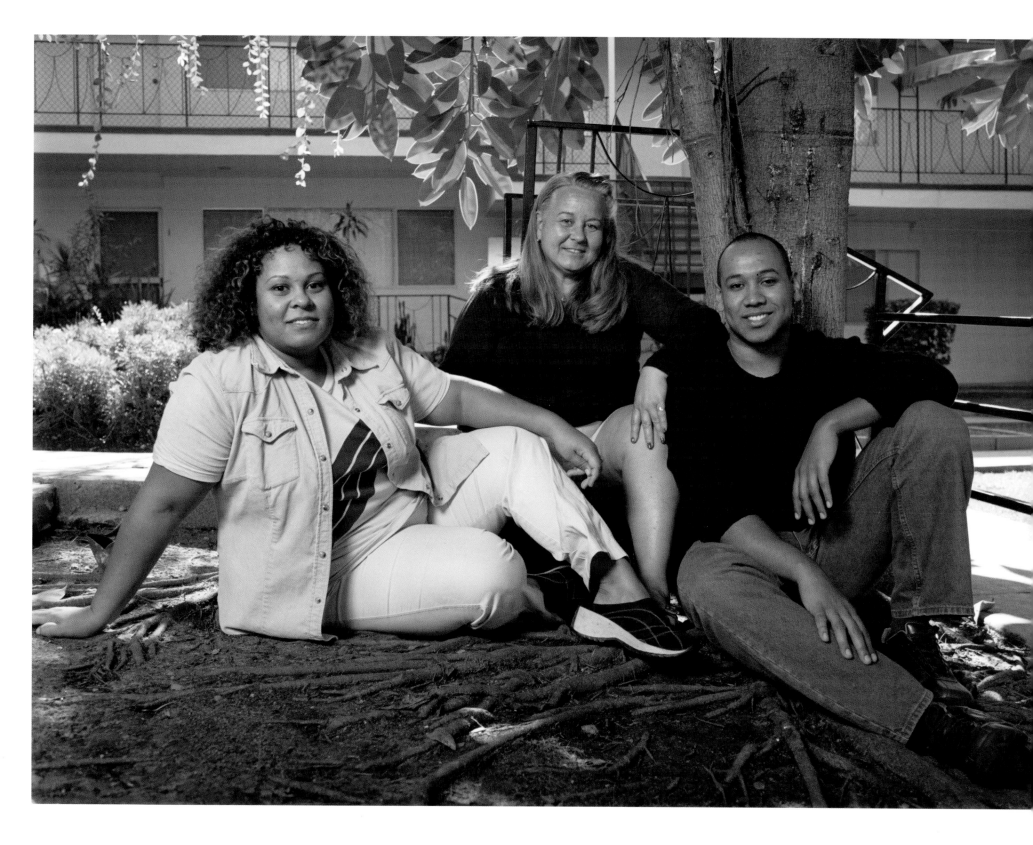

Asian (Chinese), White (Ashkenazie Jewish)

Jen Chau *Photographed in Queens, New York*

My life has been greatly impacted by my mixed race identity. Growing up, I had the experience of never fitting in, but always switching to be "more of this" at one moment, and "more of that" at another moment. In the 1980s, when I was in my adolescence, there really wasn't a language to talk about a mixed experience. Everything was "either/or" and I was constantly asked to choose one ethnicity over the other. I had a tough time reconciling this as a child because I felt strongly that I was a part of both of the cultures that made me up. At the same time, the way many strangers classified me was very different than the reality. This was also a strange experience for me. People

Growing up and never feeling that I had a community of my own led me to become an activist within the mixed community. It's the intricacies of living a mixed experience that tie me to other mixed people…

would always ask me if I was Hawaiian, probably because I look like what they think a Hawaiian looks like. I was also assumed to be Latina. All my life, I have experienced this kind of ambiguity.

Growing up and never feeling that I had a community of my own led me to become an activist within the mixed community. During college I started Fusion, the mixed organization for students at Wellesley. Upon graduating, I took my energies and devoted them to the creation of SWIRL, a community organization based in New York City. Swirl is now a national organization with chapters across the country. Knowing how difficult it can be to live as a mixed race person in a world that only sees things in simplistic terms and boxes, I wanted to create change. I wanted to make a space for mixed people, transracial adoptees, and interracial couples and families to come together. There are so many commonalities in our experiences, but no structure in place that allowed us to meet. I also wanted to bring more awareness and visibility to the issues that impact our communities.

More recently, I have begun

to focus on advocacy efforts. Along with my colleague Carmen Van Kerckhove, we direct Mixed Media Watch and New Demographic. MMW tracks and comments on how the media represents the mixed community, and through New Demographic, we facilitate discussions and present workshops on topics that are relevant to our ever-diversifying world. As you can see, my experiences as a mixed race woman have largely impacted who I am and the work that I have chosen to do.

My ways of dealing with the "What Are You?" question have definitely shifted and evolved throughout the years. At present, I am content with answering the question, but usually try to engage the individual in a discussion. Education is MY focus even if the interrogator has no interest in anything more than "placing" my face.

I identify MORE with being mixed than either of my "racial heritages." I often find that I can relate more with another mixed person no matter what their mix…than other Asian, white, or Jewish people. There are so many intricacies involved when you are thinking about a cultural experience.

It's interesting, because obviously, mixed people don't necessarily have one cuisine, culture, set of traditions, and language in common due to all of our diversity. Rather than those, it's the intricacies of living a mixed experience that tie me to other mixed people: answering the "What are you?" question, dealing with people's discomfort around ambiguity, experiencing a chameleon-like existence, straddling two or more cultures, etc.

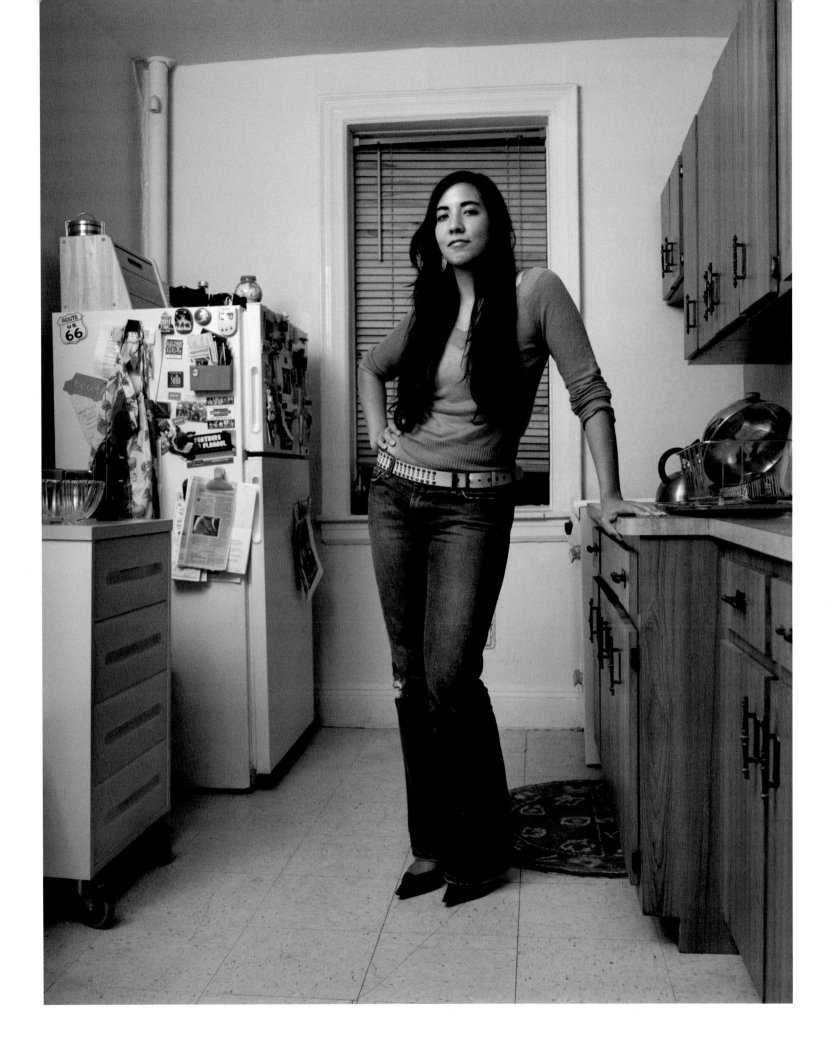

Black, White (Russian), Native American (Cherokee)

Shira & Shan Howerton

Photographed at home in Tremont, California

Shira: It's hard to explain how your ethnicity can have such an impact on the way others perceive you, react to you and acknowledge you. As I was growing up, my family did so much to make me feel justified for being who I am. I have carried that into my later years, but there are still struggles. I would say being biracial has affected my path because it is hard to fit in some times, and at other times you don't want to fit in, you want to fight against any type of conformity.

There definitely has been that pressure to "choose one box only." Everywhere you look it seems someone is giving you that, "What are you stare?" It can be weird, it can be menacing and it can be downright uncomfortable. I've had people stop me on streets, turn around in movie theatres, ask me in bathrooms—you name it. Internally I have been fighting a battle to stay one step ahead of the questioning crowd. It is really hard to be yourself when everyone questions who that self is. I

It is really hard to be yourself when everyone questions who that self is.
– Shira

can't say I really identify more with one part of my ethnicity over the other. I have a wide range of friends, and I talk and relate to many different people. I find that okay, but I think at times, some people wonder why I'm so friendly, or why I make an effort to talk to people. I can't really explain that. I guess I just wish more people would talk to me just to talk to me, instead of having the first or second thing out of their mouth be, "So you're mixed, right?"

My parents have had many struggles in their life. First of all, neither of their parents wanted them to marry, and when they did decide to marry, neither parents came to the wedding. They then moved across the country without the support of any family members, and had to start their lives from scratch. I remember my mother telling me when she was pregnant with my sister, a woman saw her and my dad walking down the street, and she asked my mom how she could bring a child in the world like this. She said this just because my father was black, with no care that my parents would be good parents. She was only outraged because my sister would be mixed and "terribly confused in the world." I feel blessed that my parents

are such strong individuals and that they were able to overcome the hard times and look past the criticism. But sometimes their past is really hard to take, because it shows my parents had to go through so much just to be together, and just to have me and my siblings.

I just want to say for anyone who reads this, no matter what race you are, or who you identify with, or what you think, feel, or believe, understand that people are people. In our society we give so much credit to certain ethnicities, and downplay others to an extreme low. This world will only keep turning the same way if it has no one who does anything to change the direction. As the great peaceful minded Mahatma Gandhi said, "Be the change you wish to see in the world."

Shan: I am not a race or a culture, you cannot define me by one word. I will not be a number or just another random body to answer your simple questions. I personally took up no racial heritage. I became myself which has been seen as funny and lovable by some. I play with how serious people take their race or culture as there own person, especially when people try to consider

me as black or white (usually black).

I have had to deal with many people accepting only what I look like and not who I am. It's silly how some people try to talk to you by your race and not by your personality.

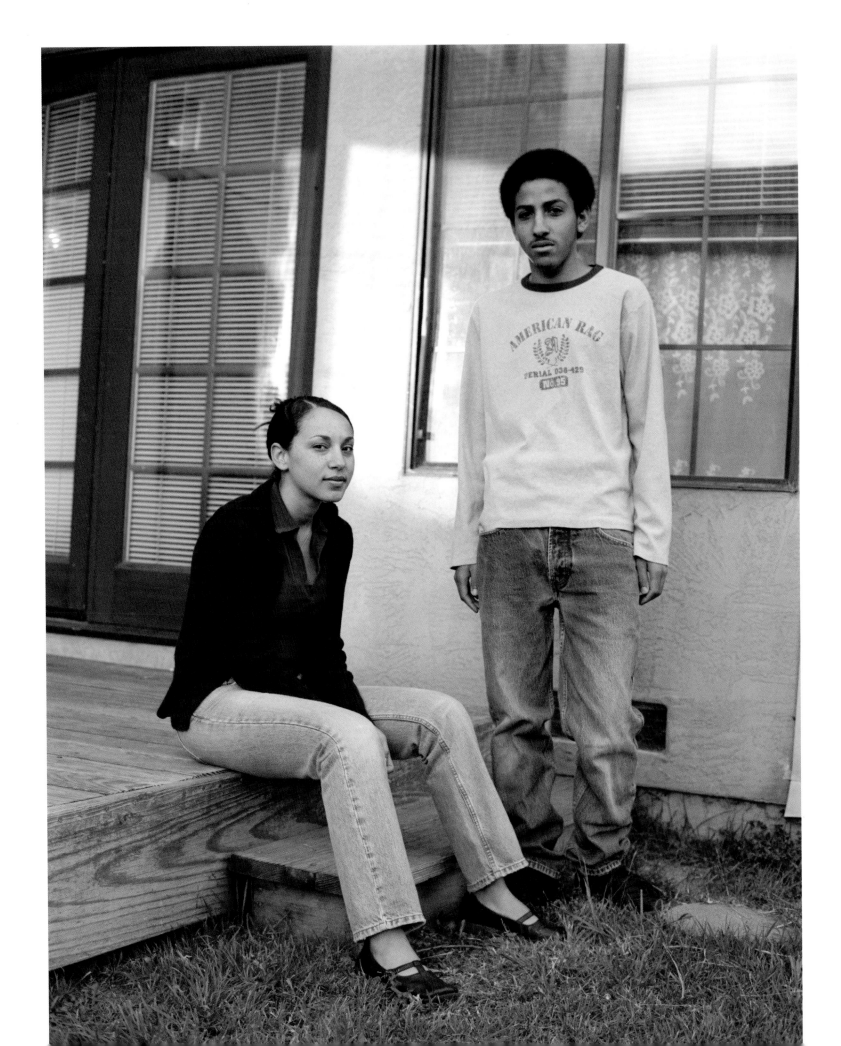

Half Asian (Japanese), Half White

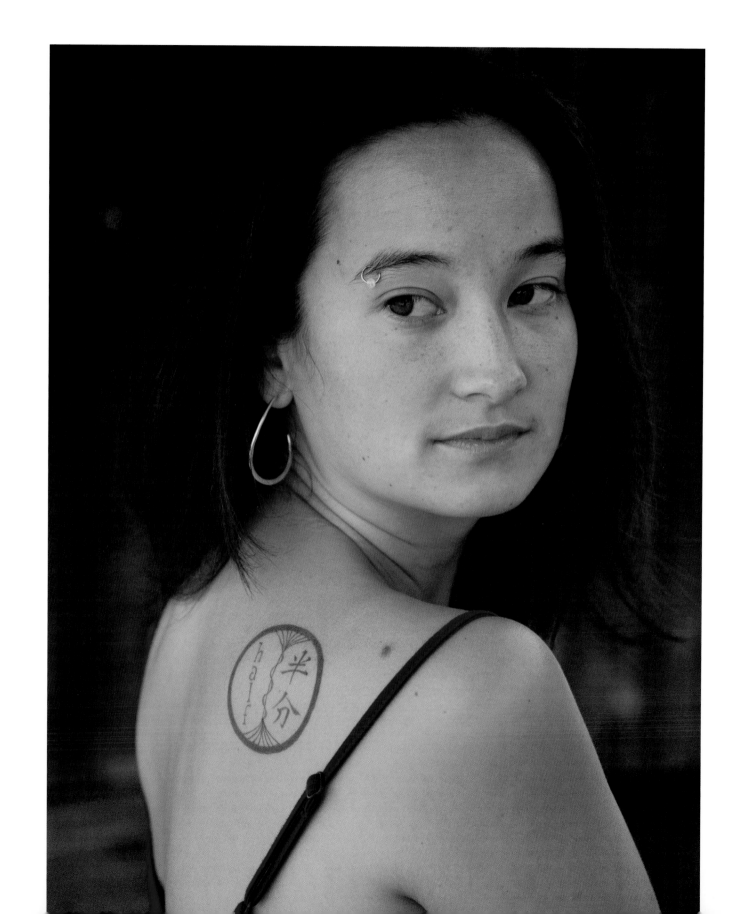

Sashya Clark *Photographed in Seattle, Washington*

Anita: Indian
William: African American, White, Native American (Blackfoot)
Yasmin: Indian, African American, White, Native American (Blackfoot)

Anita Sansguiri, William Adams & daughter Yasmin *Photographed in Kirkland, Washington*

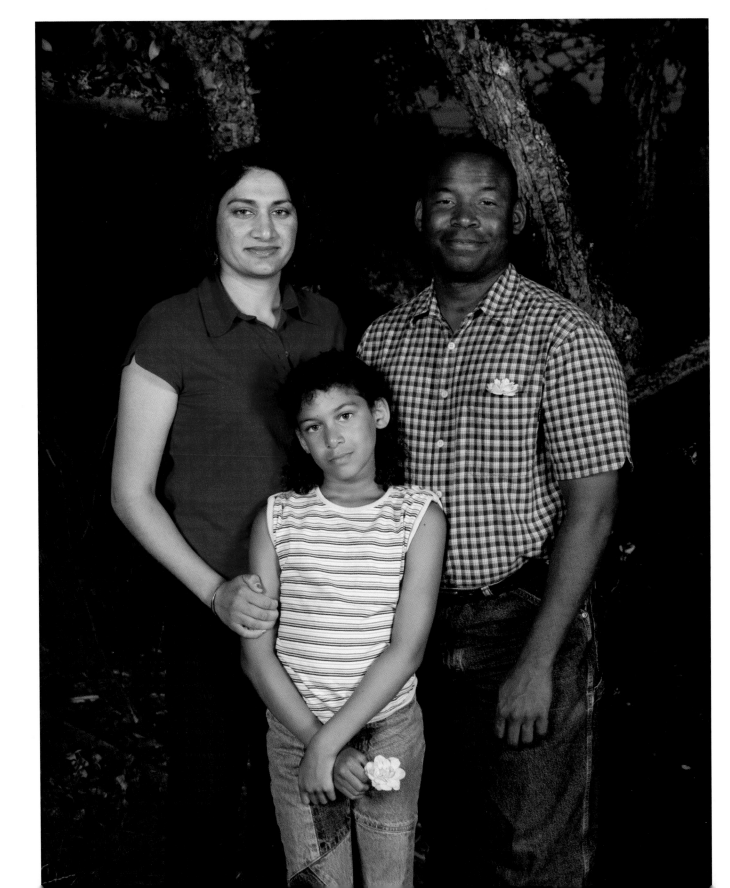

Half Asian (Japanese), Half Mexican (Half Native Mexican, Half White Mexican)

Tania Hino Gonzalez *Photographed at home in Seattle, Washington*

I am married to a born South Indian (from Tamil Nadu). I am half Japanese from my father's side Mazayuqui Hino Hino that is a first generation born in México. Both of my grandparents are from Japan and immigrated to México. My mother is Mexican mixed blood of Native Mexican blood and German/Spanish.

Being a mixed race person has impacted my life in different ways. It has its positive side to being multicultural and it also has its negative side. It is not a simple matter to be a multicultural individual when society wants to classify a person with a specific race. Some of the issues I had to deal with growing up are the constant explanation of my heritage. I look Asian because of my Japanese heritage but I was born in México, so when people ask "Where are you from?" My answer is México and the immediate response of 99% of the people will be "really?"

When religions discriminate other types of rituals or religions, it discriminates one of my other racial identities.

Growing up in the USA is especially hard because you have to identify your race. I never felt I belong to the Japanese culture and never fit in the Mexican culture either. I had to develop my own identity and pick and choose what fit best for my personality from all the cultures around me. Now I believe that there are more positives then negatives of me being a multicultural individual because I am flexible to different cultures and I now know there is no perfect culture in the world. Every individual has is own culture and there is no race that is better then the other. We are all people and we all want to be happy in the end.

I had identified myself as a Mexican most of the time because I was born in México but most of the time during my teenage years identified myself as "other" in exam papers or applications. Most of my life was influenced by Mexican culture and deep inside I had always admired the Japanese culture.

I am a Catholic because of tradition and being born Mexican, but I had always been interested in the Buddhist concepts. I now prefer to meditate with Vipassana

Meditation that does not belong to any religion but is just a technique to purify your mind. I guess being multiracial influenced me in believing that rituals of religion are part of cultures that discriminates other cultures. When religions discriminate other types of rituals or religions it discriminates one of my other racial identities.

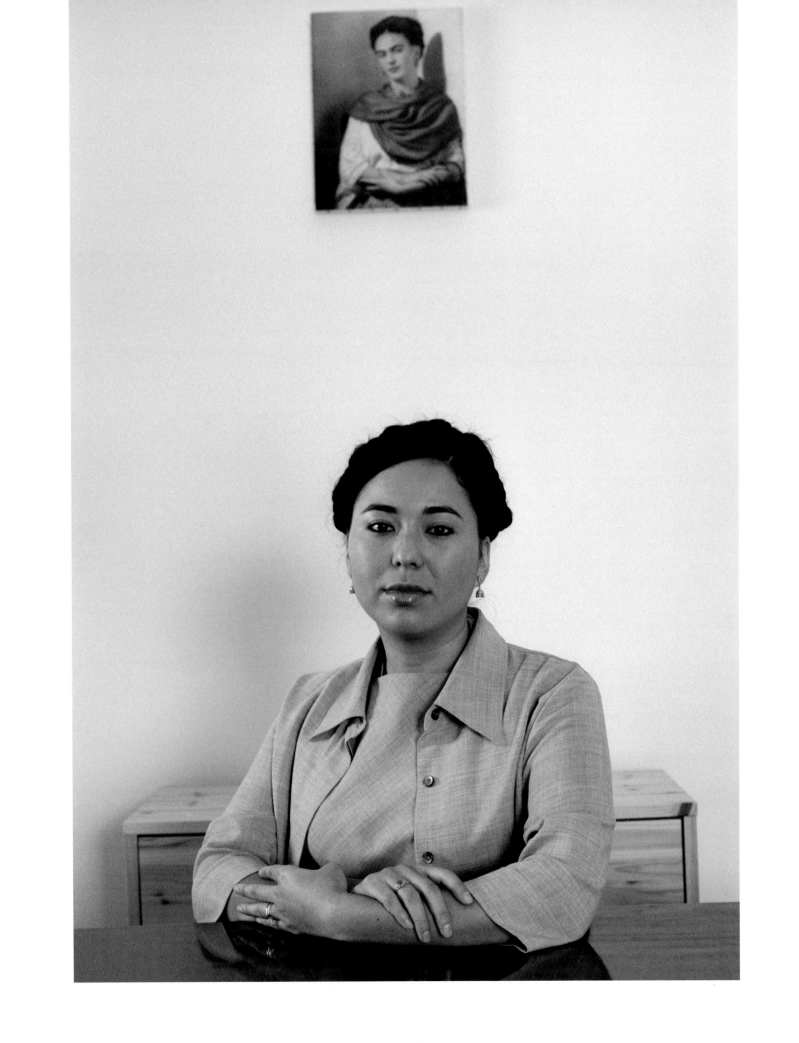

Half African American, Half White (Danish)

Being mixed has been a defining part of my identity and discovering and claiming an identity. And really, it's something I'm still figuring out —I didn't live full-time in the United States until I turned 11 and it wasn't until then that I learned that people thought of themselves and each other as black or white. Race hadn't occurred to me until we moved to Portland, Oregon, a racially divided northwest city. I learned to identify as just black at that point, though I think there was some cost to it. By that I mean it involved a bit of schizophrenia. I lived in a black neighborhood and was being raised by my white Danish immigrant mother. At home we spoke Danish and outside of home I struggled to fit in with other black students

I lived in a black neighborhood and was being raised by my white Danish immigrant mother. At home we spoke Danish and outside of home I struggled to fit in with other black students – to fit into what was my community.

Photographed in Los Angeles, California

Heidi Durrow

—to fit into what was my community.

I have had many different answers [to the "What are you?" question] over the years. I think lately I politely ask the questioner to rephrase: "Do you mean, what is my ethnic background?" I don't know why it rankles me so much to hear the question: "What are you?" I know often people ask, and then say: "That's a great mix," meaning they simply wanted to compliment me. Often people ask because they think I might belong to their "tribe," Inevitably if people want to know whether I am Bangladeshi, they are Bangladeshi, or Dominican, or Italian or Greek or whatever. People are often startled or intrigued when they see me because I am clearly a brown-skinned woman with dark hair but I have blue eyes. "What are you?" comes out of people's mouths because they can't put it all together. You get the answer in sixth-grade biology. I tell them my mother's eyes are this color.

I think less and less of my racial heritage as something that can be divided into parts. I have both a biracial and bicultural background, but I can't separate it all out. I'd have to say it's easier for me to

talk about the ways in which I identify with Danish culture and my Danish heritage (there's the language which I speak, the foods, the traditions, the very close relatives who live in Denmark, and of course there is the whole country). It is difficult to say that there is something necessarily black about my upbringing, but I very much identify with black culture which is also an American culture, and I identify as an African-American biracial/bicultural woman, but I don't know how to talk about that in the same way.

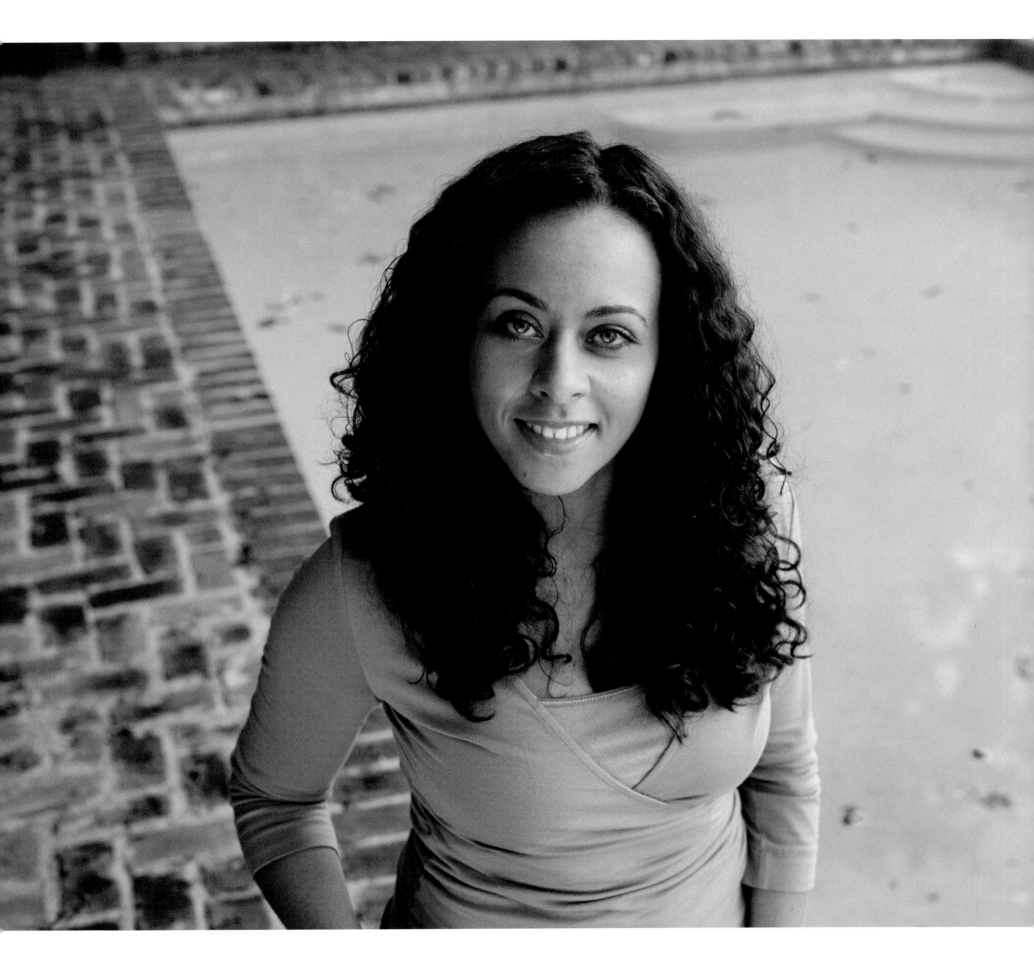

Fode Sissoko: Mandinko tribe of West Africa (Senegal)
His son Noah: Half African, Half White (Jewish)

Noah & Fode Sissoko

Photographed near Squam Lake, New Hampshire

Being in an interracial relationship was part of the dream of my life since childhood. My child's name, Noah, represents the peace and love through all living things and all nations. I know my child comes from all of the strongest tribes in the world. God is one, the truth is one, we are all one. He is being raised by the one truth that unites us all.

My child is well aware of his color and who he is. He's connected to all of his background.

My child's name, Noah, represents the peace and love through all living things and all nations.

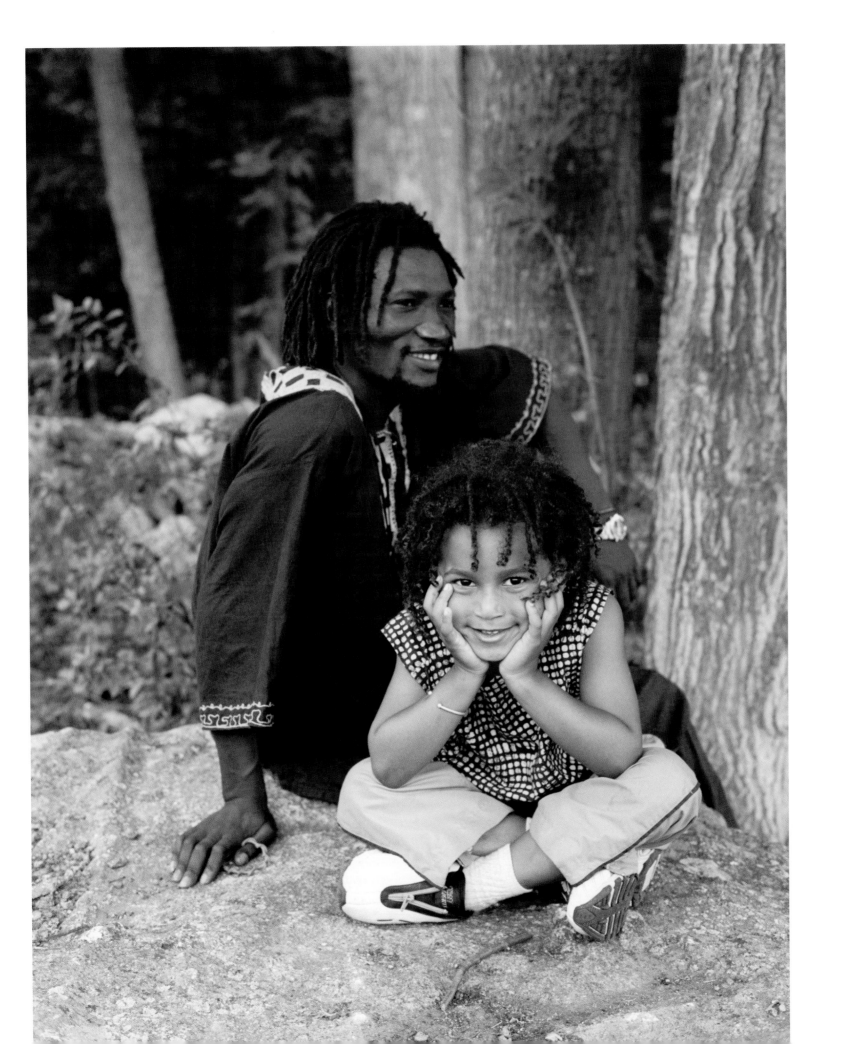

Johanna: Half Asian (Filipino), Half White (Finnish)

Johanna Novales
& her parents Asta & Ramon Novales

Photographed in Queens, New York

Johanna: I grew up feeling like I didn't belong to any sort of community. People were constantly asking me, "What ARE you?" or making unwanted wild guesses. There weren't large numbers of mixed-race people around in our part of Long Island, and there were hardly any Asians, period. No one looked like my brothers and me.

I have also at times been made to feel that I'm not "ethnic enough" if I attend events geared towards either side of my background. I've been told, "You don't look Asian," as if they're about to throw me out the door, or I get a hesitant, "Are you Filipina?" I've also been asked, by Finns, "How did you get interested in Finland?" I like to answer them

I find it really creepy when people talk about the increasing numbers of mixed-race people as some new, enlightened group. We're not any better or any worse than anyone else.

in Finnish by saying that I am Finnish!

When I was younger I would always answer the [What are you?] questions. Nowadays if someone asks me in public I'll try to put them off; if it's a complete stranger on the street (this happens more than I would like to believe) I'll say, "I don't share that information with strangers." If they phrase the question, "Where are you from?" I always give them the stink eye and say, "Long Island." Sometimes I can tell that people are asking because they think we might share the same background, in which case it's less annoying.

As far as internally, I don't think I ever thought about "what" I was in terms of not being able to find an answer. It was weird, though, as a young child, even though I knew that I was half-Filipina, I identified as white, because in school there were only white people & black people – and I knew I wasn't black. Although I remember learning about Martin Luther King, Jr. in kindergarten and thinking that Dr. King had "saved" my dad (never mind that he wasn't even in the country at that time), which seems to indicate that I thought he was black.

In high school, people would throw racial slurs at me: Connie Chung, egg roll. They would say, "Chinese can't play softball," when choosing teams in gym. It always infuriated me —probably just as much the assumption that all Asians were Chinese as the hostility itself.

I identify as both halves of my identity: Finnish & Filipino both. I also identify more broadly as mixed-race, and as Asian, because I know with the racist one-drop attitude still prevalent in American society, no one is going to buy me being white anyway, even if I tried to pass (which I would never do). I've been involved in Asian political and social activism, which means I spend a lot of time publicly identifying as Asian. There isn't the same opportunity to be immersed in a Finnish social milieu here.

I find it really creepy when people talk about the increasing number of mixed-race people as some new, enlightened group. We're not any better or any worse than anyone else.

Ramon: Having an interracial family has made us aware and more appreciative of American society and what makes it unique: the qualities

that make it in a lot of ways, the most rewarding, most gratifying environment for a family such as ours. We were aware that some segments of society would never be accepting or approving of families such as ours. We never really felt that there were any negatives in an interracial relationship.

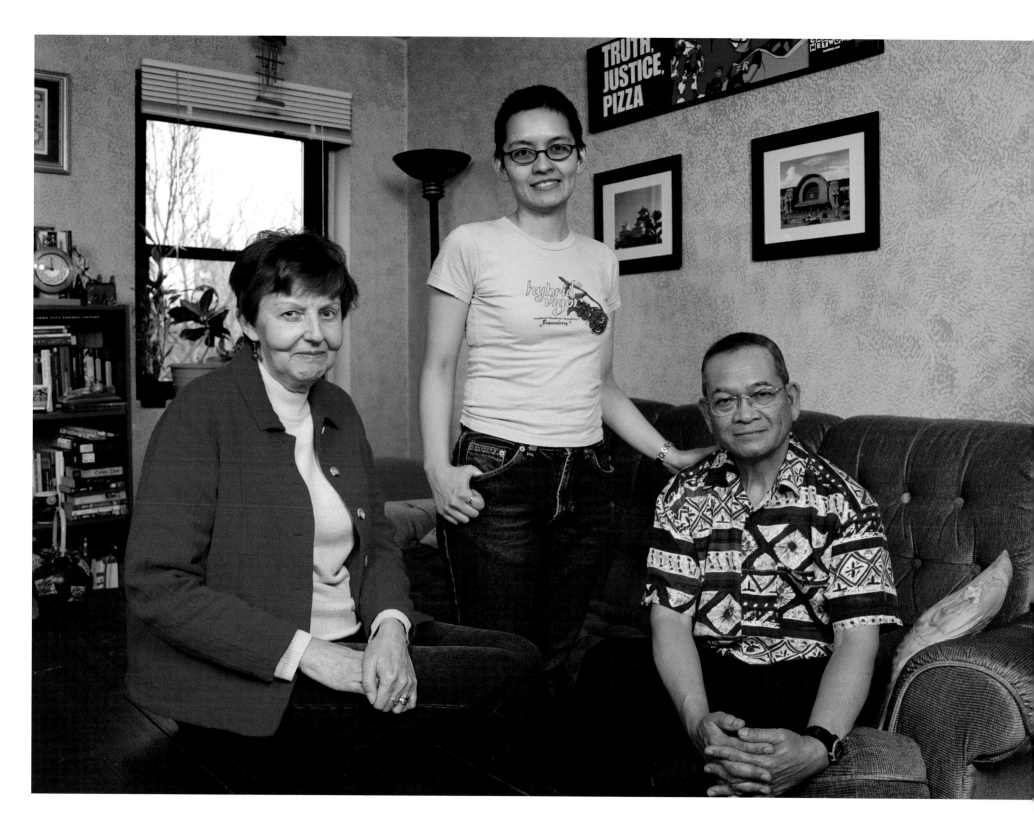

Half African American, Half Asian (Japanese)

Simone Momoye Fujita

Photographed in Alhambra, California

When you grow up with total strangers constantly asking the "What are you?" question, you become extremely aware of how others view you as well as how you choose to define yourself. Even as a child, I was aware that I didn't quite blend in, and I think that eventually worked to my advantage as I began to care less about others' opinions and instead tried to focus on being my unique little self. It might sound a bit cliché, but I really think that being multiracial has encouraged me to think outside the box. It has taught me to value difference rather than to fear it.

Being multiracial has pushed me to take on leadership roles creating community among mixed race individuals. In college, I founded the Biracial and Multiracial Students Association (BAMSA) at NYU and post-college,

I really think that being multiracial has encouraged me to think outside the box. It has taught me to value difference rather than to fear it.

I co-founded Swirl, Inc.'s Los Angeles chapter. The experiences I have had as a result of working with these groups have been really meaningful and led me to consider nonprofit organizing as a career.

I used to flinch internally whenever someone asked me the dreaded "What are you?" question. Now, I deal with the question based on the way it is asked and who is asking. Each answer varies, but no matter what, I always include both parts of my heritage. I am uncomfortable saying that I identify more with one side than another because both sides are inseparable parts of me. However, I was raised predominantly by my third-generation Japanese American mother and her side of the family, and I am aware that in many ways, my everyday life is greatly influenced by that upbringing.

I grew up as an Afro-Asian, Catholic, only-child in Southern California, spending summers in East LA with my Japanese grandparents and attending Obon festivals at Buddhist temples. My Catholic elementary school was close to downtown LA and filled primarily with Asian and Latino students from working-class

backgrounds. Fast-forward to my all-girl Catholic high school, where I was suddenly surrounded by wealthy white students in the suburb of Pasadena. Then I flew far away to attend college in New York and experience a completely different lifestyle there with new friends from all around the country. It seems like my whole life has been full of mixage and contradiction. It's a great feeling sometimes, but it's not all good all the time. The feelings of belonging (and not belonging) I have encountered among Asian and African American communities along the way have unmistakably impacted the way I see things. Every experience teaches me something new about American society, race, culture, human nature and myself.

As an ambiguous-looking multiracial person in the United States, one really experiences the effect the concept of race has had on this country. The assumptions that are made about a person's life based on a few facial features never cease to amaze me. I've been mistaken for Filipino, Hawaiian, Mexican, Puerto-Rican, Dominican, Chinese, even Middle-Eastern—basically everything but what I really

am. When I'm hanging with a multiracial friend, sometimes strangers will come up and ask if we're related even if we are different mixes and look nothing alike! One thing I can say for sure is that being multiracial is never boring. I've been hurt, offended and felt marginalized by others' comments, but these days, I take them in stride. I am better about speaking up for myself (e.g. "Actually, I AM Asian!" Or, "Hey, I'm black, too!") and try not to take occasional ignorance too personally.

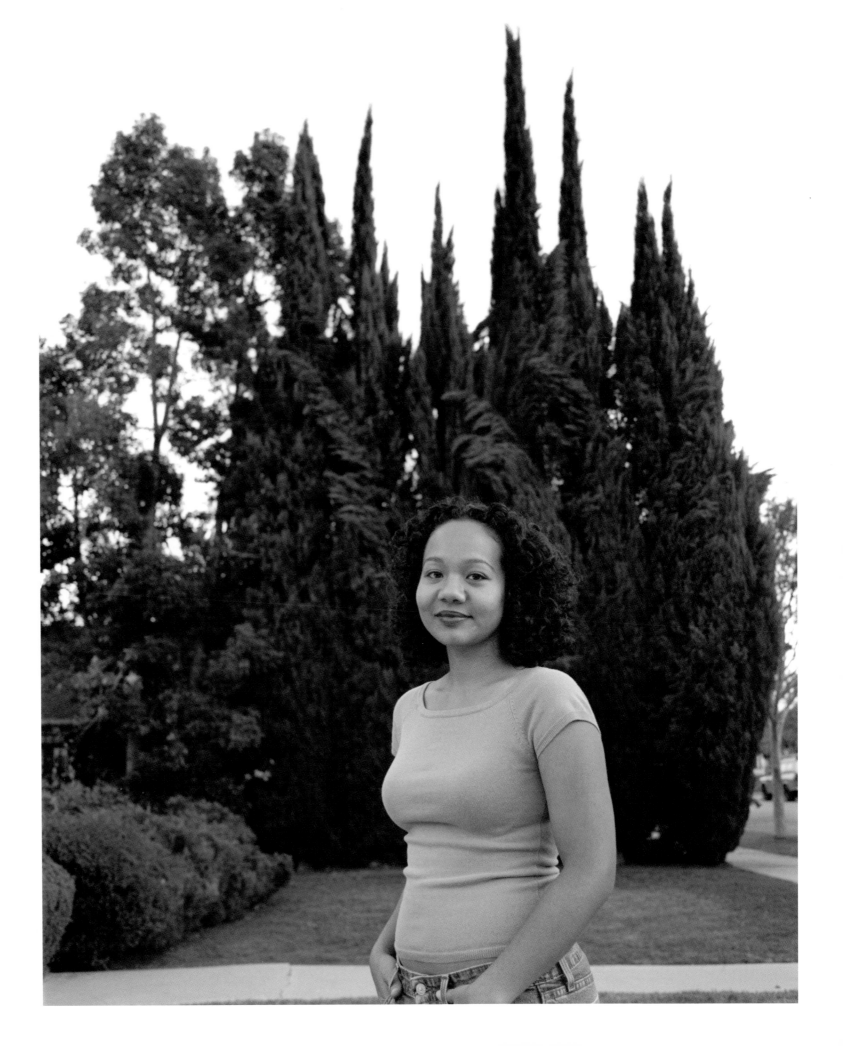

Half Asian (Chinese, Korean), Half White (Sicilian, Italian)

Frances Kao *Photographed in Seattle, Washington*

I grew up in Hong Kong, a city filled with people from all over the world and filling with a growing number of mixed race families. I am blessed to have grown up with and been a part of a large family that is as racially mixed as the number of countries we have traveled to and lived in.

There was a time in my life when I checked the box labeled Asian Pacific Islander. I grew up in Hong Kong so my life experience was literally Asian Pacific Islander. In the last few years I have found myself checking the box labeled OTHER. Until there is a box that reads Korean , Chinese, Italian American I'll continue to tick the OTHER box. The thought process behind this choice is simple in one sense: that the census or whatever research is being done should accurately reflect the demographic of the population it seeks to explore. On a much deeper, personal level I will with pride check the OTHER box until society deems there are enough of us or that we are important enough of a group to be labeled with specificity.

In my short 27 years in this world I have had, and am grateful for, the opportunity to work and play with a WIDE variety of people. My parents hugged me, told me and demonstrate every day of my life that I am loved, respected, supported and am part of a family and community. I feel this, more than anything else, has built in me a strong sense of self, and understanding that to be part of a community is to also be accountable to it. My racial identity, by way of how others around me respond to the way I look, has changed each time I have moved to a different country or region and has changed each time my personal interests have guided me from one social group to another. The foundation has always remained, and this is what enables me to BE in whatever space I have chosen for the moment and to appreciate all that comes with that space.

Until there is a box that reads Korean, Chinese, Italian American, I'll continue to tick the OTHER box.

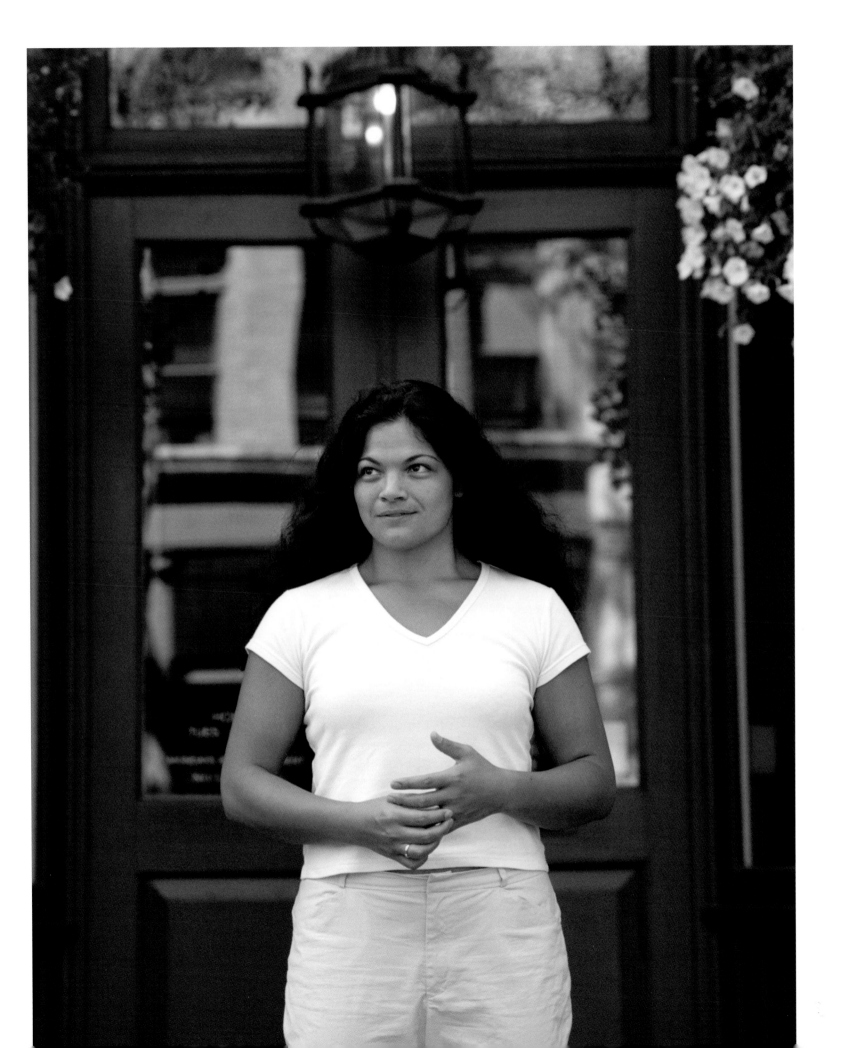

Half Asian (Vietnamese), Half White (Irish, French Canadian)

When I was growing up in the late 80s, in an all Irish-Italian neighborhood, you always knew you were different. Yes, you knew because you physically looked different but you were also reminded, in not always a "kind" way. Kids, heck even parents asked questions like "What are you?", "Where are you from?" "Are you Catholic?" As a kid, you know if someone is coming from a sincere place of interest or if someone is fishing to make an insult and say something hurtful. It was usually insult for me and eventually, I trained myself to avoid questions with short answers or avoid people and places that I know might hurt me. I tried to protect myself from the constant

inquisition. I grew a callus over those insults. It wasn't until I moved to NYC that I was able to digest, reflect and sort out all that really happened to me during my childhood. For the record, in the whole scheme of the world, I had a great childhood. I was healthy. I had a loving family and I had a circle of friends that appreciated my differences. NYC is truly a melting pot and my differences were celebrated – not put down. I stopped being ashamed of whom I was and realized that my ethnicity was interesting to other people in a good way. I became proud of my heritage and wanted to know more about it. All these experiences, positive and negative, shaped my life. I am who I am because of them.

Growing up, I always checked off the "Asian/Pacific Islander" box. I guess it didn't matter that you could be Asian or Pacific Islander. They are two separate regions! It would be like checking off "North American." In retrospect, I was doing everything in my power to be as "white" as possible. So I guess I identified myself with being "white." These days, I don't have a category. I am of mixed ethnicity, a person of color. As an actress, I always sign in to my auditions as the

ethnicity they are casting. When you think about it, it's completely unfair that I have to constantly "define" my heritage. Caucasian people don't have to answer if they are German, Irish or French. Why should I have to?

I'm not sure if my parents were unaware of the societal prejudices or they just chose to ignore them. It was never even discussed with my father who is Caucasian. I think mostly because my father is so open-minded and loving that he can't comprehend that anyone would purposely be racist or insensitive. My father separated from my mother when I was young, which only added to the insecurity and confusion I was suffering due to my ethnic mix. My mother was much more aware, but as a single mom she had other axes to grind. She always taught us (my sister and I) to be proud of our heritage, but in all honesty it was just words. When kids are making fun of you and stigmatizing you on sometimes a daily basis, your mom's pep talks on "being proud" don't really register.

Vivan Dugré — *Photographed in Brooklyn, New York*

Growing up, I always checked off the "Asian/Pacific Islander" box. I guess it didn't matter that you could be Asian or Pacific Islander. They are two separate regions! It would be like checking off "North American."

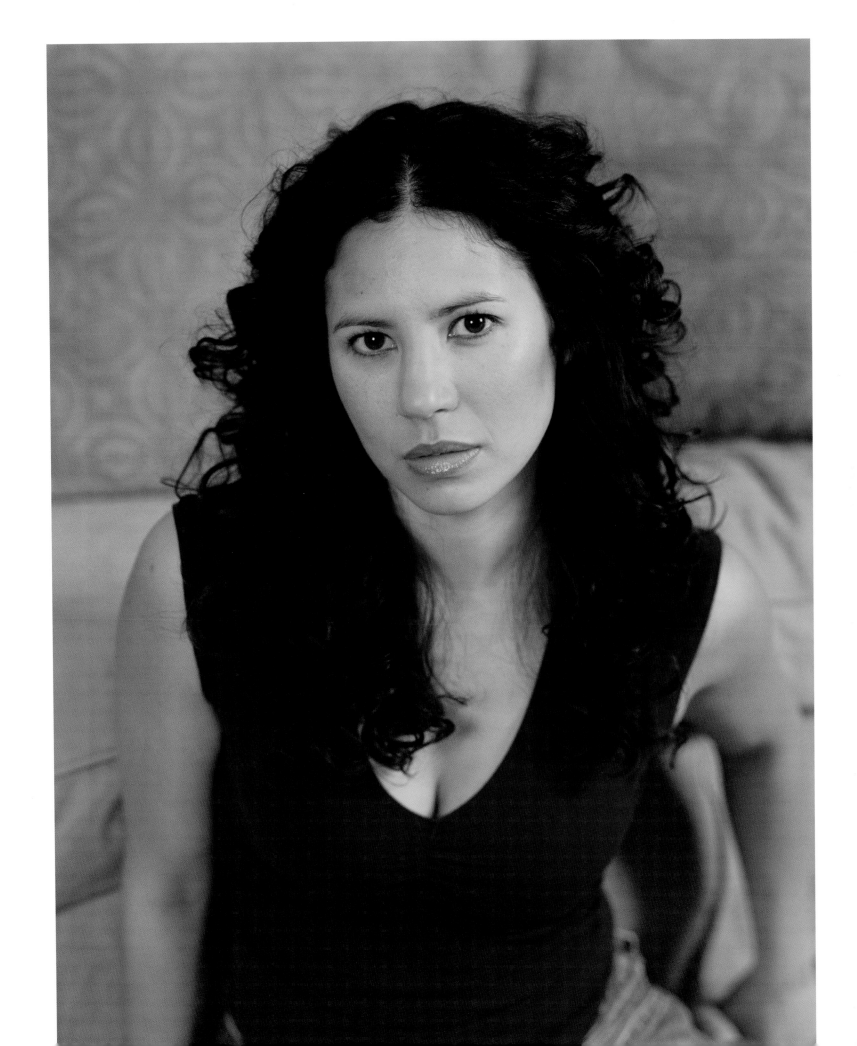

Anand Vaidya *Photographed in Queens, New York*

I grew up both in the United States and India and have found my racial ambiguity read differently everywhere I've lived. In South India I'm often assumed to be white (and therefore foreign) or North Indian. In the United States, especially in New York, people often assume that I'm whatever they are —so I hear a lot of Spanish, Arabic, Portuguese. It's definitely opened up room for play, but also made me less comfortable in homogeneously white or South Asian spaces. I'm just starting a PhD in Social Anthropology, and I know that my interests there follow from my experiences growing up "betwixt and between." Internally my identification has changed over time, from Indian to white to multiracial, but I don't think I've settled on anything yet.

Because I grew up with a large Indian community in the United States and went to high school in India, I definitely identify more strongly as Indian. That identification is often frustrated by my failure to meet some of the usual criteria of "Indianness"—phenotypically, linguistically, cricket-wise.

People often assume that I'm whatever they are – so I hear a lot of Spanish, Arabic, Portuguese.

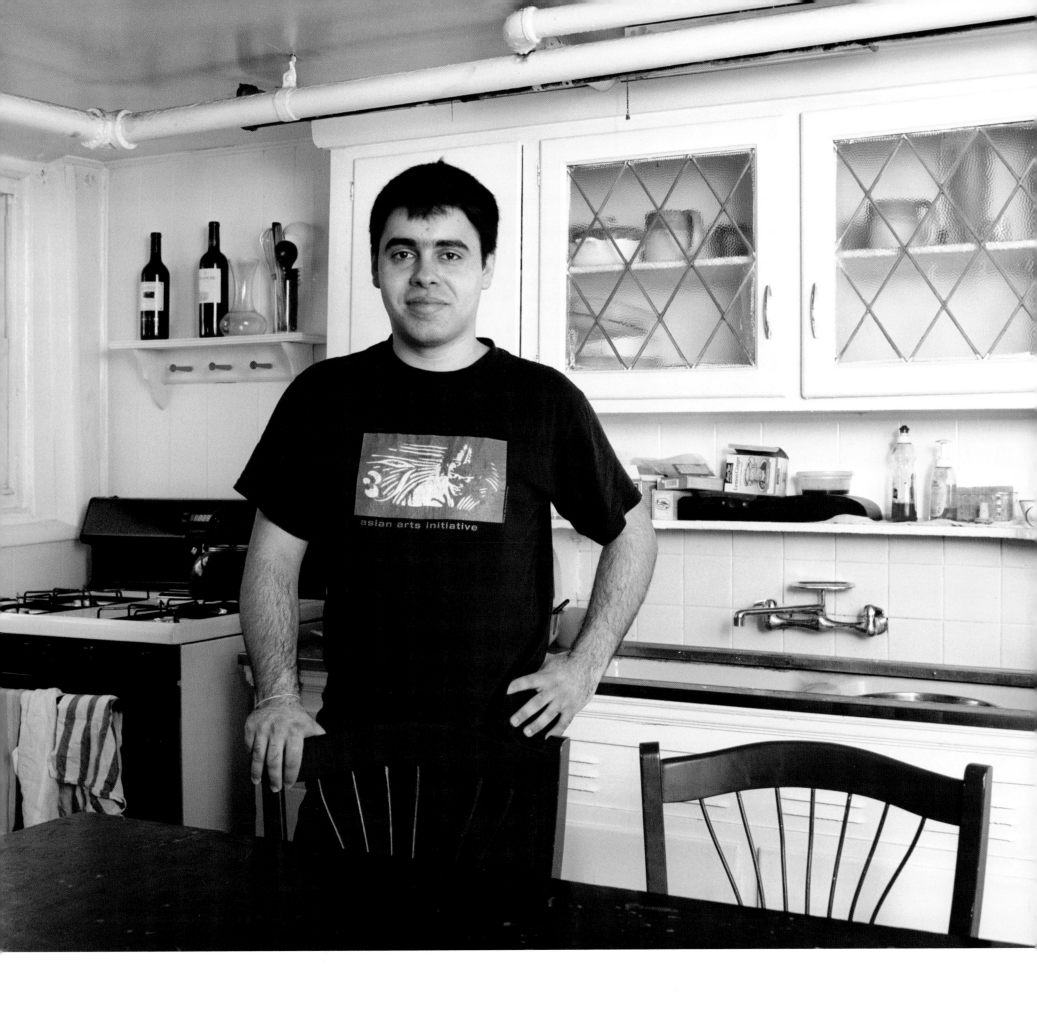

Being a mixed race person has made me a very open minded and understanding person. It's made me realize that you can't judge someone by appearances because people may be brought up in all sorts of backgrounds and situations that color their personality. They may look one way and act another. I grew up in schools in which Caucasians made up the majority. If at all I would be the only "Asian" person in a class, although I am half. This has really impacted me growing up because since I was used to being around Caucasians, I identified with them. Yet at times it was hard because I would be called names or made fun of because I looked Asian. I often didn't understand when I was younger that I was different and often felt confused, because I didn't feel different inside. Now I realize that being biracial has opened me up to being aware and understanding of other races. I feel it has made me a unique individual because I am able to experience both cultures.

Since I look more Asian I mostly identify with Asian yet if someone specifically asks "What are you?" I explain that I am biracial with Japanese and Caucasian because I feel I do not look full-Japanese or full-Caucasian, and therefore do not want to give half the truth. Society has played a role in my sense of racial identity because most people assume I'm Asian. Growing up in primarily white schools has made me "feel" more Caucasian, yet because I look Asian, and people assume I'm Asian or part Asian because of my looks, I have done what's easiest and identify as Asian when I am to classify myself as either/or.

Tiffany McIntosh *Photographed in Seattle, Washington*

Society has played a role in my sense of racial identity because most people assume I'm Asian.

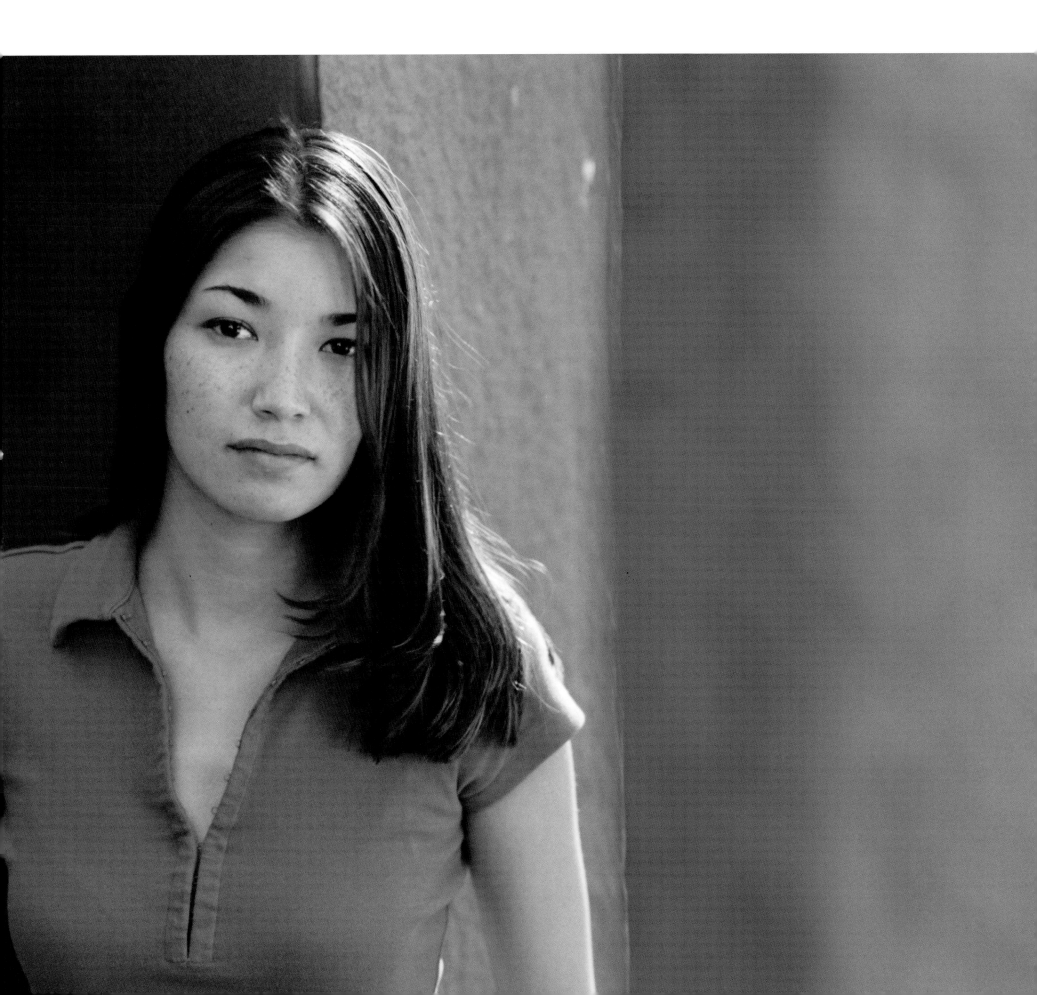

Half White (German), Half Black

Donna & Kim Hunter

Photographed in Oakland, California

Donna: My mother was white German, but my heritage on my father's side is much less cut and dry. The genealogy, as far as I can remember from the bits and pieces I've been told is as follows: great, great grandma was impregnated

Since I often don't signify as black, I would say I rarely feel forced to fit myself into a single category; I just get assigned whiteness.
– Donna

As adults, my parents shared some of the struggles they met and I came to understand better their courage and the importance of being everything you are. Sometimes that's not easy, but denying who you are is always worse.
– Kim

by her white master, and I believe, had her back broken by the white mistress as a result. Nevertheless, she bore my great grandpa, who is said to be part Native American, so he must have been 1/4 black, 1/2 white, and 1/4 Native American. So my paternal grandma is about 3/4 African American and 1/8 Native American and 1/8 white. That makes my dad 7/8 African American, 1/16 white and 1/16 Native, which means I'm 17/32 white and 1/32 Native American and 14/32 black. Hmm . . . guess I am more white than black. But this is all hearsay, and I bet I'm really even more than 17/32 white since very few blacks in the US are free of white blood.

My racial makeup probably began affecting me at a very early age, but I don't recall consciously thinking about race, particularly about my own race, until I was in my late twenties. In terms of my upbringing, my family didn't talk about race or about us being mixed race. I must add that I typically "pass" as white whether I want to or not. Blacks can often tell that I am part black, but most whites think I'm tan or something.

I see myself in terms suggested by Homi Bhabba, as "not-quite-white." Although this may

seem ridiculous and perhaps racist, I don't identify as black because I don't feel I've been oppressed enough. This is not to say that there aren't blacks who are more privileged than I am, but that because I don't look or sound "black" to most people, I typically pass as white with white people and black/biracial with black/biracial people. However, I actually feel insulted when I am considered white. My skin is visibly brown, not white, and since I feel a kinship with the underdog, I don't like to be considered wholly complicit, even racially so, with dominant white society.

Since I often don't signify as black, I would say I rarely feel forced to fit myself into a single category; I just get assigned whiteness. And when questioned I answer, "My mother was white-German and my father is black." I have never once thought to be ashamed of my racial heritage – it's always been at least who or what I am, and is oftentimes a source of pride.

Kim: Being biracial has been a blessing for me in my lifetime. Born in 1958, as the Civil Rights Movement began, developed, and exploded with energy, so has my awareness of who I am and where I have come from. This unique trait

has opened me more easily to celebrate others' differences. I happily tell people my biracial category and let them ask me more questions to lessen any ignorance or myths he/she may have. I have found when most people ask, they are truly interested and appreciative of who I am.

I identify with both my white and African-American racial heritage. It has always bothered me to have someone request I choose one over the other. I refuse, because I love both my mother and dad, and their histories. Our parents shared with us often how they met and fell in love and were a united front when dealing with the world. When we were children, we were told positive stories about how well received they were as a couple and how people thought my sister and I were beautiful. As adults, my parents shared some of the struggles they met, and I came to understand better their courage and the importance of being everything you are. Sometimes that's not easy, but denying who you are is always worse. I rejoice in being a half German, half black, gay woman.

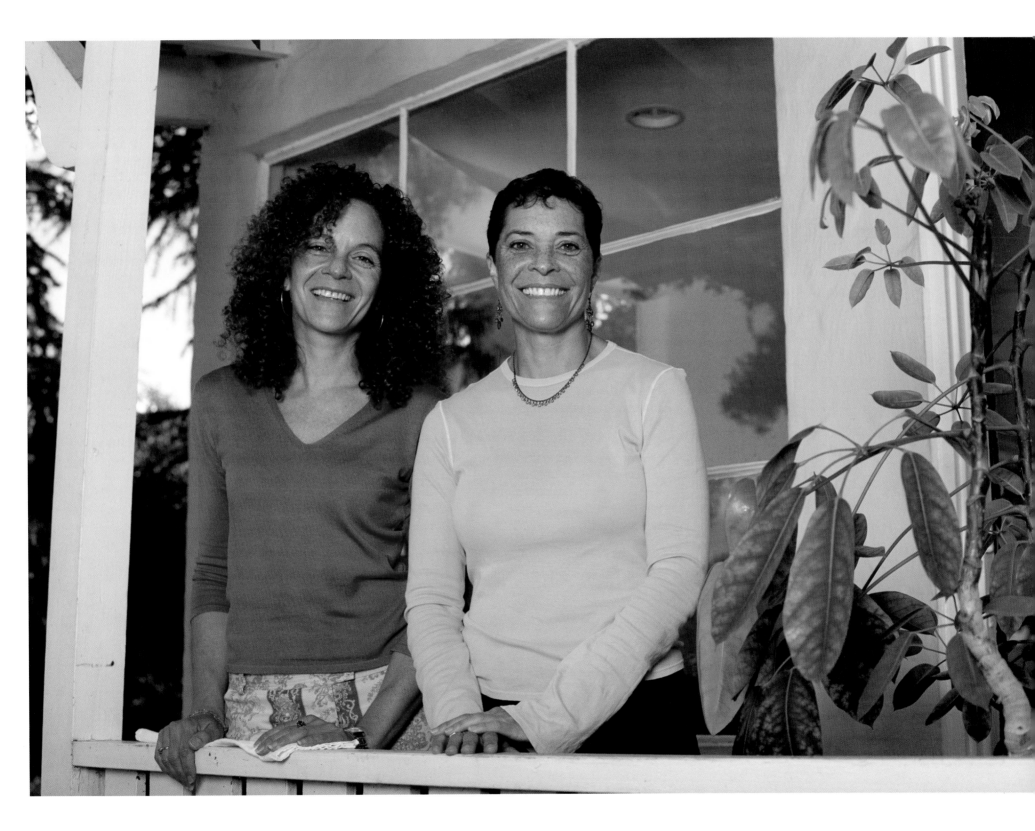

Kenji, Teshika & Maya Hatch
Photographed in Seattle, Washington

Maya (right): It's been hard for people to understand the very simple fact: I am just as much Asian as I am white. For some reason, many of my white friends in high school could not fathom the idea; I was Asian to them because I look more Asian than white. It's absolutely offensive to me that people can and will choose to their own liking and convenience how to define my racial identity. When people define me as Asian it really pisses me off because that's not only

> When people define me as Asian it really pisses me off because that's… disregarding the other half of my DNA.
> – Maya

> It may seem almost too simple for those who aren't familiar with being biracial or having to relate to more than one culture, but its much harder than most people can imagine.
> – Kenji

disregarding the other half of my DNA, it means I wouldn't even be alive at this moment.

I have been asked "What are you?" enough times that I just expect to be asked it each time I meet someone new but I will admit that I'm guilty of it too. The beautiful thing about America is that it's not a one-race country; everyone has a story to share about their heritage and I think it's something we should all take advantage of because we can really learn so much about other cultures and countries by being curious. On the other hand, being mixed has given me mixed feelings about the concept of race. I am both overly aware of (and sensitive to) race and color-blind to race, in the sense that race should not even matter and certainly should not be the sole definition of or response to "What are you?" While I recognize and relate to the immense impact that race has on an individual, I feel that racism will never completely disappear until we demolish the man-made system of hierarchy by seeing each other for who we are internally, and not externally.

Kenji: Asking myself, "Who am I?" is no longer the confusing question it once was. It may seem almost too simple for those who aren't familiar with being biracial or having

to relate to more than one culture, but it's much harder than most people can imagine. Besides having a slight tint of yellow to my skin and a dark brownness to my hair, I never thought twice about having to fit in or try harder to be like everyone else until I came to the realization that people thought of me as an Asian. There must have been more minorities than whites [at school] because it seemed like every time I turned around I saw two dark colors for every light one. Of course I found myself mostly with Asians but occasionally was surrounded by other ethnic groups. Slowly, I learned from the rough lifestyle most of the kids led that to be white was not "cool." And so I did what I thought would allow me to fit in. I naturally started to hate my white half. I told friends that my father was not my blood father, that he was my stepfather. To everyone else, I was full Japanese, I was "cool."

[In Japan], I met one of my best friends at my new school: a half Japanese, half white guy like myself. He had been raised in Japan the majority of his life and had attended a private school mainly for kids in Japan that spoke English. At first I questioned him about why he tried speaking English to me, telling him that this was Japan and that we should speak Japanese. "Why not talk

in our mother tongue?" He saw no reason for excluding English. There were other mixed kids at the high school and I began to incorporate English into my everyday language again. Soon most of the multi-ethnic group started to hang out a lot together and I was introduced to many more "half breeds" who were proud to be what we are. Suddenly it dawned on me that there is nothing wrong with who I am and that there are actually benefits to being biracial.

Teshika: It was never easy to live in Japan as a partially white child. The country seemed to be filled with people not accepting others as one of them, but as an outsider or "alien." Before moving to Japan, we lived in a neighborhood full of minorities and went to a school with only about 1/3 of the students as whites, so I didn't really notice myself as much different. After we came back to the U.S. I would often be asked what I was and never knew how to respond. The curiosity of Americans towards other people's racial identity, as well as the Japanese way of calling others "outsiders," became more understandable to me over the years. But because I am as much white as I am Japanese, the way people in both countries assumed you were different from them seemed ridiculous.

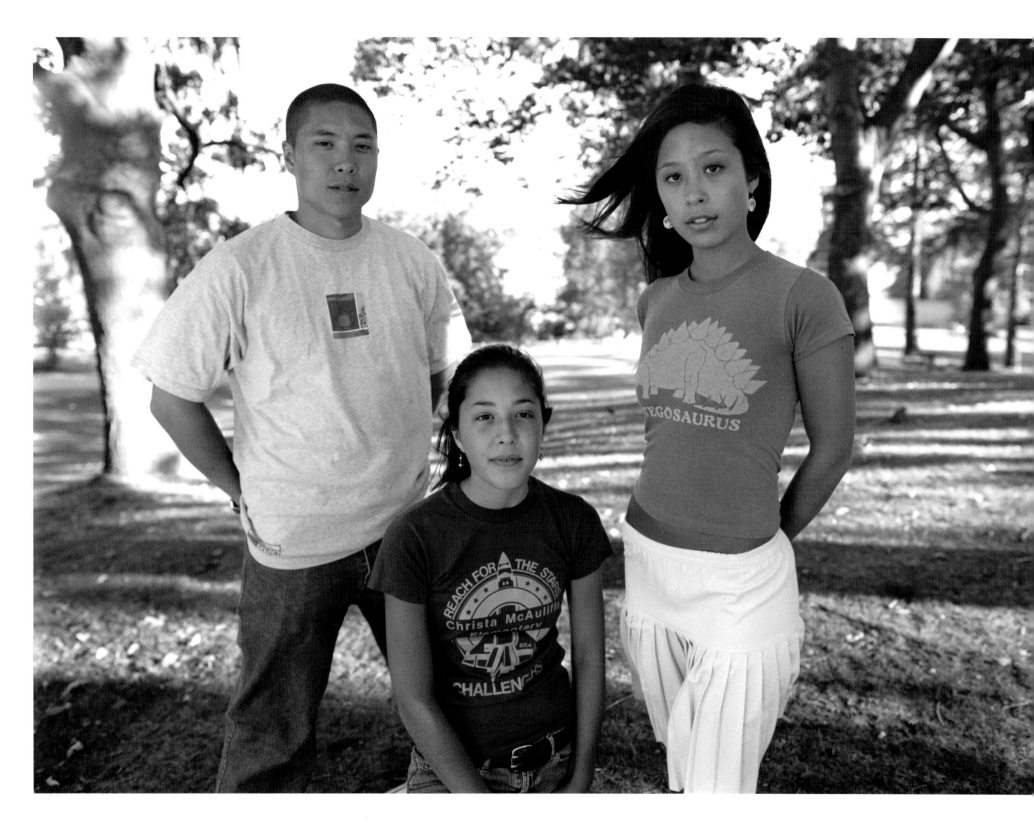

Native American (Cherokee, Blackfoot), White (Spanish/Dutch from Curaçao), African American

Andre Johnson

Photographed in Brooklyn, New York

Being a man of mixed race and having grown up in a diverse community, I have had the pleasure of enjoying not only the wonders of my own heritage, but also experiencing those of my neighbors. The co-habitation between cultures that exists when living in a city such as New York has introduced me to many customs. My upbringing has been enriched by the music, arts, foods and spiritual influences of other ethnic groups. These interactions have allowed me to expound upon the traits of my own existence. Furthermore, I believe that as a result of being mixed race, social interaction with peoples of other lands was a natural and

Being seen, and labeled, as "a black man" has never bothered me. Nor have I felt challenged to announce that I am also Native American/Dutch West Indian, and that my great great grandfather was a southern man of Jewish descent.

purposeful response towards the understanding that we collectively serve a similar purpose to relate, and evolve as human beings.

Growing up in New York, there was always an open-door policy in my home for all welcomed. The understanding that one's heritage is that which makes us unique was an integral part of me acknowledging the significance of my own racial make-up. The relevance of being an "African/Native American" in this country is something I have always been proud to announce when questioned, "What are you?" The struggles that most people of color, my people, have endured to date, have been the driving force fueling my direction towards a pride-full, prosperous and dignified life.

Society has a way of shuffling people into racial brackets. This is truly a fact I have experienced. Being seen, and labeled as "a black man" has never bothered me. Nor have I felt challenged to announce that I am also Native American/Dutch West Indian, and that my great, great grandfather was a southern man of Jewish descent. Internally I am completely content with the external make-up I wear.

I'd have to say that I mostly identify with my black heritage. Due to the disenfranchisement and displacement of Native Americans in America, there is little that I can say that I relate to (through society) in regards to this part of my heritage... if not for my grandmothers's (mother's mother) tales of native peoples long gone, and the fact that most of what I know I've researched and read on my own. I'd only know the simple stories taught in school. Occasionally I attend and participate in Native American ceremonies with my mother and younger sister. They have managed to immerse themselves in this part of our heritage in order to preserve and share with the generations to follow.

As for my Dutch/West Indian influence, I've only visited Curaçao once. I met my grand daddy (mother's father) when I was eight years old and was amazed by the cultural differences between the peoples of that land, and my own back in the States...one of my most profound memories having visited Curacao. Proud to be Jacob Leoncio Henriquez's first grandson and, as an American detached, I dream of returning to the home where he lived and died.

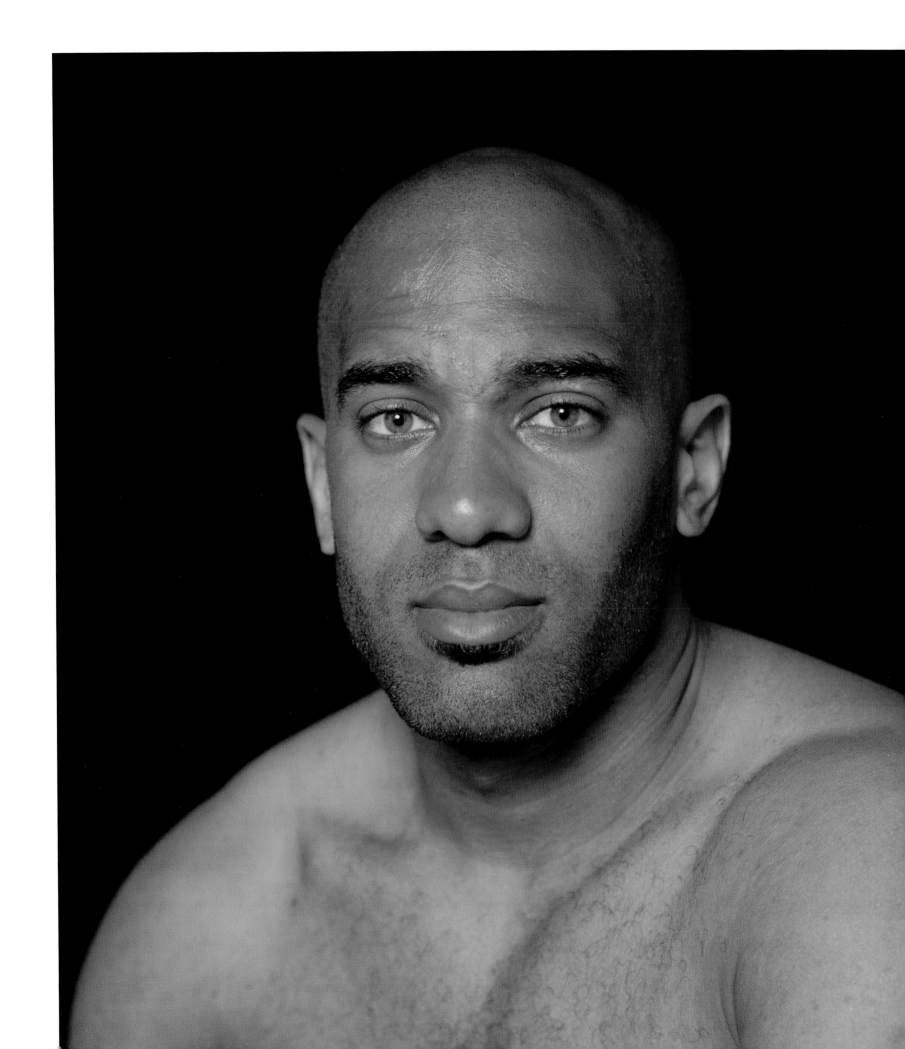

Aimee Bullock, sons Gabriel & Lucas

Photographed in Seattle, Washington

Being multiracial gave me a profound sense of being different: not really a part of any one group, which can be a good and a bad feeling when you're growing up. I think in some ways it gave me the freedom to explore different sides to myself.

For me, since people can't tell at first glance what "nationality" I might be and they almost certainly would not guess African American, I guess I would have to say [I identify as] Caucasian. Although the majority of my friends and many members of my extended family are people of mixed race, I think

Being multiracial gave me a profound sense of being different. Not really a part of any one group, which can be a good and a bad feeling when you're growing up. I think in some ways it gave me the freedom to explore different sides to myself.

I identify most closely with people of any mixed race combination because we have so many more shared experiences relating to identity, than I have with the people of either of the two races of my parents.

Since my parents divorced when I was very young, my father's family (my African American side) had very little direct influence on the formation of my identity. Or more realistically their influence was only in my own and societie's assumed interpretation of who they were. Additionally my mother's parents (my Caucasian side) played a large role in raising me. They had adopted five children of mixed race after the Korean war, so the household that I grew up in and was most influential in the formation of my identity had many examples of how to interpret being mixed in the predominantly Caucasian society where we lived.

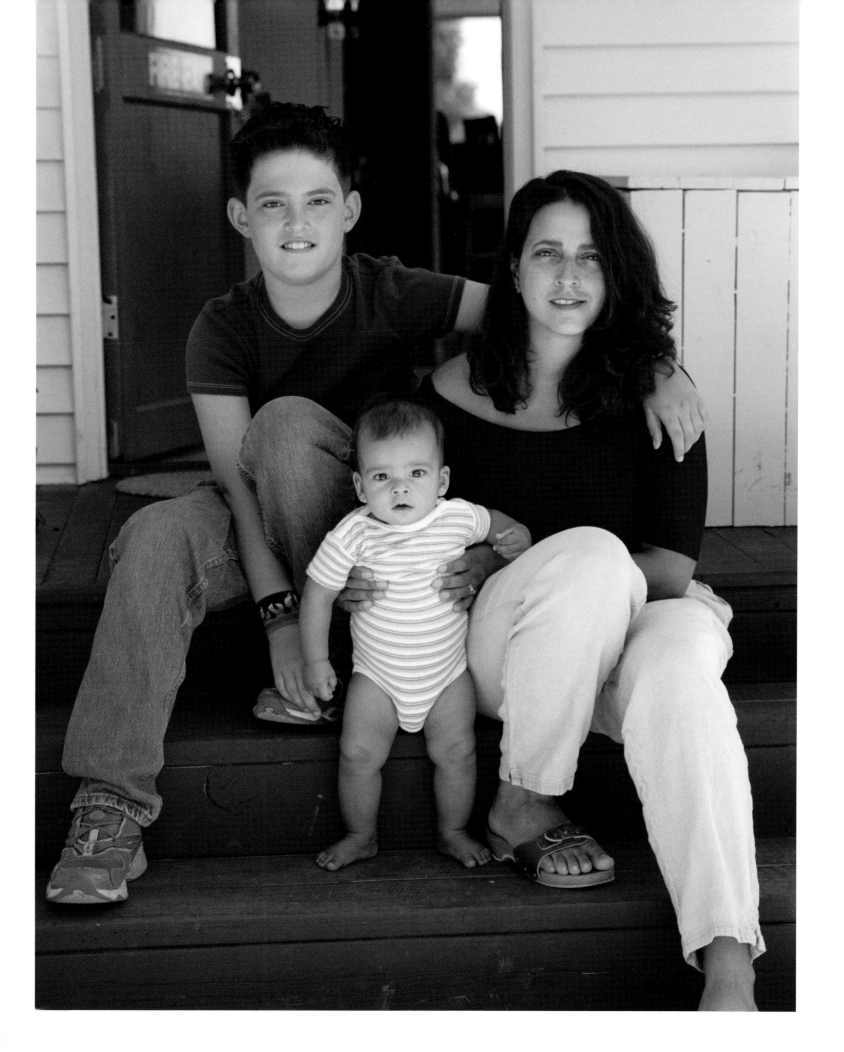

Epilogue *by Mike Tauber & Pamela Singh*

The journey of *Blended Nation* began in late 2001 when New York City was still reeling in the aftermath of the 9/11 attacks. Mike had spent some time photographing Sikh vigils around the city in the days after the incident. The Sikhs – despite practicing an entirely different religion from Muslims – found themselves at the receiving end of the fear, ignorance and xenophobia following the attacks. They had to deal with unwarranted scrutiny and discrimination primarily because they wore turbans and their skin color bore a resemblance to anti-American Islamic fundamentalists. Although the Sikhs' predicament had more to do with religion and ethnicity, we found ourselves intrigued by the issue of race and identity being heavily based on visual cues. For example, what happens to the identity of those individuals who are a quarter this, a half that, etc., who don't visually correspond to any particular group when it comes to race, ethnicity and ancestry? Where do they fit? What box do they check? Moreover, most importantly, why is this even considered an issue? A few years later, Barack Obama would bring this issue to the forefront by making his first foray into national politics. As a biracial American, Obama was often criticized as not being black enough or white enough. However, he was able to use this to his advantage to appeal to a much broader group of Americans. Still though, Obama often referred to himself as black, rather than biracial.

We asked ourselves, 'What is race anyway?' How does one define race, particularly when it is constantly evolving? If race does not have any scientific justification in human biology, then it is obvious that race is primarily a social construct that helps us categorize people. The concept of race is so thoroughly and perniciously embedded in the cultural framework of the United States that it has become a key element of both individual identity and government policy. The problem is that while both race and ethnicity are perceived as fixed categories, research continues to indicate that individuals' view of their identities remain fluid and changes according to specific contexts in which they find themselves. This trend is even more pronounced in the mixed-race population in the United States, where race, ethnicity, culture, identity and visual cues – in terms of skin color, facial features and hair texture – are closely intertwined and constantly shifting.

A blend primarily of Indian with some African and Carib Indian heritage, Pamela has dealt with her share of the 'What are you?' questions. She had originally floated the idea of writing a book about the subject but we agreed that since the concept of race tends to be tremendously based on visual cues, it would be most powerful to explore the mixed-race experience through words and images. For a photographer with a background in anthropology and human ecology, this project was a fascinating way for Mike to explore the concept of race and how society perceives race.

We began photographing in the spring of 2002 with a network of mixed-race friends and expanded with the help of organizations like SWIRL and MAVIN that are resources for the mixed-raced community. We photographed individuals and families across the Northeast, California and Washington State, concentrating on areas of the country with the largest populations of mixed-race individuals. To substantiate the images, we then asked each subject to share with us his/her personal experiences of existing between the perceived racial categories designated by the U.S. Census. On the 2000 Census, for the first time in history, multiracial individuals were allowed to indicate more than one race. Nearly seven million Americans did so. Already, in some large U.S. cities today, 1 in 6 babies born is multiracial. According to the US Census, Hispanic is considered an ethnicity, not a race, since Hispanics can be of any race or combination thereof. For subjects, we sought as many ages and varieties of mixes as possible but were no doubt limited to those to whom we had access and those who wanted to be involved in the project. We asked each individual to self-identify, which is why some have, for instance, referred to a part of his/her heritage as 'Black American', 'African American' or simply 'Black.'

As you will see from the words the subjects in *Blended Nation* so graciously shared, the mixed-race experience is as varied as the number of mixed-race Americans. Skin color and facial features are the main drivers of the experience, but socio-economic status and the nature and location of one's upbringing play major roles in that experience.

The faces and very personal stories presented here attempt to shed light on the greater issues of race in America through the prism of the mixed-race community. At the very least though, this collection of experiences provides some insight into the feelings and potential identity issues that might arise for the younger generations of mixed-race Americans and reinforce the pride in their heritage.

Acknowledgements

We would like to thank everyone who participated in the project. Your willingness to share your time and personal experiences has made this project possible. We have enjoyed meeting and talking with all of you and thank you for entrusting us with your stories.

Thanks to Wyatt and Rohwan for constantly inspiring us with your curiosity and love. We are extremely grateful to our parents: Jeff Tauber for his unending support and guidance, the late Trish Tauber for fostering a love of travel, and Rosie Singh for always being a pillar of strength. To our sisters - Deb Tauber, Cerah Singh, Shadee Dumas, Kamla Hosein - who are always quick to help solve problems and offer a different viewpoint.

Thanks to Ron Acquavita for his patience and beautiful design work on the book mock-up used to get a publisher. Everyone at the MAVIN Foundation for their help on the Seattle phase of the project: Matt Kelley, Sashya Clark and our Seattle assistants Cary Thielen and Sheri Thom. Thanks to Jen Chau of SWIRL for not only lending your time and thoughts, but for getting the word out to potential subjects. Thanks to George Pitts and Katie Schad formerly of Life magazine and Buzz Hartshorn at ICP for your advice.

Thanks to Mark Barker for his support of the project and for his friendship all these years. A big thank you in no certain order to Phoenix Blackhorse, Elizabeth Barker, Robert and Robbie Bailey, Kristofer Dan Bergman, Chanda Butler, Chris Rainier, Kim Sauvageot, Adam Braun, Mark Slidell, Peter Spear, Drew Bryson, Brandon Remler, Kate Raudenbush, Rob Griffitts, Kevan Bean, Josh Rosen, Jon McBride, Mimi Gary, Sara and Guy Ardrey, Amanda Back, Ron Amazan, Steve Williams and many others. You have had an impact on us or this project in ways big and small.

A huge thanks to Steven Goff, Beth Maseuli, Adrianne Casey and everyone at Channel Photographics and Global PSD. Thanks to Jacqueline Domin who did an amazing job on the book design. We are also incredibly grateful to Alan Goodman for contributing his fascinating essay on race and to Joseph Jones at the American Anthropological Association. A big thank you to Rebecca Walker for lending her words to the project. Finally, we would like to express a sincere thanks to Ann Curry for taking time from her incredibly busy schedule to contribute her Foreword to the book.

Channel Photographics
980 Lincoln Ave. Suite 200 B,
San Rafael California, 94901

T: 415.456.2934 F: 415.456.4124

www.channelphotographics.com

ISBN-13: 978-0-9773399-2-1

US/Canadian Distribution ·
Publishers Group West
1700 Fourth Street,
Berkeley, CA 94710

T: 877.528.1444

Photography Copyright · Mike Tauber www.miketauber.com
Foreword Copyright · Ann Curry
Introduction Copyright · Rebecca Walker
Essay Copyright · Alan H. Goodman
Design by Jacqueline Domin, www.jaccadesign.com

Printed and bound in China by Global PSD
www.globalpsd.com

Channel Photographics & Global Printing, Sourcing & Development
(Global PSD), in association American Forests and the Global ReLeaf
programs, will plant two trees for each tree used in the manufacturing
of this book. Global ReLeaf is an international campaign by American
Forests, the nation's oldest nonprofit conservation organization and a
world leader in planting trees for environmental restoration.

REPLANTED PAPER